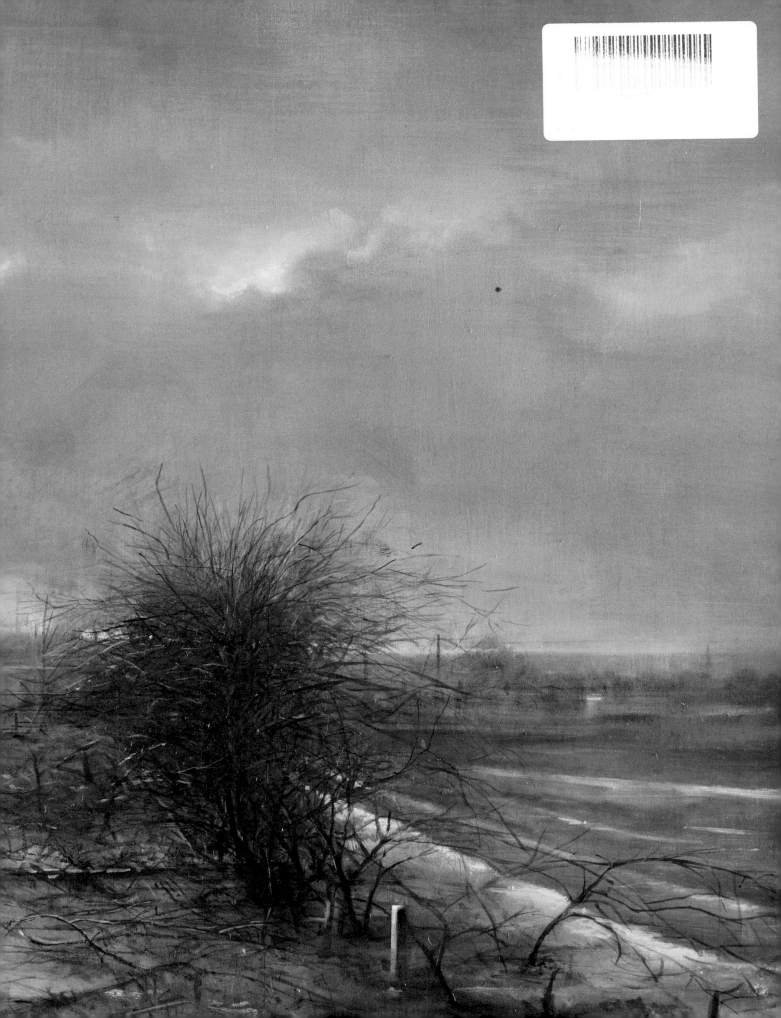

How to Paint
Atmospheric
Landscapes
in **Acrylics**

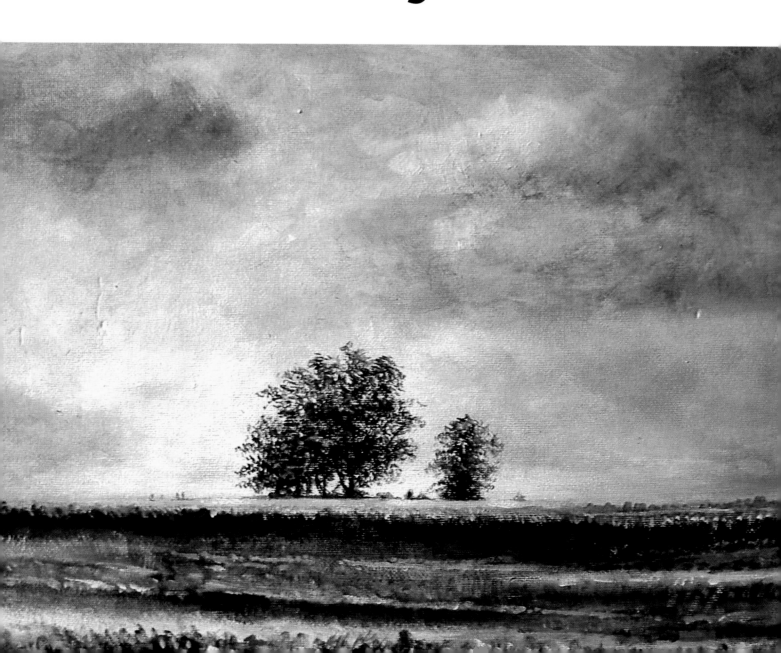

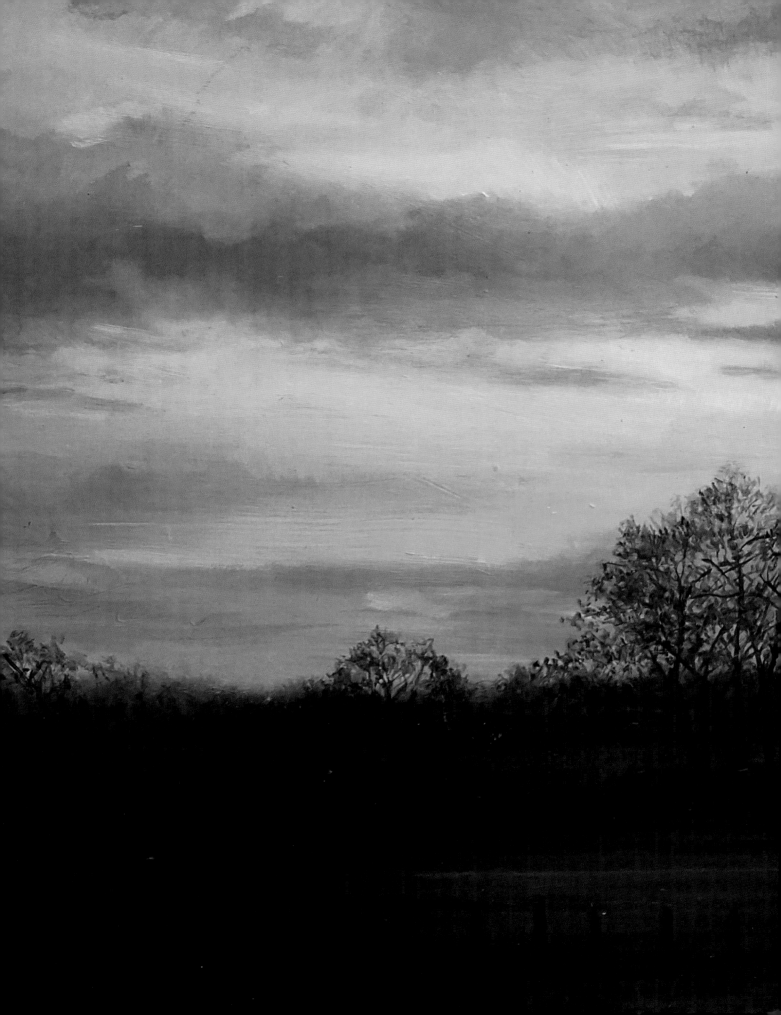

How to Paint
Atmospheric
Landscapes
in Acrylics

Fraser Scarfe

Search Press

Acknowledgements

My heartfelt thanks to my parents and family for their continued and unceasing support throughout my career, helping to guide me at every step of the journey. Thank you so much.

Secondly, I must thank Richard, Jean and the whole team at the SAA for giving a young artist a chance to grow and develop, it's been a joy to work with you.

Thank you to the Royal Drawing School for providing an unparalleled arts education at the time I needed it the most.

Thanks also to the following for the loan of pictures: Janis and Steve Wright; Simon Would; Sir Mike Moritz; John and Rosie Burkes; The Estate, Dumfries House; Sally and Stuart Scarfe; James and Laura Parry; Jo and Ray North; The Jews House, Lincoln; Muriel Brooks; Greg Kapka; and The Alexander Miles Gallery

Finally, thanks to everyone at Search Press for their hard work, and especially to Edd Ralph for guiding me so expertly through the book-writing process.

First published in 2017
Search Press Limited
Wellwood, North Farm Road,
Tunbridge Wells, Kent TN2 3DR

Suppliers
For details of suppliers, please visit the Search Press website: www.searchpress.com

You are invited to the author's website: www.fraserscarfe.co.uk

Publisher's note
All the step-by-step photographs in this book feature the author, Fraser Scarfe, demonstrating acrylic painting. No models have been used.

Printed in China

Contents

Introduction

I have a confession to make. I have never been a great reader of art instructional books or step-by-step guides. I learned to paint in such a haphazard and irregular way that they never seemed fitting for me, so it seems funny that after ten years of painting I am now sitting down to write one. I have laboured long and hard over how best to do this and to condense what I do into manageable chunks. It has not been easy.

My saving grace when writing this book has been that I have always kept a painting journal – a ramshackle sort of diary of my day-to-day painting activities, my travels and ideas for new work. Flicking back through these various scrawls and musings seemed to present a way into this project. My life as a painter is a varied one – a fact for which I am thankful – and so what I wish to do is present you, the reader, with a glimpse into this life.

The following chapters include a collection of journal entries, thoughts on painting, and a closer look at the projects that I have undertaken over the course of a typical year. You can read it chronologically by all means, or just dip in and out at your own leisure. My hope is that it will offer some insight into the practicalities, challenges and rewards of being an artist, some inspiration and also some instruction if desired.

The overall topic of the book was a straightforward choice. I have worked with various types of paint over the years but acrylics have always been my 'go-to' favourites. I have seen them go from strength to strength as a medium and hope that this book goes some way to promoting them as a serious choice for artists. When I teach and demonstrate I talk with a lot of die-hard watercolour and oil painters, and no one really knows what to do with the acrylic painters!

The Adam Bridge
120 x 90cm (47¼ x 35in)

Acrylics are sometimes written off as lower in quality than other types of paint – a poor imitation of oils, a less 'serious' medium. I will readily admit that my first experiences with acrylic paints were not great. I can distinctly remember the cheap plastic bottles at secondary school and the oozing neon colours that looked more like nuclear waste than paint. This was not a good introduction, and I suspect many of you will have had similar encounters with acrylics in the past. Please don't let these first impressions put you off. Having stuck with acrylics, trying countless brands and types in many different ways and on many different surfaces, I have learned a lot about the materials with which I paint.

I can safely say that acrylics are one of the most straightforward and versatile painting mediums you can use. They are also one of the most forgiving – which, if you make as many slip-ups as I do, is very handy! My hope with this book is to reinforce the appeal of acrylics and to show some of the ways that you can push the medium further than you may have previously thought possible.

In terms of subject matter, this book deals primarily with landscapes. Growing up in a rural county, I have always been attracted to the landscape and enjoyed portraying it through my art. I do, of course, love and respond to a whole manner of different subjects in my professional life, but landscape painting is my constant.

Like many artists, I began my career painting all the usual landscape scenes in order to 'learn the ropes'. It was a slow and often fraught process. I found myself making perfectly satisfactory landscape paintings but they often seemed a bit static or lifeless. To combat this, as I became a better painter, I began to look for ways to inject something more into my landscape paintings. I started to experiment with different approaches and techniques, looking for ways to inject that 'atmosphere' into my painting and to take my work to another level. It is these techniques and approaches that I hope to share with you in this book, so that you too can take your paintings that bit further, and overcome any plateau in your painting.

Wherever you find yourself, the landscape is almost always an approachable subject. Painting the land around you is a great way to learn about composition and light, and the genre has another clear advantage in being relatively loose. If a hill is too high or a tree has too many branches, who is going to know? Over the years I have been lucky enough to work in some truly fantastic locations and parts of the world, but these do not always make for the best paintings. I am just as interested in the locations that are right on my doorstep and I would like to show you that a familiarity and love of your immediate surroundings can provide valuable inspiration for your work.

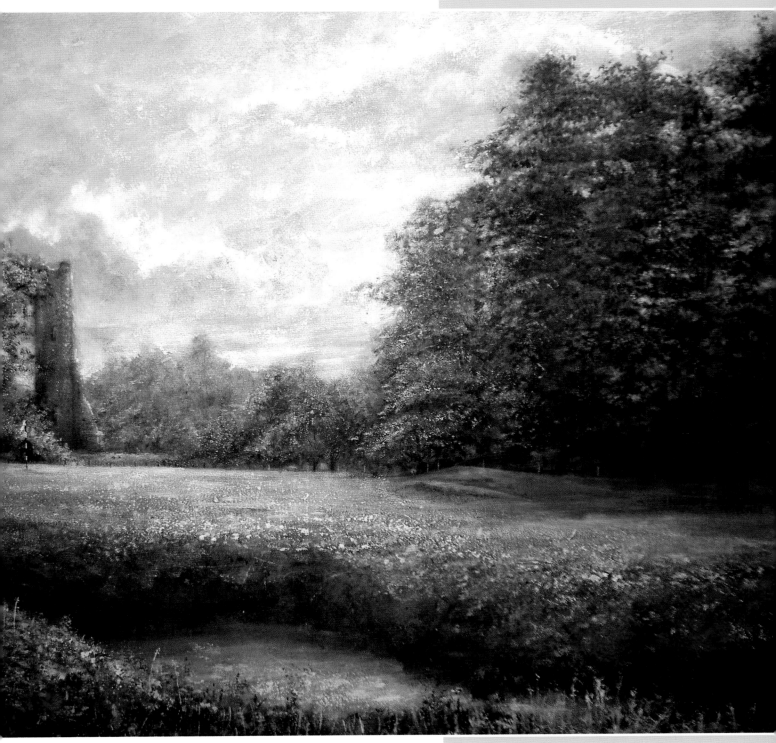

Third Hole, The Hotchkin Course

102 x 70cm (40 x 27½in)

A very early acrylic landscape painting. This was commissioned by a local golf club and depicts the view from a bunker on the third hole of the course. It was an excellent introduction to dealing with foliage and foreground texture.

Acrylic paint

As a medium, acrylics have a truly great potential for any artist. To me, the greatest benefit of acrylics is their versatility. By heavily diluting the paint with water you can achieve free-flowing colours that look and behave like watercolour.

They can be used to create very vivid and graphic works of art – exemplified in the Pop Art movement of the 1960s and the graphic design and advertising pieces the movement inspired – but they can also be used to achieve the same level of richness and subtlety seen in classical oil paintings. Indeed, my work is often mistaken for having been painted in oils – which goes to show the powers of modern acrylics.

Acrylics make an excellent choice for beginners and professionals alike. They are affordable, easy to master and can be tailored to suit your preferred way of working.

A brief history of acrylics

Acrylic paints first became widely available in the early 1950s and have grown in popularity as a medium since then. These exciting paints arrived at a time when many artists were beginning to explore movements such as Pop Art and Abstract Expressionism. Acrylics offered artists a liberating and versatile paint that allowed them to work quickly and experiment freely. Artists such as Andy Warhol (1928–1987) and David Hockney (born 1937) were quick to identify the benefits of working in the medium.

Acrylics have also been widely employed in a whole range of different industries from automotive to fashion. While other types of paint have remained largely unchanged over the years, acrylics are worth keeping an eye on, as new processes and technological advances promise to push the limits of the medium in the future.

Working with acrylics

Acrylic paint is still a relatively new medium in comparison with oil and watercolour paints. The medium is continually developing and being refined. Even in the past five years, many new brands and types of acrylic have been released.

Whatever sort you use, acrylics have the advantage of being fairly easy to work with. Acrylics are incredibly flexible and remain stable under varying degrees of dilution. You do not need to worry about the minefield of technical problems that face the oil painter, as the chemistry is much simpler. Indeed, they can be used directly from the tube with no dilution whatsoever. However, being water soluble, you can dilute them with normal tap water, just like watercolour.

The use of water rather than any spirits or solvents is a big plus, especially for those who are sensitive to the odour involved with oil painting. Adding a little water will increase the flow of the paint but you can also dilute them to a watery consistency, which allows you to lay down washes and glazes or to block in areas of a painting quickly.

Eventually, as your skills develop, you may wish to experiment with different mediums to alter the properties of your acrylic paint. You can read more about mediums on pages 22–25.

Basic working tips

As a rule, you can work in pretty much any order with acrylics – light over dark, thick over thin or vice versa. Mercifully, mistakes and errors are usually easy to correct. Wet paint can usually be rubbed away with ease or re-blended, while in the event of a real catastrophe, you can simply wait for the paint to dry and then work over it.

Keep water handy. Whether in a spray bottle or a jar it is always worth having some water close at hand. For the most part, acrylics do not require massive amounts of water – certainty not the amounts required for pure watercolour painting, for example. You need only a jar of water at your workstation to dip your brush into to thin your colours as you work. However, do make a habit of washing your brushes out, both between mixing colours and at the end of a session, as acrylic paint will damage your brushes if it is allowed to dry on them.

I have found warm water and soap has always been able to tackle my acrylic cleaning jobs, but you may wish to use a specialised brush cleaner from time to time.

How I work

I work thin to thick – that is, I begin painting using diluted paint to block in very loose shapes, then gradually increase the thickness of the paint as I build and refine the image. You will see examples of this approach over the following pages, as I scrub in the basic composition or tones of a painting using a heavily diluted mixture of burnt umber as a ground to work upon.

You do not necessarily have to work in this way, but I find it gives me a sense of progress if I can quickly block in some of the overall shapes and masses before committing to the 'real painting' as it were.

The great drying question

Acrylics are famous – or perhaps infamous – for their extremely fast drying times. You can work quickly and have a fully dry painting complete within a couple of hours. There is very little waiting about and you do not have to adhere to many of the rules about layering paint that you need to when working with oils. If you are a fast worker or like the ability to paint over your work multiple times, acrylics are a great choice.

However, this fast drying time can have downsides, too. It can sometimes be quite hard to blend and rework colours. This means that in some cases you need to complete a section of work in one go before the paint has dried, adding a certain element of time pressure to working with acrylics. You also need to be wary of washing your brushes frequently – dried acrylic paint essentially becomes a plastic, making it quite hard to remove once set.

Thankfully, the huge range of mediums and types of acrylic available can help to combat these problems. For the most part, you can tailor your paints to your own particular needs. I find it best to harness all aspects of acrylics, which will allow you to take advantage of both the quick drying time and the ability to extend that when necessary.

Types of acrylic paint

Painting need not be a major financial investment to the beginner. My collection of paints and materials has grown from very humble beginnings over several years. Broadly speaking, acrylic paints are bought in tubes or pots, but they also come in different qualities – cheaper students' ranges and more expensive artists' ranges:

Students' acrylics These entry-level acrylics vary enormously according to brand. These are a great way of introducing yourself to acrylics and, for the most part, are very affordable and easy to use. Students' acrylics often use more filler, have a lower level of pigment concentration and the more expensive pigments are often replaced by synthetic imitation hues, all of which results in the students' quality paints not being quite so vibrant as artists' quality. That being said, students' quality paints are still an ideal way of making your first steps with the medium.

Artists' acrylics These acrylics, which make up the majority of brands available, have much higher pigment concentrations than students' ranges. This allows for more accurate colour mixing and results in fewer changes or shifts in hue as the colours dry. Major manufacturers such as Winsor & Newton, Daler-Rowney and Schmincke produce their own ranges of professional quality artists' acrylics. Other companies such as the SAA (Society for All Artists) also produce their own brand of high quality artist pigments. Try out as many types as you can to see which work best for you.

A variety of tubes and pots of acrylic paint.

Specialist acrylic paints

The following are just a few of the varieties of paint available that offer properties that differ from standard artists' acrylic ranges. Many of the properties can be replicated through the addition of acrylic mediums (see pages 22–25), but being able to buy them ready-made offers convenience and consistency.

Open acrylics Produced by Golden Colours, these acrylics dry more slowly than a standard acrylic, offering an increased working time and reduced wastage. These are a great choice if you feel limited by the swift drying speed of a standard acrylic.

Heavy body acrylics Several manufactures now offer ranges of heavy body acrylics. These paints have a thicker viscosity than standard artists' acrylics and lend themselves to impasto or thick painting techniques. Heavy body acrylics are able to hold brushstrokes and palette knife marks and so can be used to create sculptural relief effects on a surface. They are also ideal for use with collage techniques.

Interactive acrylics Developed by Chroma, Atelier Interactive acrylics are a relative new addition to the acrylic market, but are an exciting look at how the medium might be advanced. In addition to an increased working time compared with standard acrylics, they also offer the artist the ability to delay drying or to re-wet/re-blend work after it has started to dry through the use of an unlocking formula (see box, right).

My recommendations

The range of acrylic paints that is available is quite staggering, and it can be quite a minefield choosing which sort to use. With so many options to choose from it is best to consider what sort of work you personally want to make and then try and find an acrylic paint that suits your application and budget. It can take some trial and error, but it is worth finding a brand with which you are confident.

A range of different brands and manufacturers have crossed my easel over the years – you name it, I've tried it. The key things that affect my decision when buying an acrylic are the quality of the pigment and the working time. I look for high-quality pigments that will mix to produce clear colours and do not change as they dry.

Predominantly, I use artists' grade acrylic paints for my day-to-day studio work. These give me consistency and a great finish in my work. I also find the range of colours to be more supportive of some advanced work and techniques. That said, I do also keep a range of students' grade acrylic paints handy for quick sketches and studies.

I also like the ability to freely blend my colours and to achieve soft edges in my work. For this reason I tend to favour an Open or Interactive Acrylic or the use of a retarder medium to extend my working time.

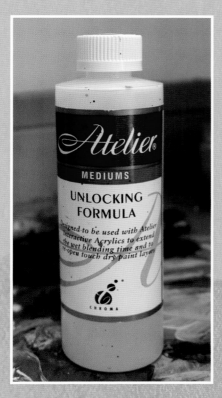

Unlocking formula

This medium is specifically for use with Atelier Interactive acrylics, and allows the artist to 're-open' sections of their paintings even after they have dried. This is a powerful medium and is best applied in small amounts on the end of a brush or via a fine mist water sprayer.

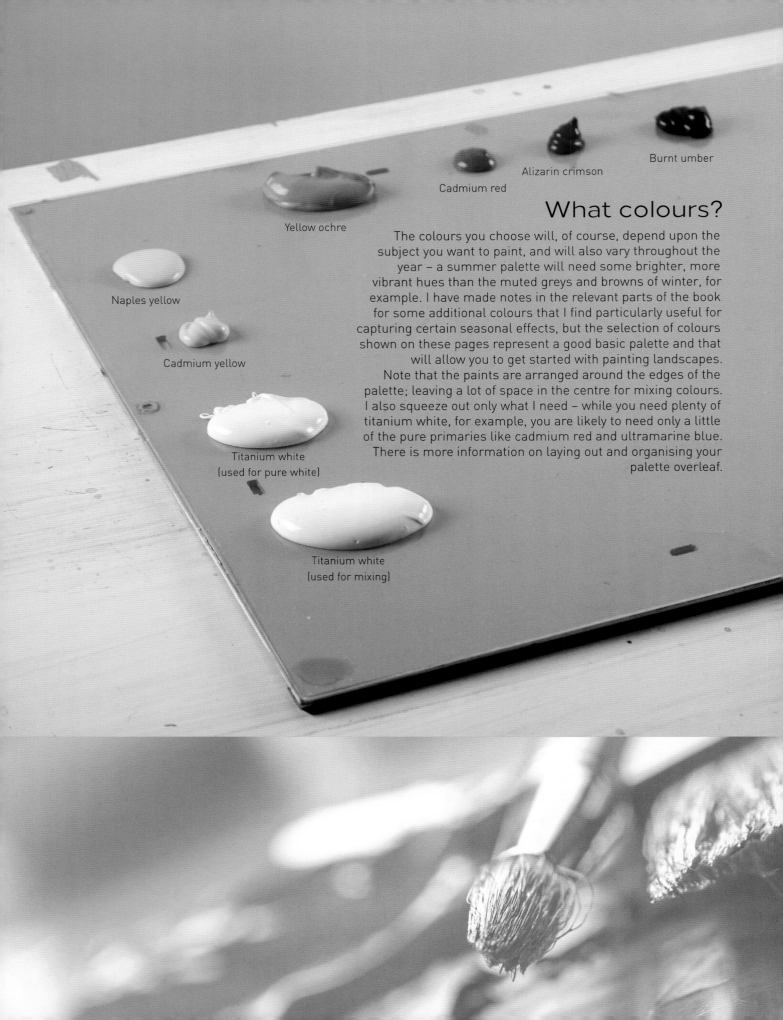

Burnt umber

Alizarin crimson

Cadmium red

Yellow ochre

Naples yellow

Cadmium yellow

Titanium white
(used for pure white)

Titanium white
(used for mixing)

What colours?

The colours you choose will, of course, depend upon the subject you want to paint, and will also vary throughout the year – a summer palette will need some brighter, more vibrant hues than the muted greys and browns of winter, for example. I have made notes in the relevant parts of the book for some additional colours that I find particularly useful for capturing certain seasonal effects, but the selection of colours shown on these pages represent a good basic palette and that will allow you to get started with painting landscapes. Note that the paints are arranged around the edges of the palette; leaving a lot of space in the centre for mixing colours. I also squeeze out only what I need – while you need plenty of titanium white, for example, you are likely to need only a little of the pure primaries like cadmium red and ultramarine blue. There is more information on laying out and organising your palette overleaf.

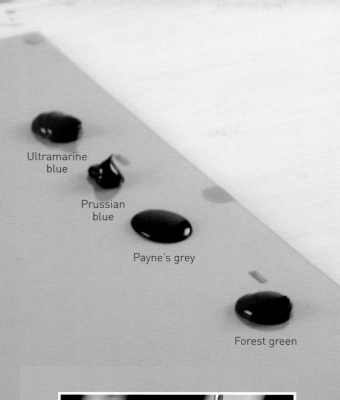

Ultramarine
blue

Prussian
blue

Payne's grey

Forest green

Palette grey

Around a year ago it dawned on me the little piles of paint that became muddy during mixing, or were left at the end of a painting session, could be mixed together to produce greys. I now scrape any leftover or dirty paint into an old paint tub, then thoroughly mixed the colours together using a chopstick.

The result is usually a very beautiful chromatic grey – although you can add a bit of white or black to the mix as well if you want to alter the tone. I use this 'palette grey' for priming boards and also for many aspects of my painting practise – so if you see a reference to palette grey, it is simply a mix of the leftover paint from my palette. Best of all, it stops any paint going to waste!

The painting palette

Palettes have an important job: holding your paint and, more importantly, allowing you to mix it. They come in many shapes and sizes and many different materials. Like any piece of equipment used on a regular basis, your palette becomes a very personal thing. Its look and feel, the arrangement of colours and how you hold it become your own.

I have used many different palettes over the years and have improvised a fair few on occasions, ranging from plastic stay-wet palettes, to old tea trays and bits of scrap wood. Of course I have also tried the iconic kidney-shaped palettes because I thought that's what 'real artists' were meant to use!

The type you choose will ultimately come down to personal preference. However, I offer one important piece of advice: avoid making do with a tiny palette. These soon become chaotic, and a chaotic palette means muddy colours. In the case of palettes, bigger is better.

My palette

My preference these days is for the glass palette shown to the left. It is a sheet of glass mounted to a piece of plywood. Glass is a great surface to work upon because it is smooth and allows you to mix colours easily. Perhaps more importantly, it is incredibly easy to wipe down and keep clean, so you can rely upon the colours you mix being exactly what you want. I used to be somewhat messy, allowing my colours to build up and stain my palette – these days I won't leave the studio without having cleaned my palette down thoroughly. It is a reassuring thing to open the door the following morning and have a nice clean surface to work with.

The other advantage of the glass palette is that I can change the colour underneath the glass, which allows me to match the colour of a primed surface by inserting some similarly coloured paper or card underneath the glass. I mostly work with a grey paper underneath the glass, as shown here. I find this midtone allows me to mix my colours more accurately and allows me to see my highlights and darks much better than mixing on a white background. My palette has a large surface area and sits on a desk next to my easel at all times.

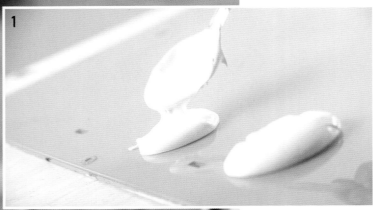

Laying out your palette

There are infinite ways to lay out a palette, and ultimately where you squeeze the paint comes down to you. As a rule, I usually start with my brights and work around in a clockwise fashion. Remember, this is just my preference so do whatever feels best for you.

1 Squeeze or scoop out two relatively large amounts of pure white on the left-hand side of your palette. One will be used for adding to mixes, while the other is kept pristine for the brightest highlights.

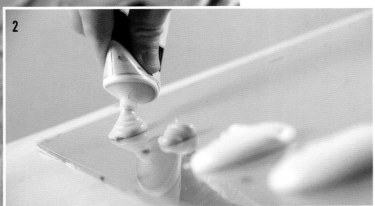

2 Squeeze out light colours next, working clockwise round the edge of the palette.

3 Continue working round the palette, laying out the warm reds and earth colours.

4 Add darker colours next, then add any little-used colours – in this example, forest green – on the far right-hand side.

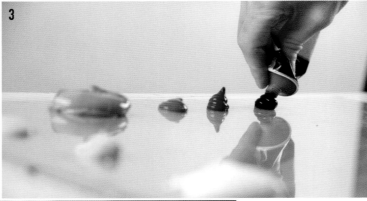

Tips for laying out your colours

- Only squeeze out what you need. Avoid laying out large amounts of paint at the start of the day, only to find you don't need it or it has dried up before you can use it.
- Consider buying pots of paint rather than tubes, so that excess paint can be returned using a knife or spoon.
- Give some thought to which colours you use most frequently and how you access them. I have had many a ruined sleeve in my time from placing paint in places that I have to reach across to access other areas of my palette.

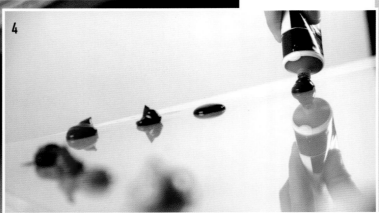

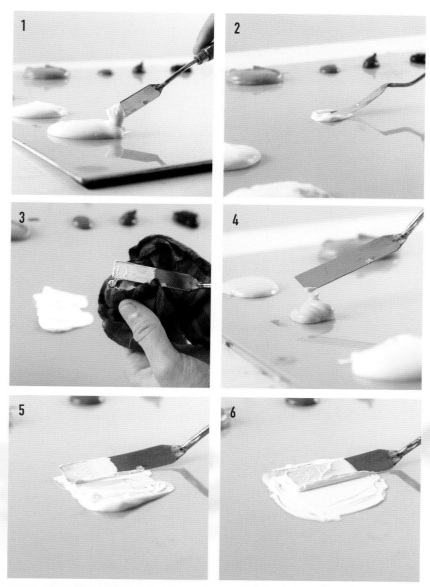

Preparing and mixing paint

When it comes to the actual mixing of the colours I tend to favour a painting or palette knife. The flat blade makes it easy to pick up accurate amounts of colour and also to mix them thoroughly in the centre of the palette. It also makes scraping colours away a lot easier.

1 Pick up the first colour with the palette knife. In this example, I am using titanium white.

2 Apply the paint to the central mixing area of the palette.

3 Clean the knife on a rag to avoid polluting the other paints.

4 Pick up the next colour (cadmium yellow in this example).

5 Place the paint in the centre, smearing the colours together.

6 Chop and smear the colours together into a consistent mix using the edge and flat of the knife.

Keeping your paint wet

If you are using acrylics straight from the tube you may find that they dry on your palette faster then you would like. Stay-wet palettes are essentially plastic trays that have a paper membrane, onto which you place your paint. By dampening the membrane, you keep your acrylics moist and workable for a lot longer, and many also come with a lid. These palettes can extend the working time of acrylics quite considerably – worth bearing in mind if you are having a long painting session or are mixing lots of colours that you need to reuse.

If you can't get a stay-wet palette, there are other ways to keep your paints moist. An occasional spray with a fine mist water sprayer will help to keep paint on the palette wet. Also, consider ways of stopping the air getting to your paint. Plastic food wrap can be placed lightly over a palette to help preserve acrylic paint. A plastic food storage box can be used as a makeshift cloche to cover the palette during breaks, too.

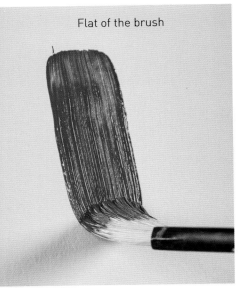

Flat of the brush

Applying the paint

It is worth spending time with your brushes and really getting to know them. Once you become familiar with a brush you will find that you can use it to create a wide range of different effects instead of having to reach for a different brush each time. This saves cleaning lots of brushes at the end of your session and, more importantly, it will also save you breaking concentration and the flow of your painting.

Over time, your brushes will come to seem like an extension of your arm and you will find yourself able to use them to create lots of different effects. The examples on this page show the range of effects that can be created using just one brush, in this case a 25mm (1in) flat blender brush.

Flat of the brush The wide flat head of this brush allows you to cover a large surface area quickly and to make bold confident downward strokes using the flat edge. I use the brush in this manner during the early blocking stages of a painting or to fill in large surface areas quickly and confidently.

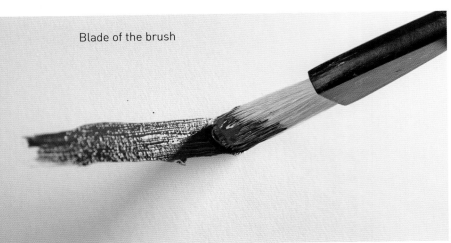

Blade of the brush

Blade of the brush The flat top or 'blade' of the brush can be used to create smaller marks in your paintings and to create straighter lines of paint. I often use the blade of the brush to create horizon lines, fill in areas of foregrounds or create rays of light in the sky.

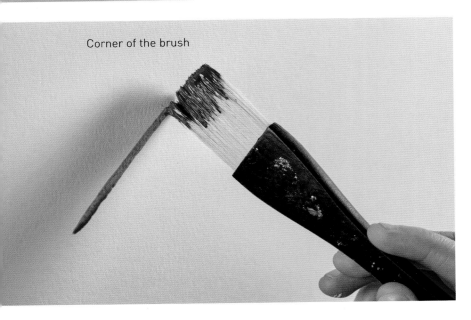

Corner of the brush

Corner of the brush Even a large brush such as this can create delicate lines if used in the correct way. Here I am using the very corner of the brush to create a long thin line – useful if you need to do something more challenging or detailed quickly without having to change to a different brush.

Fanning the brush Holding the brush very lightly and barely touching the surface of your paper or canvas can create a fanning effect. This is very useful for creating fine glazes and for giving the indication of atmosphere in areas such as the sky.

Full control For more control, try holding the brush much lower down, closer to the bristles. This gives you lots of control over every movement of the brush. I use this grip to help me to blend and move colours around on the surface of the canvas. It comes in particularly handy when I am working on the sky and really want to create soft effects in the clouds. By applying lots of pressure to the surface and holding the brush low down you will be able to create very soft blended effects.

Scratching out I often use a pencil sharpener to sharpen the ends of my paintbrushes to a point. I find this incredibly useful as I can use the sharpened point to apply the paint in very fine, broken lines, or to scrape wet paint off the canvas to create light detail.

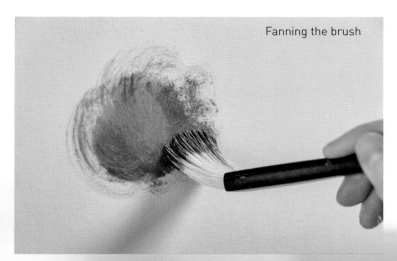

Fanning the brush

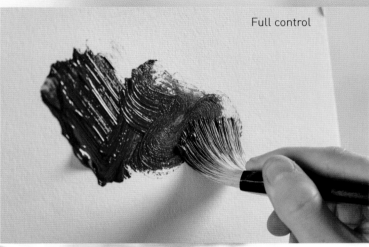

Full control

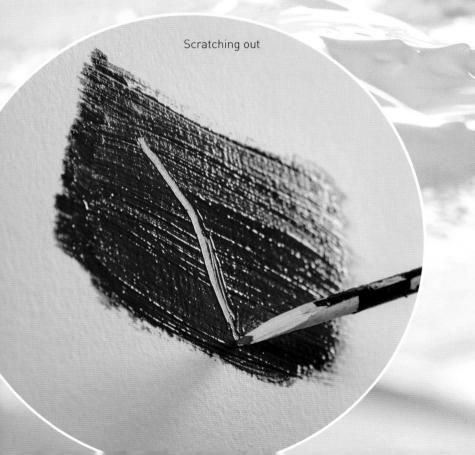

Scratching out

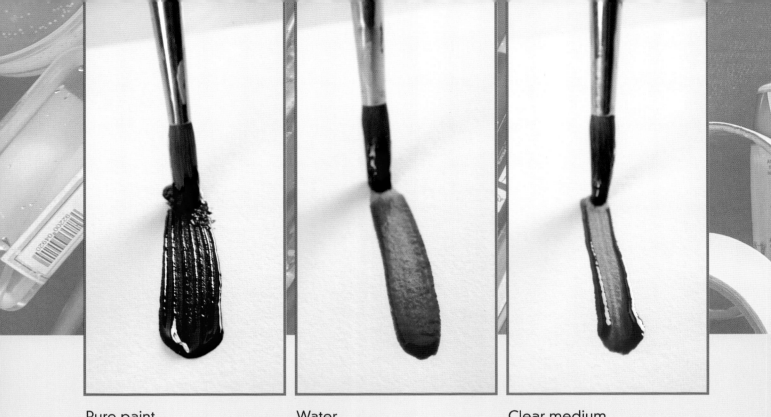

Pure paint

As easy as it gets. Acrylic paint has a distinctive consistency which is ready to use straight from the tube.

Water

Water is the primary thinning medium for acrylics. Adding it to paint will alter the consistency and vibrancy of your colours, making acrylics behave a little like watercolour paint.

Clear medium

This medium allows paint to be diluted smoothly without altering sheen levels or making the paint too watery. It can be used for fine detail work and glazing applications and will also improve the working time of your acrylics.

Acrylic mediums

The way in which acrylics can mimic other painting media is fascinating, but they are more than mere imitators. I have created many paintings with watercolour techniques by using acrylics heavily diluted with clean water. I also use diluted acrylics to block in and plan out paintings, in much the same way as an oil painter might block in a painting using paint thinned with turpentine. I think the thing that really surprises me most about acrylics is how, through clever use of mediums, they can be used to achieve some of the feel and texture of rich, thick oil paint.

In a nutshell, a medium is something that is mixed with your standard tube paint in order to bring about a different effect or to enable a different technique. Clever use of mediums can elevate your painting style and unlock new ways of working that you may not have previously considered. The sheer versatility of acrylic paint has seen them adopted by a huge range of different visual artists and practitioners, who tailor the paint to suit their specific working methods through the addition of acrylic mediums. Through mediums, most acrylics can be altered and used in different ways as well. Experimentation is an excellent way to push yourself and to discover what can be achieved. New mediums are being released constantly, so it is worth keeping up to date with your chosen manufacturer's range of products.

Gloss medium

Many acrylic paints dry to a satin finish, and in some cases can be slightly uneven. Mixing gloss medium into your paint can help to add depth, translucency and a rich oil-like finish to your work. It can be mixed directly into your paint or used as a glaze or varnish between different layers.

Retarder

Many acrylic manufacturers now also make retarder mediums. These are designed to slow the drying time of acrylic paints and to offer the artist more workability. Different retarders will vary, but in most cases the retarder is mixed with the paint on the palette before application. Try not to use more than a proportion of ten per cent retarder to paint at a time.

Structure gel

Structure gel and other texture mediums can be used to add body to your acrylic colours. This is usually done by mixing the medium into the paint on the palette. The medium changes the viscosity of the paint allowing for impasto techniques and the building of structural effects.

Modern acrylics and mediums

You can, of course, be painting in a matter of minutes using pure acrylic paint or simply add water, but acrylics can also be mixed with a huge a range of different mediums to produce many varied results. As shown on these pages, acrylic mediums can change the flow, opacity, sheen and texture of the paint, which results in an endless array of possibilities and applications.

The list of acrylic mediums available is quite staggering, with more being introduced all the time. I tend to have a staple five or six mediums that I use constantly, but I am always trying new things as well. As with introducing any new material or product, try it out first – do not jump into using a new medium in the middle of a painting or you risk it not having the desired effect, or simply not fitting your intent. In addition, be aware that the same mediums by different brands can behave in slightly different ways.

Mediums can be used for many different reasons. I usually use a medium to achieve a look and feel with the paint that I wouldn't otherwise be able to achieve, or to let me subtly rework a painting. Mediums have enabled me to rescue many a painting and they have been key in allowing me to play around with the atmosphere in my work. Through clever use of your paint and mediums the potential for acrylic paint becomes truly massive.

Why use mediums?

I spent the early years of my painting life desperately trying to improve and create paintings that looked the way that I wanted them to. It was a tough struggle, but I gradually got to grips with acrylics and learned what I could and couldn't do with them. Eventually I reached a point where I became dissatisfied with the finish I was able to achieve. I was happy with how my paintings looked but felt that I was unable to render the atmosphere and power of the works at the level I wanted. I also wanted to experiment with different techniques such as glazing. It was here then that I began to shop around, looking to find a way to spend longer working with my colours, thus achieving a greater range of blended techniques and subtlety in my work.

I found that mixing a retarding medium with my acrylics gave me a much improved working time and took away some of the time pressure involved in using acrylics. I was then introduced to Open and Interactive acrylics, which are essentially acrylic paints premixed with mediums that make them behave differently. Both offer a significantly improved working time straight from the tube. Because the paint stays wet on the palette longer, they also reduce waste and cut down on the frequency of washing your brushes. The Interactive acrylics in particular will allow a greater range of effects on the canvas itself, as you can spend longer mixing colours and blending them together to create beautiful soft gradients and edges. If you make a mistake, these paints allow you to simply re-wet the surface of the painting and re-blend or erase brushstrokes. This gives you a longer working time, which can dramatically increase your potential when it comes to working with acrylics.

As a rule, most artists' acrylics usually have a satin finish when dry. However, some pigments behave differently from others. Colours such as burnt umber tend to dry to a more matt finish than others, which can give a finished painting a distractingly uneven result. To combat this and to give my acrylics a nice rich quality I often mix a small amount of gloss medium into my colours on the palette. This gives the colours a real depth and creates a nice uniform finish to my work.

Glazing medium offers the ability to build depth and atmospheric effects, subtly and effectively altering finished paintings.

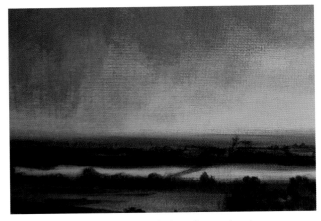

No matter what I tried, the painting above, of a stormy sky, just did not feel quite right to me. Eventually, I added glazing medium to the paint. With this I was able to add some translucent rain falling from the clouds and down to the horizon line, completely transforming the look of the picture in about four minutes (see detail below).

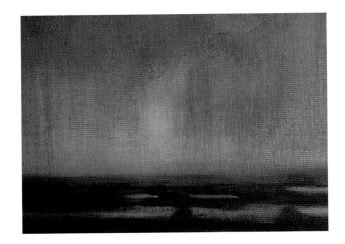

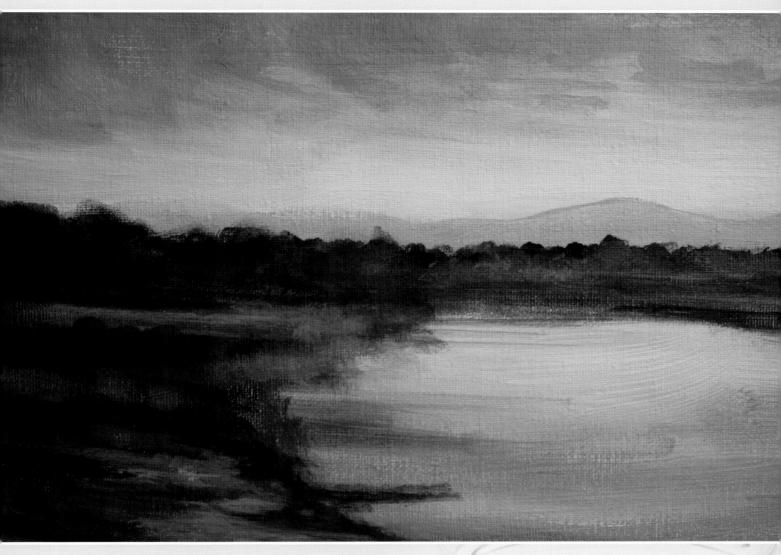

The ultimate medium

Do not automatically reach for an additional medium – sometimes persevering with clean water can be enough, as with this simple landscape. Note the variety of textures and brushstrokes possible with simple dilution and the use of different parts of the brush.

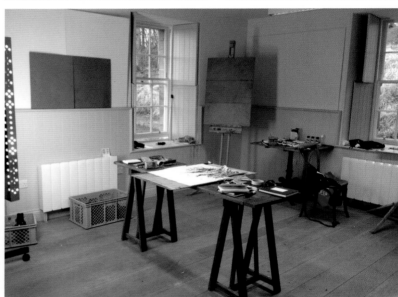
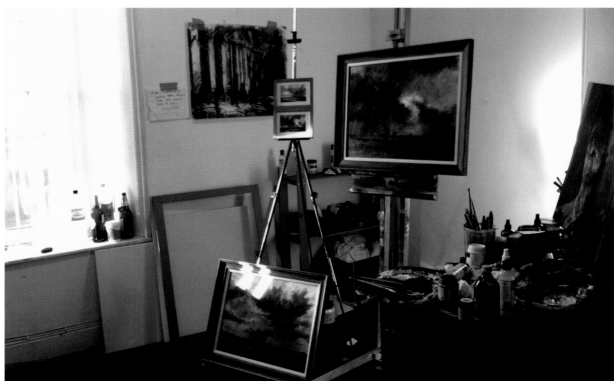

Where to work

Where you paint is a personal place. Some artists prefer to work only indoors; others only out in the fresh air. For me, choosing whether to work indoors or out varies as much on my mood as the time of year – not to mention the weather!

The following pages look at some of the advantages of working both inside and outside, along with the different sets of equipment each environment requires.

Working indoors

While some of us have a dedicated space in which to paint (I am lucky enough to have a humble room in my house set aside), you may have to squeeze your painting in around everyday life. Rest assured that a permanent studio, while desirable, is by no means necessary to be able to paint.

Whether you have a studio or not, planning where you work is important. The organisation of your studio is determined by many factors: the physical space available to you, the size at which you predominantly work and the materials you work in.

Your indoor workspace should have good – ideally natural – lighting, which is not always easy to come by. We would all love huge north-facing windows and lots of natural light, but I cannot think of many studios that actually have this. A floor standing lamp with a daylight bulb is a good substitute; I use one myself in my studio. Daylight bulbs are especially bright bulbs that more closely mimic natural light than regular lamps.

Space is also important, but a lack of it is easily solved through clever organisation. I used to keep something of a messy studio, but knowing where things are will save you time to concentrate on painting rather than spending it digging out brushes or searching for a particular colour. Time is probably the artist's greatest asset, and it can be one of the hardest things to come by. Keeping a tidy work area will help to save more precious time for painting.

Ventilation

If you work in a small space, make sure that you have ample ventilation, especially if using oil-based paint or solvents. If you are working purely with acrylics, this is less important.

Opposite:
Some of the studio spaces I have worked in – as you can see, there is great variety even within indoor spaces.

What you need for painting indoors

In addition to your acrylic paints, you will need a few other tools and materials to begin painting indoors. There are no rules for what you should and should not have in your space, but these pages detail my approach and the equipment I use when painting in my studio.

Brushes and painting knives

I am probably supposed to tell you to always buy the best brushes and take very good care of them. In reality my brush bag is something of a lucky dip between old and new. There are my staple workhorses alongside shiny new brushes that seem almost too good to use and old favourites with flaking handles and gummed-up bristles.

The versatility of acrylics mean that you can get away with using pretty much any type of brush without too much care. I tend to favour synthetic brushes as they are good all-rounders. More importantly, synthetic brushes are hard-wearing.

Shape and size come down to personal preference. I often use filberts, which are a midpoint between sharp-edge flats and traditional round brushes. Occasionally I will buy a brush with a specific effect in mind, such as a particularly large brush to help with blending or varnishing.

I also keep a range of palette knives, mostly for mixing but occasionally for building up texture in certain parts of the painting.

Surfaces and supports

Acrylic paints will successfully fuse to a range of materials and do not require the same levels of preparation that oils and watercolours do. As a result, they can be used on a huge range of surfaces, including wood, card, fabric and some

plastics. Indeed, this is one of their key advantages. As a rule I like a fairly smooth working surface, and so usually use primed canvas boards to paint upon.

Canvas and board Pre-stretched canvases or canvas boards are perfect surfaces for use with acrylics and are also readily available from most art suppliers.

Paper A range of papers and blocks designed specifically for acrylics painting exist, all ideal for quick studies and colour tests as well as finished paintings. Acrylic paper tends to be reasonably smooth. Acrylics can be used on watercolour paper, but the high absorbency of the paper can make it hard to blend.

Priming

While not always necessary, priming can offer some advantages. On absorbent materials such as paper or wood, priming will give an even surface to work upon and stop your paint being absorbed into the support.

I tend to use a pre-made acrylic gesso primer that can be applied straight from the pot. Occasionally I use old acrylics or household emulsion to provide an undercoat to work upon.

Note that a primed surface does not have to be white – I will often work onto a coloured ground. White can be intimidating to face when starting a new painting!

Other tools

Easel An easel is near-vital for working indoors, but the choice of a free-standing easel or a table easel will depend upon space and your preferred way of working. In addition to a table easel and a lightweight aluminium travel easel, I keep a trusty old floor standing easel, which creaks and groans when moved. The wing nuts have long since seized, meaning hammers and other tools are required to alter the height and angle. It is undoubtedly past its best, but I can't quite bring myself to get rid of it!

Palette My glass palette (see pages 16–17) is large and fixed immovably to my desk, although I do have various other lightweight palettes at my disposal as well.

Spray bottle A water spray bottle with a fine nozzle is not the most technologically advanced piece of equipment, but it is one that has changed the way that I paint with acrylics. It is used to spray mist over the surface of paintings or the palette, which helps to keep the paints moist and slows down the drying process. It is also useful for diluting colours. Rather than dipping the brush in a jar of water in order to thin paint, you can spray the brushes directly, which gives you much more control than dipping the brush.

Using a spray bottle

Try to get into the habit of having a brush in one hand and a spray bottle in the other. This is by no means necessary, but it is a good way to control the amount of water that you use with your paints.

Water pot It is worth having a couple of pots of clean water, one for mixing water and one for washing your brushes. Old jam jars are more than adequate.

Rag Painting can be a messy business. I cut up old clothes into painting rags and also have a good supply of kitchen paper on hand to clean and dry brushes.

Painter's tape and masking tape Both can be used to mask off sections of a painting to leave very clean straight lines. Masking tape is a studio staple for most artists and I also use painter's tape, which is less adhesive.

Desks I make drawings and plan new paintings on a large solid desk, and use a separate desk which has my computer on. This allows me to work from digital photographs and reference in the studio.

Trolley Many artists adapt kitchen trolleys or similar devices to store their brushes and paints in. They can then be wheeled around the studio and moved with ease.

Plan chest/storage unit A plan chest is a large series of drawers used by architects and artists to store finished works and protect them from damage. They can be quite large and expensive to buy new, but bargains can be found in local auctions and office clearances.

Lights In addition to a source of natural light, consider investing in some daylight bulbs for your studio. These help to maintain a constant and natural light in the studio. They can be used overhead or in standing lamps.

Craft knife These are useful for a range of reasons. I mostly use mine to cut down canvas boards, wood and paper.

Working outdoors

Working *en plein air* sounds very 'arty', but it simply means working outside, in front of your subject. It is an activity that is in equal parts frustrating and rewarding, and it tests an artist's resolve and abilities. Working outdoors is also a great way to explore colour mixing and working from direct observation.

When I began painting I was incredibly nervous about working outside – my main fear being that I would look like an idiot or that some passer-by would tell me that my work was a load of rubbish. I'm afraid that these fears never go away; you simply learn to embrace them.

As with any pursuit, practice is important, and by painting outdoors on a regular basis you will really build your confidence. Even then, working outdoors can be something of a lucky dip. There are days when the conditions are seemingly perfect but the painting does not turn out as you had hoped, and then there are those strange times where you are really up against it but come away with something really good.

Working outdoors will not always be easy, but it is one of the most fantastic ways that I have found of combining my passion for painting with my love of nature.

Impressionism, technology and working *en plein air*

Prior to the nineteenth century, most artists worked in the studio. This was due in part to practical limitations of their materials – paint was stored in small bladders that did not lend themselves to being transported or thrown in a bag of kit.

Painting outside did not begin to flourish until the Impressionist movement sprung into life. The Impressionists' desire to work directly from nature might have proven more difficult, if it were not for the invention of the collapsible paint tube. These sturdy metal tubes allowed artists to take premixed colours into the landscape in a portable and practical format.

The outdoor experience

Working outdoors brings with it plenty of practical considerations. I have been both frozen to the bone and burned to a crisp when working outdoors – neither experience was particularly pleasant. To avoid discomfort, think about the environment, climate and terrain that you are going to be working in. In addition to your painting kit, you may need walking boots, waterproof clothing, gloves or even sun protection. Try to anticipate the weather, although this is sometimes more easily said than done!

If the experience of painting outdoors becomes a chore, you will not want to do it, so try and get used to working with a limited kit. This will mean that you spend less time setting up and more time painting and enjoying yourself.

Be mindful of the environment that you are working in and make sure that you are able to carry away any rubbish and dirty paint and water. All paints can be hazardous to the environment if discarded carelessly, so always take away any waste products.

The pictures shown here are examples of my *plein air* work, accompanied by notes on the practical challenges each gave me, in order to show the enjoyable challenges working outside can offer.

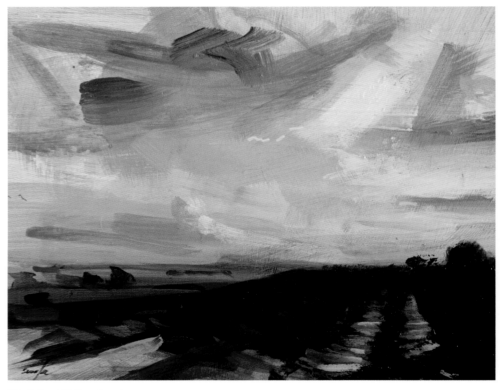

Field at Wispington
25.5 x 20cm (10 x 8in)

This is a *plein air* study of some farmland at dusk. The light at this time is fleeting, and you can see how quickly I had to work to form the bold, flat brush marks. There was very little time for the blending of colours, and so I had to block the painting in using confident single brushstrokes.

Newport
31 x 25.5cm (12 x 10in)

Plein air work is fast-paced and all about capturing the essence of what stands before you. This was a very rapid acrylic sketch made on an early February morning. I wanted to capture the pale morning light and the tall tree on the left-hand side of the picture. The distant background towers are those of Lincoln Cathedral.

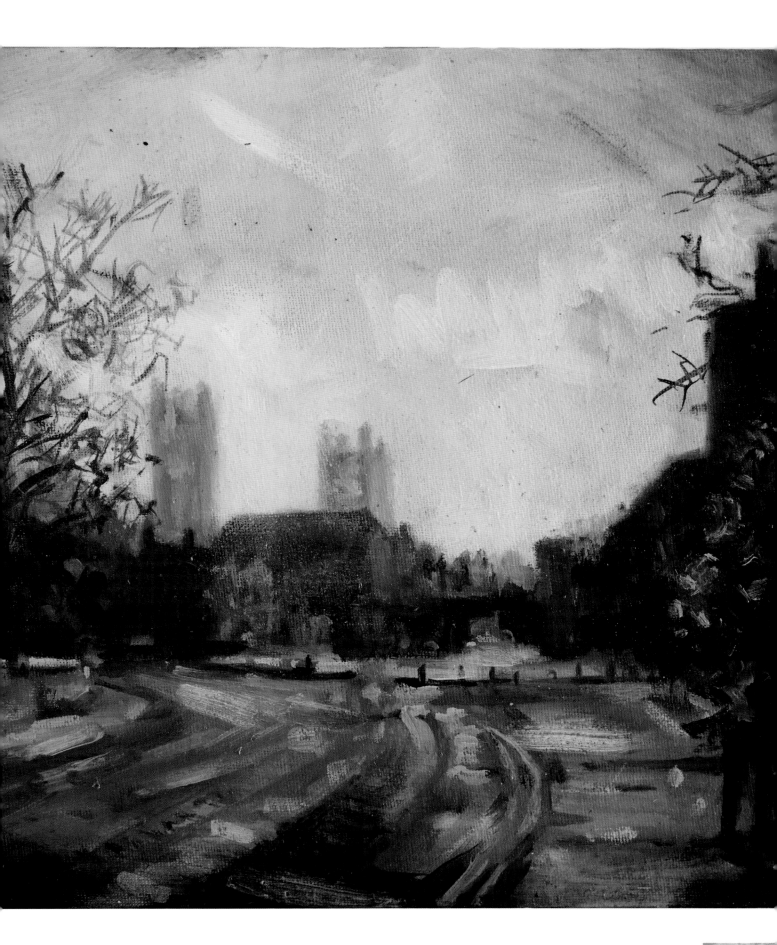

What you need to work outdoors

With a few exceptions, the tools you use indoors work just as well outdoors, so the information on pages 28–29 applies here too. The main consideration is weight and portability. Today there are a wealth of products on the market designed to make working outside easier and more manageable. I have taken to having a small selection of painting equipment in my car at all times. This means that if I ever forget anything on a painting trip that I usually have a stand-in. It also means that if I'm driving anywhere and inspiration strikes that I am able to make a quick study.

There's nothing to stop you simply grabbing a sketch pad and going out with a couple of paint tubes and brushes. However, the following pieces of kit are useful for a dedicated outdoors painting session:

Paints I would recommend sticking to a reasonably limited palette. It is not practical to take a massive bag full of paints out into the landscape and, for this reason, it is best to choose a core six or so colours to form the backbone of your palette, plus black and white. This saves weight and also encourages you to mix colours rather than relying on premixed tubes.

Brushes Taking fewer brushes into the landscape than you would use in the studio saves on weight and also saves you having to wash them out and clean them on location. It is likely that you will also be working on a smaller surface than in your home studio, and so there is less need for larger brushes. When working on location, I aim to stick to around five main brushes, ranging from a size 2 round for detail work up to a size 16 flat for larger blocking in.

Easel I recommend a lightweight folding aluminium easel. These are quick to set up and pack away, fairly resilient and also come in a bag that can be slung over your shoulder. If you are setting up an easel out of doors, pay attention to the wind – you may need to use a bag to hold your easel in place. There are times when I have had to put my full weight onto an easel to stop it blowing over!

Pochade box An alternative to an easel is a pochade box: a wooden or plastic box that unfolds to reveal a palette and space to slide a small canvas. Many of these have legs attached – like an easel – or can be mounted onto a camera tripod. Pochade boxes have the advantage of being compact and also save you having to carry a separate palette. Some also contain storage for brushes and paints.

Support Most *plein air* paintings take a couple of hours at most. The constantly moving light and changes in weather mean that a subject can change dramatically in a very short space of time. With this in mind it is perhaps best to take a few small canvas boards out rather than attempt one large-scale painting. For these reasons, it is unlikely that you're going to need anything gigantic when working outside. Don't forget to consider how to transport the wet painting home when it's done!

Other materials Clean water – preferably in a resealable bottle – is a must. A rag or paper to clean down brushes and your palette is useful. Some protection for your finished paintings, to avoid them being rubbed, smeared or marked when moving them, is useful.

Basic outdoor palette

This portable palette of just seven paints will provide you with the means to mix almost any colour you will need while out and about:

- Titanium white
- Ultramarine blue
- Cadmium yellow
- Cadmium red
- Black
- Burnt umber
- Yellow ochre

Checklist

We all rely on different things in our day-to-day painting. It is best to double-check before any outdoor painting trip that you have everything that you need:

- Small selection of brushes
- Warm clothing
- Limited number of paints
- Spray bottle
- Travel easel
- Small palette
- Small boards on which to paint
- Tripod
- Backpack and bottle of water
- Rag
- Apron

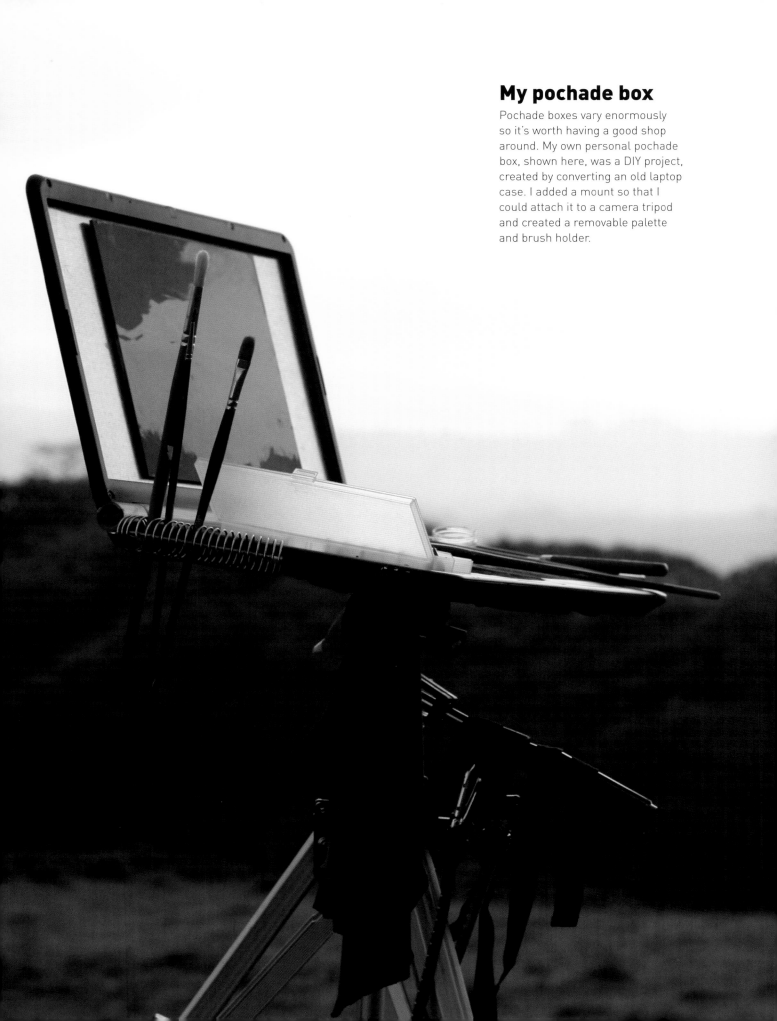

My pochade box

Pochade boxes vary enormously so it's worth having a good shop around. My own personal pochade box, shown here, was a DIY project, created by converting an old laptop case. I added a mount so that I could attach it to a camera tripod and created a removable palette and brush holder.

Painting the landscape

I am standing at the edge of some ancient rocks, nearly seven hundred feet up in the air, looking out across the mountains of the Peak District in the UK. Assorted bags hang from my aluminium easel, which I am desperately trying to keep still in the prevailing wind. A flat canvas board is attached by reams of duct tape that I dug out from a forgotten corner of my car.

The painting itself is not going well… The clouds are moving faster than I can paint them and I have not been able to capture the sense of light in the valley below to my satisfaction. To add insult to injury, one of my favourite brushes has rolled away and is now lost – and did I mention my hands are freezing?

Why go to these lengths in the pursuit of art? This is a question I invariably find myself asking from time to time. The answer? I have a love of the act of painting but, more than that, I have a love of the landscape – even when it is cruel to me.

The attraction of the landscape

The landscape affects us all. It is not always easy to put our finger on exactly why this is, but the weather and our surroundings undoubtedly have an important role in determining our moods. Different people respond to different environments. Some seek out the rugged and barren, others the hustle and buzz of city life. The landscape is constantly changing and moving, as are those living in it.

Subject is very important in art. I believe it is vital to engage with those things that affect and move you the most. This is very true of landscape painting. I think in the most successful paintings you get a sense of what it is that the artist is really responding to.

If I could offer any advice in choosing your subject matter it would be 'find what it is that really interests you'. This may be mountainscapes or crashing waves, but it could just as easily be your back garden or local park. There are no rules here. If the interest is there it will provide stimulation for your work and help you through those times when the painting is just not going right.

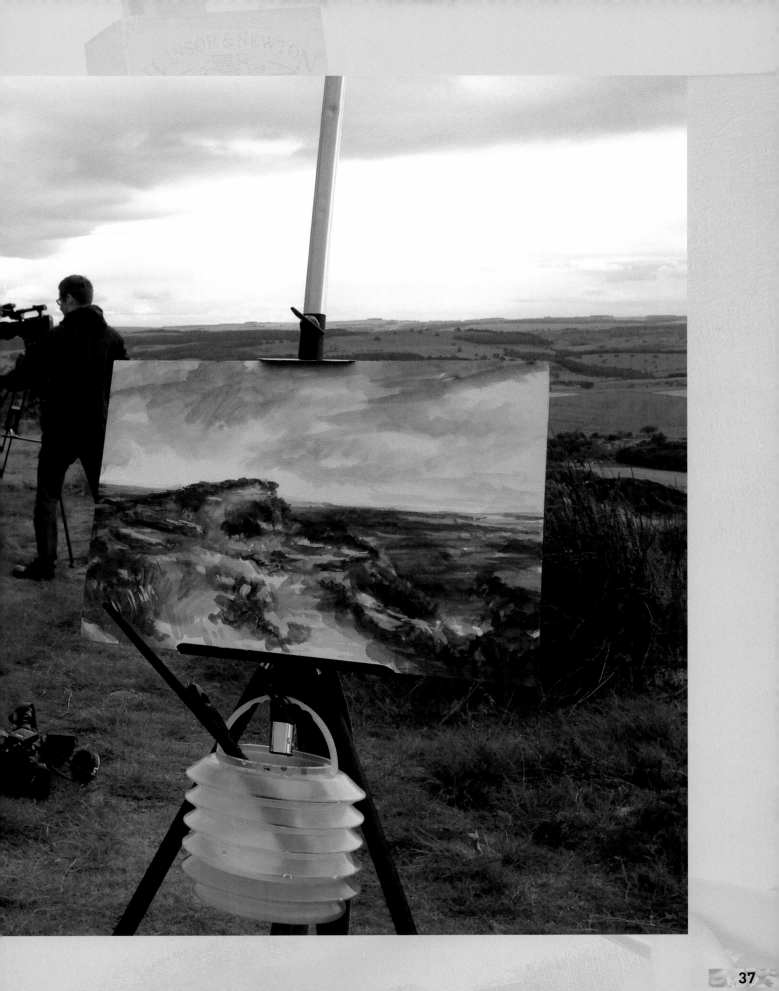

My personal goals

My tastes and interests as a painter are constantly changing, but I always aim for my paintings to show my experience of being in the landscape and to offer the viewer a way into this experience. I find that the paintings that work best are those of landscapes with which I have had first-hand experience. The stronger my connection with a place, the more I am able to inject a sense of that place into my work.

I love to travel and visit new places, and it is always exciting to be presented with a new and dramatic landscape to try and capture. There are many awe-inspiring vistas in the world, and in one lifetime it is unlikely we will see any more than a tiny fraction of them. There are also atmospheric conditions that are truly staggering – storms, dawns and sunsets – all of which can make for great paintings. However, I believe that it is dangerous to become too enamoured with the drama of the landscape. There are often things closer to home that can become just as interesting, and sometimes there are events in nature that are simply too dazzling to paint. I have seen many an incredible sunset that just would not look right were I to attempt to render in paint.

The following sections of this book are a glimpse into my typical year as a landscape painter. Each season brings with it new challenges and new skills to learn, which I touch on in my journal entries then expand upon with as much information about my process as I can. Remember that these are just my own personal ways of working and are by no means the only way!

A brief history of landscape painting

Landscape painting is a fairly recent development in the history of Western art. Artists have, of course, always painted the world around them, but it was nearly always treated as a backdrop. Many biblical and allegorical scenes from the Renaissance period, for example, feature masterfully rendered landscapes behind the subjects, but landscape painting was not seen as an artistic genre in itself. This changed in the seventeenth century as artists – particularly in the Netherlands – become increasingly concerned with depicting light and weather, leading to the period becoming known as the Dutch Golden Age of painting. This helped to legitimise landscape painting.

In England during this period, the landscape was most often used to show off the houses or estates of wealthy patrons – *Mr and Mrs Andrews* by Thomas Gainsborough (1727–1788) is a perfect example – but this gradually began to change at the start of the nineteenth century. It is at this point that the great Romantic age of landscape painting began. Landscapes became important in their own right, with a particular focus upon remote, wild scenes and mankind's place in the landscape. The contributions of artists such as J. M. W. Turner (1775–1851) and John Constable (1776–1837) helped to grow the genre of landscape painting enormously. Artists began to undertake grand tours, filling sketchbooks with studies and ideas for paintings while travelling, which could then be completed once they had returned to their studios. Turner is perhaps the best example of this, as he produced thousands of sketches of landscapes during his extensive travels across Europe. He was a master at capturing the essential details of a scene, and his late watercolours are almost abstract, such is their economical use of line and colour.

As materials advanced, so too did artists' ambitions. The nineteenth century saw the rise of the Impressionist movement. Championed by Claude Monet (1840–1926), the Impressionists began exploring the way light works, and worked from sustained and direct observation in the landscape. Artists such as Paul Cézanne (1839–1906) and Vincent Van Gogh (1853–1890) then pushed this idea further towards the end of the nineteenth century.

Landscape painting is still a thriving and important subject matter. We now live in an age where our world and landscape is changing dramatically. The landscape paintings being made now may serve as records of a natural world that will not always exist.

Opposite:

Edlington 40

120 x 85cm (47¼ x 33½in)

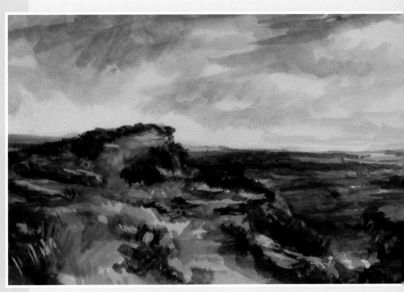

The View From Baslow Edge

33 x 25cm (13 x 9¾in)

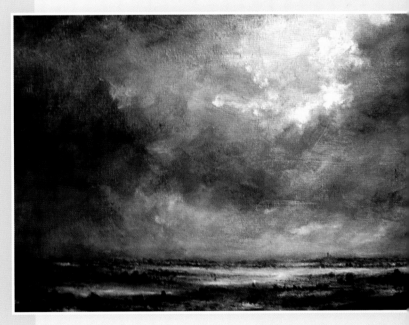

Toward Lincoln

55 x 38 cm (21½ x 15in)

The winter

landscape

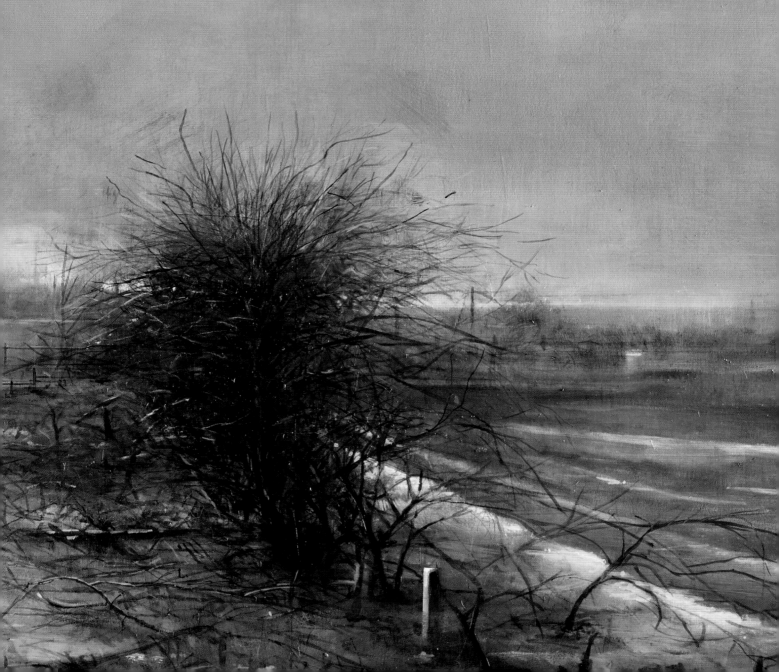

Working in winter

Writing this at the start of a new year is very exciting. I have empty sketchbooks, blank canvases and a journal waiting to be filled. There is a year's worth of travel and art ahead of me, but winter days are short so there is not much opportunity for painting outdoors. Instead, I tend to spend this period working out ideas in the comfort of my studio.

If I do venture out, the sketchbook and camera are my friends. I can work quickly on location and get ideas down without getting frozen to the bone. These can then be combined back in the studio to offer the raw components of new paintings.

This part of the book looks at some practical activities and skills you can work on over the winter months, and includes some example paintings I have made that are accompanied with notes to illustrate and explain my choices. Finally, we build up to a project that you can follow along step-by-step to get you painting the landscape.

Drawing and sketching

Drawing is incredibly important in visual art. You do not need to be a master draughtsman in order to paint well, but drawing really helps to advance your visual capabilities and your hand-to-eye coordination. Most of us draw when young but then lose that urge, which is a great shame, as it is an incredible way of working out ideas and learning about a subject.

I am slightly obsessed with sketchbooks, in which most ideas for my new paintings begin their lives. They serve their role best when they are used to capture thoughts and ideas; and when used like this they will build to form an incredible and personal visual diary.

Drawing is very personal, but there is no need to be self-conscious when drawing, especially in a sketchbook or journal. It is worth remembering that a drawing or sketch is simply something that helps you to understand a view or plan a painting: it does not need to be a finished work of art that you show to anyone. Sketches can be nothing more than scribbles – as long as they work for you. You can, of course, make larger and more finished drawings to support your artistic practice, but the sketches in my journals rarely see the light of day.

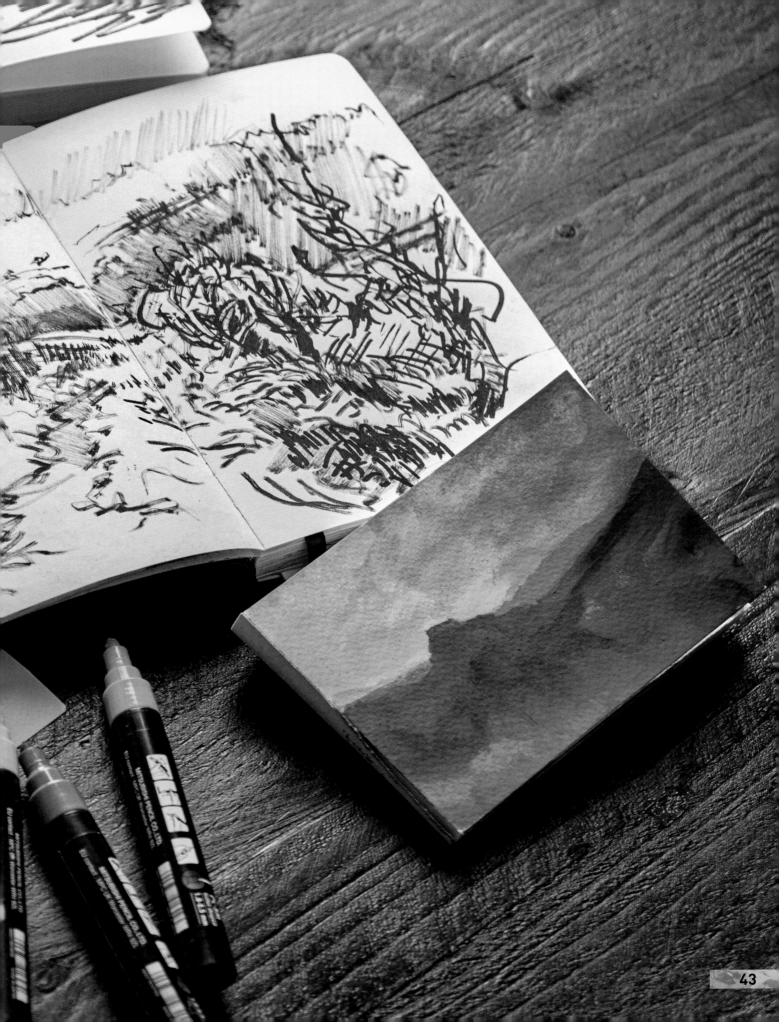

Using sketchbooks

My house is littered with sketchbooks, some full to the brim, others pristine and new, waiting for that first fateful mark. They make great souvenirs from trips or holidays, and so I am always on the lookout for new types of sketchbook. I buy new ones purely because I like the colour or the type of paper or – in one or two cases – the smell!

In a sketch, I aim to sum up the scene in front of me in the most economical way possible. I might make one drawing to deal with composition and then another to deal with the tone or light. Make the drawing process work for you and support your ambitions.

I am constantly breaking my self-imposed rule to always carry a sketchbook. As a result, my sketches for compositions or new paintings frequently find themselves on the less than glamorous surfaces of napkins, envelopes and newspapers. This is not ideal, but any blank white space will usually do the trick.

When flicking back through old sketchbooks, I am frequently amazed just how much they can transport me back to a time and location, even if the drawing is nothing more than some hastily scribbled marks. Once the first mark has been made I'm not too fussy with them. I'll paint in them, scrawl in them and generally mistreat them. This is a good thing. A well-maintained and neat sketchbook has no place in my life.

Using a pen

Pen sketching can take a little getting used to, but I think it is a great way to work. I have recently switched to using markers with acrylic-based ink, which doesn't seep through the pages of my sketchbook. This means I can work on both sides of the page. I've also taken to saving my pens as they start to run out of ink. This has meant I have built up a fantastic range of beautiful greys that I can also use to create a variety of tone in my drawings.

Using other media

Sketching does not necessarily mean using pen or pencil. I often use heavily diluted acrylic paint to make very quick sketches on canvas. These paint sketches usually give me the basic layout of a composition and allow me to see where the dark tones in the painting are going to fall. What you use to draw is a case of personal preference – though be aware that charcoal and pencil can be easily smudged when in a closed sketchbook.

Sketching with pen.

January 10th

Today I venture outside armed with a small trusty sketchbook and some marker pens. I often draw in pen. It stops me getting too fussy and I like the feel and sound of the felt nib on the page. The strength of ink on paper also excites me much more than some faint and wispy pencil lines.

A tree near my house forms the basis of a composition and I spend some time making quick sketches of it. These sketches may never be seen or they could just end up being the start of a new painting. That's why it is important to have the sketchbook entries. You just never know when they might be needed.

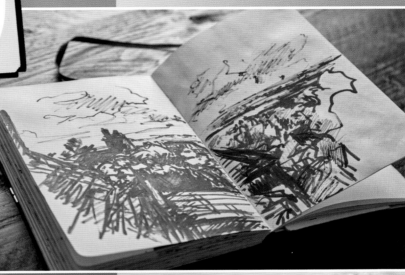

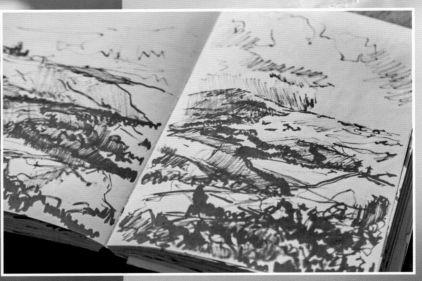

Pen sketches of the landscape.

Photography

I'll start by saying that I'm no great photographer – I'm much more comfortable with a pencil in my hand. However, we cannot deny the importance of photography. Alongside the sketchbook, the camera has a role to play in the creation of art.

Those who claim it is cheating to work from photographs are fighting a losing battle. Photography has many uses when it comes to creating art and, thanks to smartphones, we nearly all carry a compact, convenient camera with us.

Working from photographs

Working from photographs can be both addictive and restricting. The appeal is that you do not have to travel or get soaking wet outside and you can paint entirely from the comfort of home. A wealth of images to paint are available online, often free of charge, and for beginners this is an excellent way to practise and improve.

However, now for the words of warning. Relying solely on photographs for inspiration can become limiting. Photographs provide an enormous amount of information about light but very little about space, as they flatten everything into one picture plane. To illustrate this, take a good look at the space around you next time you are sitting outdoors, then take a photograph and compare the two.

This is why it is important to draw and paint directly from nature, even if you support this with photography. It exposes your senses to the landscape and gives you a much better comprehension of depth and distance than a photograph ever can. Drawing also forces you to look and understand the forms presented before you. The instant nature of a photograph does not require the same intensity of looking on the photographer's part, and this can lead to a superficial experience that misses much of the area's appeal.

In short, photography has both benefits and drawbacks. While a useful tool, the camera should not completely replace direct experience and study. I do use photographs a lot for my work but, as far as possible, make sure that I have actually taken the photograph myself and experienced the landscape first hand.

Using a camera

Looking at the landscape through a camera's viewfinder can be a good way of helping you to select a composition: many cameras allow you to bring up a grid or divide the screen into thirds, which helps further. This can be very useful when planning a composition.

Photographing your work is an increasingly important way to show it to the world, and, if you have a website, a camera is essential. It also helps to build a visual record of your paintings.

So much content exists online and in social media nowadays and looking at poorly photographed paintings is a real turn off. Many painting competitions now have online entry, and a well-photographed painting will give you a much better chance of success.

Choosing a camera

The quality of smartphone cameras is now such that it is perfectly possible to work in the studio from a photograph taken with your phone. Their convenience also makes them fantastic for those times when we see unexpected views that we would like to capture. However, a dedicated camera and some well-chosen accessories will give you more control and allow you to produce more thought-out and composed images for use as reference.

For the landscape painter who is frequently outdoors, the size and weight of your camera equipment is an important consideration – especially if you are also carrying painting materials and tools. I had this in mind when selecting my current camera. A full-scale DSLR camera is too bulky for my needs, while a compact camera offers neither the image quality I need, nor as many options as the DSLR. I therefore opted for a micro four thirds camera, which combines the small format of a compact camera with the interchangeable lenses and high resolution of a DSLR. This is a fantastic choice for any artist. It being lightweight means I do not feel emburdened when travelling or working outdoors, and it allows me to retain the option of using my favourite DSLR lenses.

If you have a camera with changeable lenses it is worth investing in a wide-angle lens for landscape photography, usually anything with a focal length less than 50mm (2in). For those times when you want to capture a really clear image to work from, a tripod is a worthwhile investment.

My camera, tripod and smartphone.

Editing your photographs

Graphical editing software has its uses for the modern painter. It will allow you to make changes to the brightness and contrast of your photographs and apply filters for various effects to the images. This can bring a bad or poorly-exposed photograph more in line with what it was like to experience the scene in person.

Landscapes usually contain a lot of greens and blues, and an editing program that allows you to tweak individual colour channels can really help make any reference photography stronger. I have also used programs such as Adobe's Photoshop to combine and edit different photographs together. This can be useful to change the overall composition or move elements, or perhaps even swapping one sky for another. Digital editing software is incredibly powerful and it is worth experimenting with as a complement to your photography and sketching.

As most of us now carry cameras in the form of smartphones, there are often ample opportunities to capture shots that can be turned into paintings. The three photographs shown to the right, for example, were taken using a camera phone over a period of around ten minutes.

Light and conditions in the landscape can change very quickly so it is worth taking several shots, as I have here. These can then be edited to improve the quality in preparation for a painting. Note that these images are slightly overexposed (a common problem when taking photographs of light sources) This can be corrected in most image-editing software.

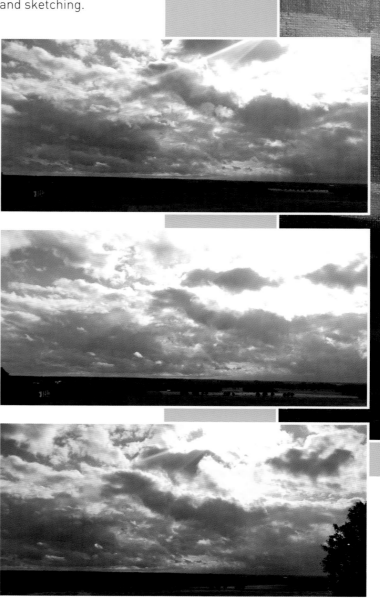

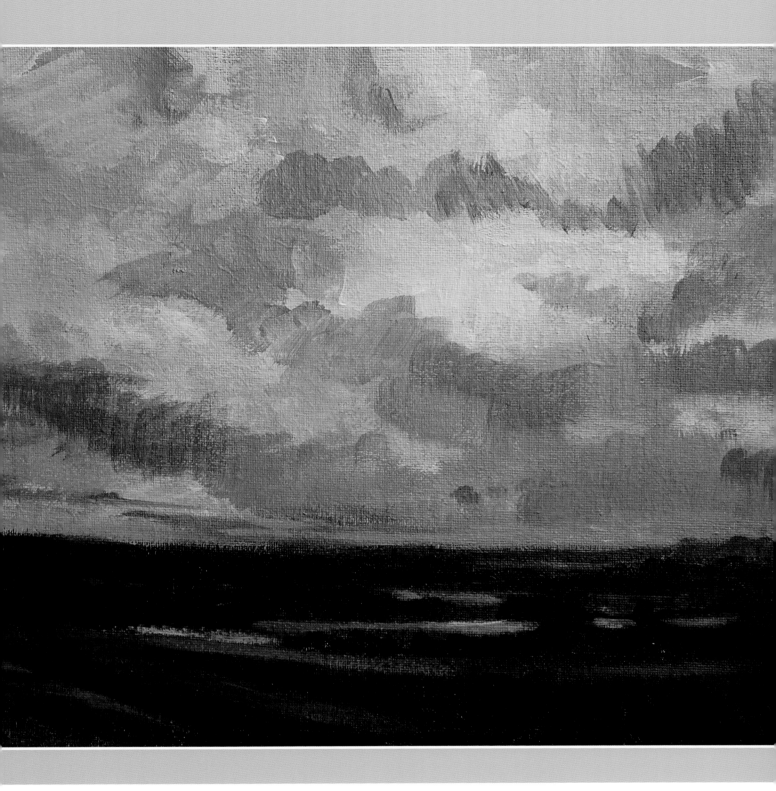

Lincoln from the West Common

22 x 15cm (8½ x 6in)

The painting above was created from a combination of the three photographs on the left. I used a fairly large brush to simplify the cloud shapes in the sky, using downward strokes to emphasise the drama in the sky. I also picked up some further highlights in the foreground, increasing the sense of light by using a brighter green.

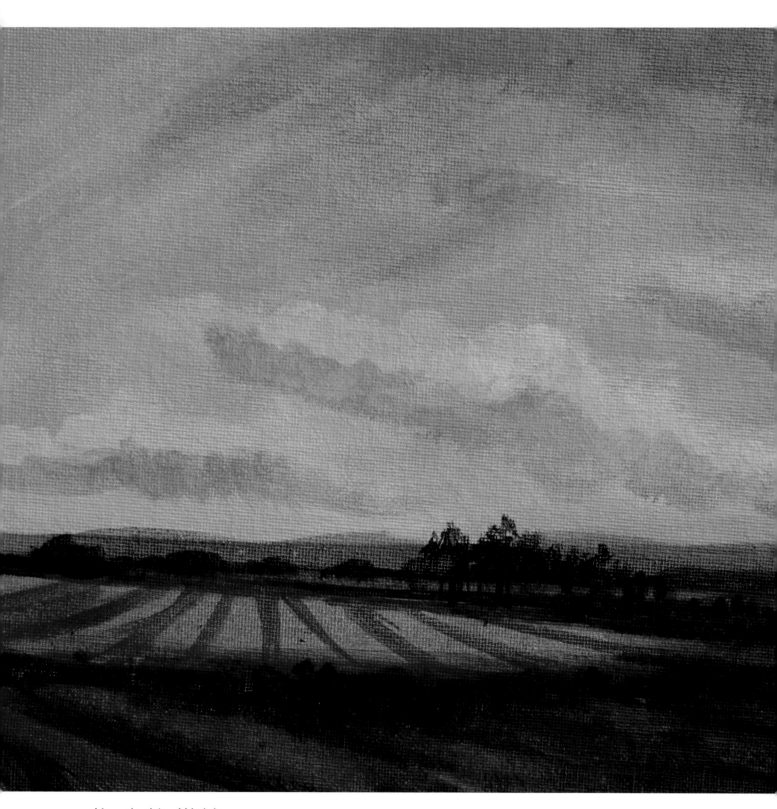

Lincolnshire Wolds

25.5 x 15cm (10 x 6in)

This painting sketch was the result of several compositional
studies and trail arrangements.

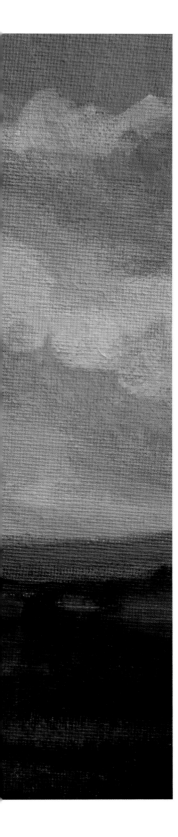

Composition

Even once you have your source material – the sketches and photographs you have made – it can still be difficult to know where to start, what to include in your painting and how to combine and arrange the elements into a successful artwork.

Composition – the arrangement of the different parts of a painting – is a word that gets thrown around all the time in painting instruction. It is a vast and interesting subject and there are many great books on the subject. My fundamental belief is that while composition is important, there are no hard and fast rules to which you must adhere. Your subject can be treated in many different ways. These pages look at some important basics of composition to get you started.

Where to start

My advice is to decide what particularly interests you in a scene and to tweak your composition to promote this. Ultimately, nature itself is bound by certain rules of composition and design – just look at the fantastic delicacy and symmetry in a leaf of a tree. Accurately recording something that appeals to you – even if you can't put your finger on exactly why it does – will often make for an effective result.

I grew up in a very flat county where the skies seemed to be massive and the horizon lines very flat and low. Perhaps as a consequence of this, one of the first decisions I make in my landscapes is to choose how much sky to include in the picture. As a simple guideline, if I am painting a picture that primarily deals with the sky then I may leave as much as two thirds of the painting to the sky. If it is the land I'm interested in, I may reverse this.

Deciding on a format

Most landscape paintings will adopt a rectangular format which is wider than it is tall – indeed, the format itself is called 'landscape' – but do not forget that there are options within this. Sometimes a more panoramic or portrait composition might help to emphasise certain elements of a landscape – if you are looking down from great height, for example.

I have had success working on many different formats, even choosing a square canvas from time to time. Do not limit yourself to pre-cut canvases and boards. It is very easy to cut down a canvas or wooden board with nothing more than a scalpel and metal ruler. This gives you much more control and allows you to tailor your paintings to their individual subject matters.

Study the Masters

Perhaps the best advice I can offer when it comes to composition for landscape painting is to look at the Masters. As a student, I spent hours trawling through art books and visiting galleries. I paid close attention to the compositions of many of my favourite painters, in some cases making simple copies of their work, looking at the core elements of the composition.

Compositional sketches

If you struggle with deciding upon a composition, try making a range of small sketches or drawings in order to try different options.

Some of my 'thumbnail drawings' – sketches made very quickly in the landscape – are shown below along with the more developed sketches made from them (see the bottom of the page and opposite). Quick drawings made on the spot allow you to play around with positioning elements in different places and expanding ideas from life. These thumbnails can then be developed in more detail later to help lead you towards the composition for a finished painting.

It is much better to spend a few hours exhausting different options on paper, rather than jumping straight to the canvas and then realising that you aren't happy.

January 11th

I'm back out sketching again. My aim today is to go back out and make some very quick thumbnail drawings. These quick drawings will allow me to play around with positioning elements in different places, expanding ideas and maybe leading towards the composition for a finished painting.

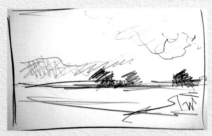 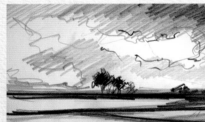 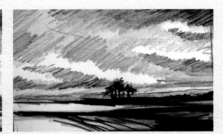

Thumbnail sketches, made quickly on location.

These sketches were made in more detail once I was back in the warmth of my studio. I used the thumbnail sketches above as the starting point to develop a few potential starting points for the painting. At this point, I try placing the trees in different locations, experiment with different formats and look at how I want to arrange the main tonal areas.

The final pencil sketch, made using the thumbnail and compositional sketches on the opposite page.

Lincolnshire Wolds sketch
This digital sketch (see page 191) allowed me to quickly try out different colours before committing paint to canvas.

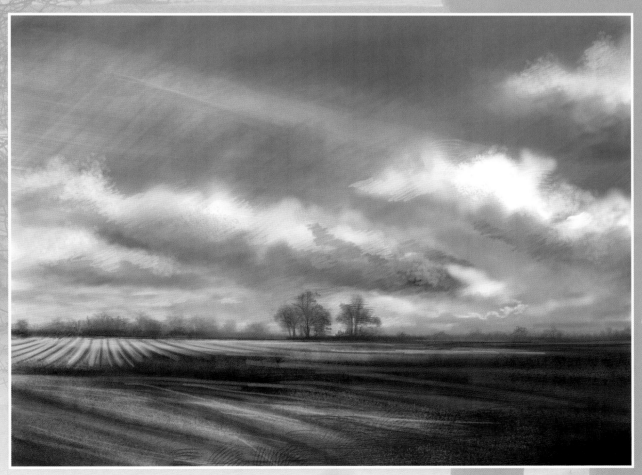

East Coast Drive

This painting was an attempt to capture the beautiful golden light of an early winter morning. Compositionally, it is a simple split between the sea and sky, as I wanted the eye to focus on the strong contrast between the dark tones on the shore and the strip of golden light running along the line of the horizon.

I was also interested in the way that the dark wooden posts on the beach offer a nice framing device. Their dark solid presence against the cold blues and greys certainly add to the composition.

February 16th

Reports of snow are the reason I find myself sat in my car early on this mid-February morning with only a collection of sketchbooks and the radio for company. My mission is to drive up the east coast of England through north Lincolnshire, cross the mighty Humber Bridge and arrive in the East Riding of Yorkshire. I don't have a specific destination in mind, preferring to meander at will and see where I end up.

Despite seeing nothing but an icy grey road as I drew the shutters at 5am, I persevered with the plan. I can't decide whether prising myself from my soft, warm bed on this cold, icy morning shows dedication or a lack of common sense!

As I drive further north, I am heartened to see snow in clean white blankets, as yet undisturbed by traffic, commuters or gangs of excited children. My meandering drive takes me to Hornsea, a small seaside town, where I stop for coffee and some coastal air.

Beaches are a subject that I have tended to avoid – I rarely find a composition that inspires me – but there is something about this desolate beach, deserted but for a few frozen dog walkers, on this bitterly cold morning. The light has a very beautiful quality and the crispness of the sky and the slate-grey sea make an attractive harmony.

I do not relish the idea of working outside, so instead opt for a few quick compositional sketches on paper and a few photographs with the intention of developing them in the warmth of my studio later.

The finished painting

40 x 28cm (15¾ x 11in)

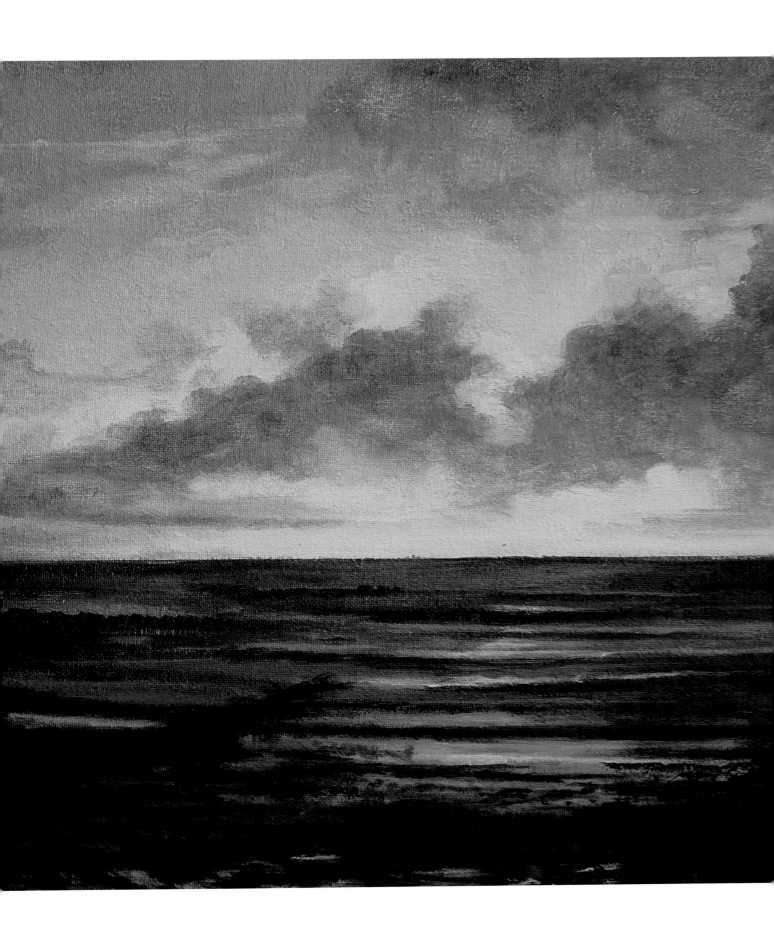

Painting *East Coast Drive*

I focussed on working quickly to establish the overall composition and tones, and so most of the initial stages were completed with large brushes. These allowed me to cover the majority of the surface area quickly and stopped me from getting too precious early on.

First stages

A 25mm (1in) texture brush was used to scumble a light-toned mix of titanium white and Naples yellow over a burnt umber tonal underpainting. The large size of the brush allows me to cover the surface area very quickly.

An eye on tone

Rather than thinking in sections of 'sky' or 'sea', the early stages of painting are simplified into areas of light and dark tone. The horizon line is an exception to this guideline; it is suggested with a midtone applied with smooth horizontal strokes using a size 14 filbert brush.

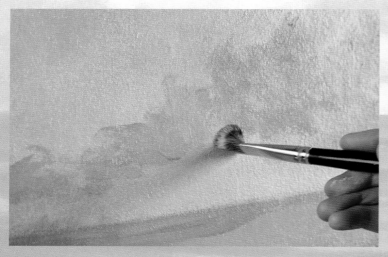

Clouds

Having added the dark tones to my beach and shore I had to revisit my clouds, making them darker to balance the rest of the picture. They were suggested with small circular strokes, working the paint into the surface.

Using painter's tape

It was important for the horizon line to be very straight. I achieved this by using the yellow painter's tape shown above. I masked off the horizon line (once the sky was dry) and this allowed me to a paint a perfectly straight dark horizon line. I then allowed this to dry before peeling off the painter's tape.

An alternative approach

Snow is something of a challenge to the landscape painter. It presents as many pitfalls as it does opportunities. I have always been particularly fascinated by the sky when it is snowing – there often tends to be a calm, oddly fragile sort of light, with beautiful inky greys dropping dramatically down toward the horizon line. The snow itself is fascinating too: the way it obscures and covers all it falls upon, creating new shapes in the landscape and bouncing light back in different directions. I always find it surprising how muddy and drab everything looks when the snow melts away, hanging on in little clusters at the bottoms of hedgerows and other shady areas.

The painting below was my first attempt at capturing the colours and composition of the scene. It was executed very quickly using a limited palette of Naples yellow, titanium white, ultramarine blue and burnt umber. As with *East Coast Drive*, I wanted to establish the contrast between the dark masses on the beach and the golden light in the sky. The painting was blocked in quickly on an old canvas board using a couple of brushes.

Sea at Hornsea

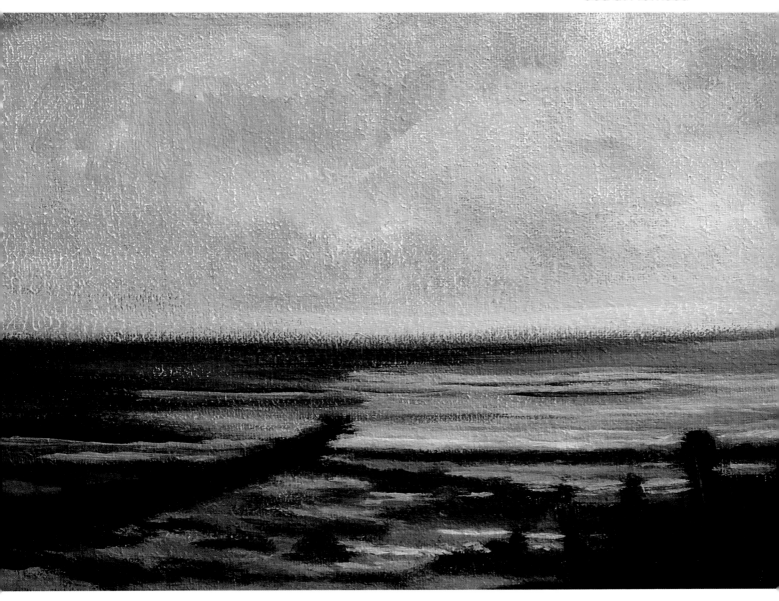

Landscape at Dumfries

I have always been charmed by the Scottish landscape. Its rugged beauty ticks all my boxes. I find the light in Scotland has a particular quality as well: the greys are somehow wholly beautiful here, whereas they would seem sombre in other parts of the UK. This is particularly noticeable in wintertime.

This painting resulted from experimentation, and while the approach I took – detailed overleaf – is not something that I would necessarily repeat, the experience was therapeutic and helped me to find a way into this demanding Scottish landscape.

I would not normally advocate such an experimental, unplanned approach as good practice, but a little frustration and adaptation on the fly can go a long way in a painting. Such experiments can help you to break away from something that has been holding you back.

February 26th

Today I find myself in Scotland, as part of a working residency at beautiful Dumfries House in Ayrshire. My studio for the week is a converted laundry house that nestles among towering evergreens on the expansive estate. The studios have been purpose-built and are perhaps the nicest space I have ever had the pleasure to work within – ample wall space, large conservation lights, great views and those all-important coffee-making facilities. With such a luxurious working space it is an effort to force myself outside into the cold Scottish air, but I eventually venture out into the grounds of the estate after lunch. It is one of those truly crisp winter days – cold but also clear.

Well wrapped up, it's a pleasure to be out of doors. It is still too early in the year to paint outside comfortably, so I take a long meandering walk through the landscape, with no particular plan in mind (which is usually the best course of action when in unfamiliar surroundings) and walk until it starts to grow dark. The days are short here.

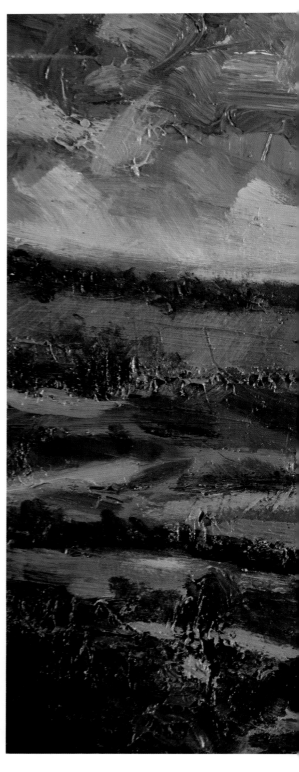

The finished painting
31 x 20cm (12 x 8in)

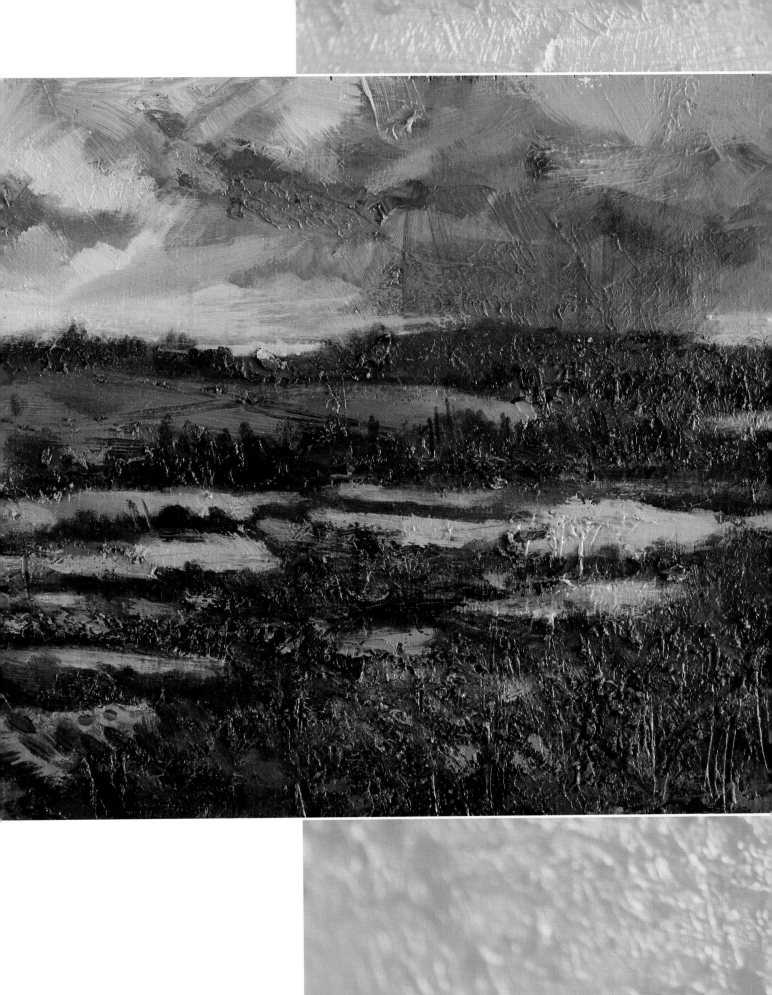

Painting *Landscape at Dumfries*

Unusually for me, this painting began with no real plan or composition. My starting point was a scribbled sketch I had made on the back of a receipt while out walking – I had forgotten my sketchbook, but the walk allowed me to absorb some of the colours and atmosphere of the landscape.

Keen not to lose the fleeting experiences of the morning, I grabbed a small off-cut of wood as soon as I was back in the studio and got to work, quickly blocking in the basic outline of a composition and some of the colours. The resulting painting was flat and had nothing of the ruggedness and vitality I remembered of the landscape. Disheartened, I grabbed a palette knife and began to proceed brush free. With little to lose, I also decide to add some texture medium that I had been meaning to try out. Initially the painting went from bad to worse, becoming a muddy amalgamation of colours, but I persevered. Eventually, some of the Scottish landscape starts to come through. The texture medium helped me out enormously here, adding to the overall effect of the picture. It was a fairly sombre palette of colours, but they seemed right for the area.

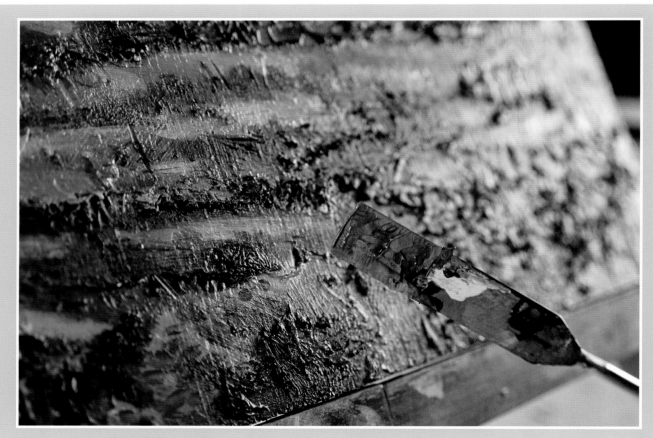

Using texture medium with the palette knife

Texture medium can be mixed with your paint and is ideal for impasto techniques. In this instance I mixed some texture medium with each colour on my palette, giving them more weight and substance. I then worked very quickly, using a palette knife to apply the paints to the surface of the board. The knife allowed me to create the rough and tactile surface of the painting. If you usually only paint with brushes, a palette knife can be quite a liberating experience.

Additional colours for the winter palette

It is a mistake to think that you only deal with cold and muted colours in winter. Some of the most fantastic bright colours can be found in my winter paintings. Sunsets in particular can be truly magnificent in the winter.

It is also true to say that if you are dealing with cold colours on their own, you will often need to introduce some warmer accents to hold the whole picture together.

Cerulean blue

Cerulean blue

The word cerulean stems from the Latin word *caeruleum*, which means 'sky' or 'heavens'. This was in turn from the Latin for deep blue: *caeruleus*, resembling the blue of the sky. In paint, cerulean denotes a range of colours from deep blue, sky-blue, bright blue or azure to deep cyan.

I find cerulean blue a refreshing contrast to my usual ultramarine blue, which is a warm, red-tinged blue. Cerulean is cooler and has a more metallic quality. The exact hue may vary from manufacturer to manufacturer, but usually errs more towards the green end of the spectrum.

This paint is fantastic for creating the feel of cold winter light. It can add a real icy quality to a clear blue winter sky or for the blue highlights in fallen snow.

Colour palette

I wanted to capture the muted and beautiful colours of the Scottish landscape. I began by mostly using a range of greens and browns to build up the overall surface, then used different accents to bring out highlights. Dotted red and purple areas were used to add interest to the foreground.

The source photograph

This photograph shows the rough viewpoint on which the painting was based. The limited range of colour is shown quite well here alongside the rough texture of the immediate foreground.

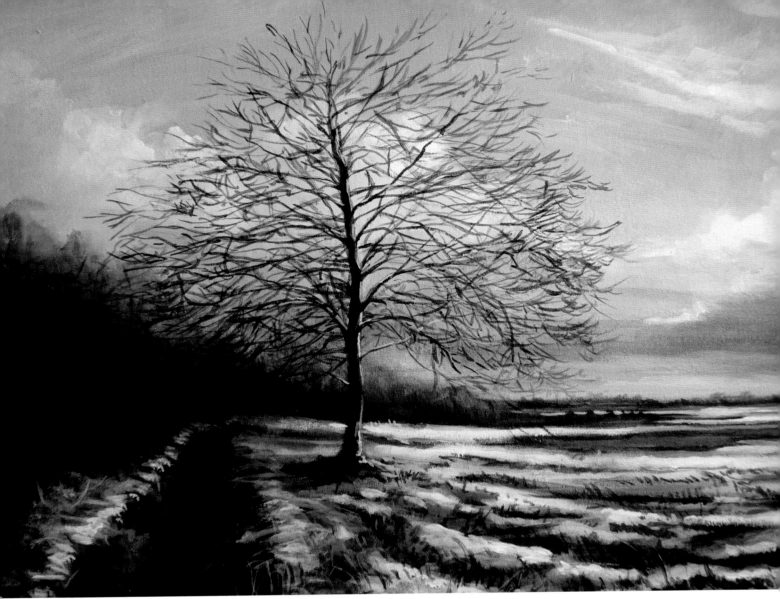

In the Snow

This project is the result of some sketches made early in the year. I had the idea for the composition and returned to the same spot, making more sketches with each visit. In mid-February we were treated to a few days of snow, and I returned once more to the spot with a view to making this into a painting.

I have painted this view a few times before, mostly in the autumn, but I think this is the first time I have seen it in the snow. The tall tree on the left-hand side of the image acts as a convenient framing device and also provides some useful contrast to the white snow that dominates the rest of the picture. I was careful not to overwork the detail in the tree. A bare tree such as this can soon start to look overworked if you attempt to paint every last branch. Instead I wanted to focus on the stark contrast between the dark tree and the snowy sky. I included some minor detail work in the immediate foreground but kept the levels of detail fairly low elsewhere to emphasise the snow and sense of distance in the picture. The following pages detail the rough steps that I took in order to complete the painting.

The finished painting

You will need

56 x 38cm (22 x 15in) canvas board

Grey matt emulsion and small roller

Paints: basic palette (see pages 16–17), plus cobalt blue

Brushes: size 8 filbert, size 4 filbert, size 10 filbert, 25mm (1in) flat, size 8 round, size 4 round, size 1 round

Spray bottle

1 Key marks

- **Apply matt grey** emulsion to the surface using a roller. Once dry, establish the basics of the composition with burnt umber and the size 8 filbert.

- **Suggest cloud banks** on the right with loose shapes in the sky, and build up the foreground more strongly.

- **Concentrate on tone,** developing the contrasts between the light and dark areas at this stage. Use the mid grey of the primed surface as your midtone.

Grey ground
In addition to creating a subtle midtoned ground, the grey emulsion will help to create a good working surface.

Watery paint
Keep the burnt umber dilute at this stage. You are aiming simply to block in the main shapes very loosely.

The painting at the end of this stage.

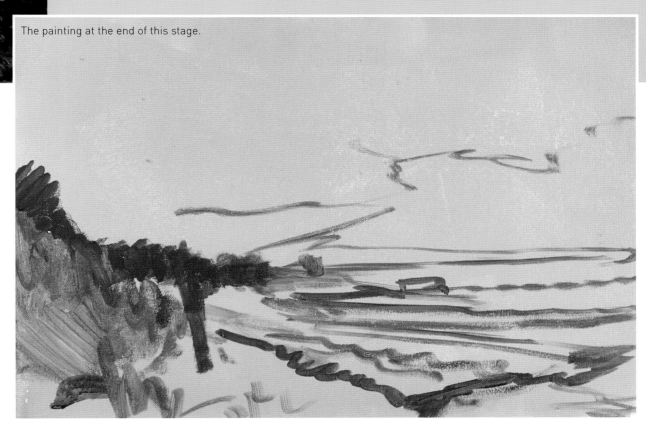

2 The sky and distance

- **Dilute titanium white** with water to a milky consistency and apply it to the horizon using the 25mm (1in) flat brush. Draw it upwards into the sky area, working quickly and confidently in multiple thin layers.

- **Add cobalt blue** to the white and immediately begin to develop the sky with quick circular motions, holding the brush near the bristles for control and strength of mark. The colour will blend into the underlying wet white paint.

- **Create a gradient** in the sky by applying darker blue (less titanium white and more cobalt blue in the mix) at the top. Start to introduce cloud shapes with more titanium white, blending lighter marks into the surfaces.

- **Suggest distant snowfall** towards the horizon by adding touches of Prussian blue, ultramarine blue and Payne's grey. Use short vertical strokes to blend the banks of cloud into a blurry, mysterious horizon.

- **Add highlights in** the clouds with pure undiluted titanium white and the size 10 filbert. Blend the paint into the horizon line to bring out the contrast.

The painting at the end of this stage.

First marks in the sky
The bristles and drying paint will naturally create texture, so aim for a chaotic structure by using varied strokes.

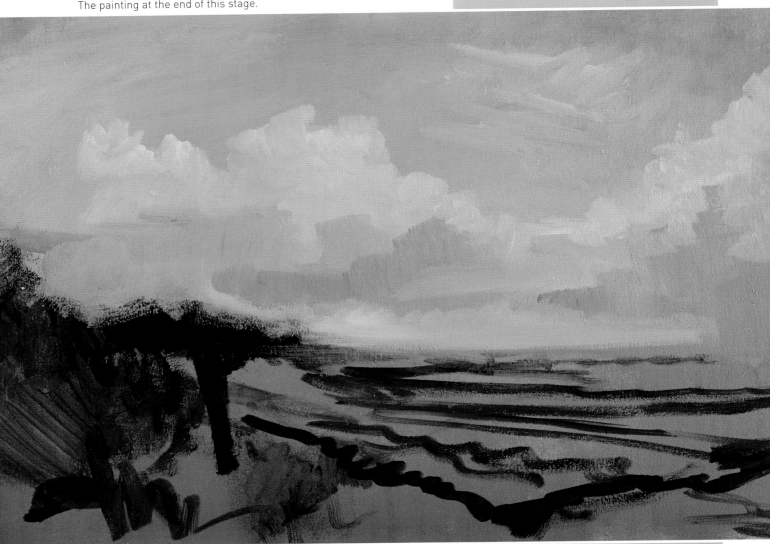

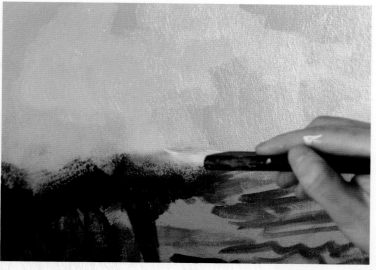

Clouds

Circular motions worked with lighter-toned paint before the layer beneath dries will create cloud shapes.

Blending

Using less dilute paint and little pressure on the brush will reveal the texture of the surface and allow you to create a hazy effect that suggests distance.

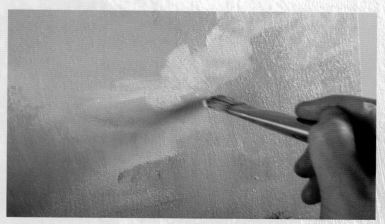

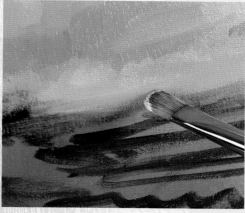

Snowfall

Vertical strokes that join the bottom parts of the clouds to the horizon help to convey a sense of snow falling in the distance. Note how the mix of blues and greys are darker in tone than the lower part of the sky.

Soft lines

With no hard edges, the filbert brush helps to suggest softness in the distance, but since it still has a 'blade' like a flat brush, you can still use it for linear marks, such as the horizon here.

3 Distance and foreground

- **Add burnt umber** to the white-blue mixes on the palette. Working forward from the horizon, paint darker, more distant shapes with the size 8 round brush.

- **Cover the foreground** with a fairly smooth coat of a blue-green mix of Payne's grey and forest green, applying the paint with the size 10 filbert.

- **Establish foliage on** the left using short vigorous strokes combined with lighter feathering touches. Use pure burnt umber, and if the area gets too strong, work in the paint very hard to scrub away excess paint and reveal the underlayer.

- **Start the tree** with strong lines of burnt umber applied with the size 4 round, then swap to the size 8 filbert for finer lines. Vary the strokes, using the blade and corner of the brush for detail. Allow to dry thoroughly before continuing.

Correcting over-darkened areas

Before the paint has fully dried, you can use the spray bottle to wet the area and scrub heavily to reveal the layer beneath.

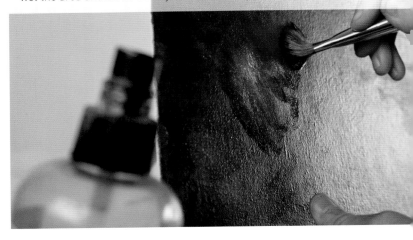

The painting at the end of this stage.

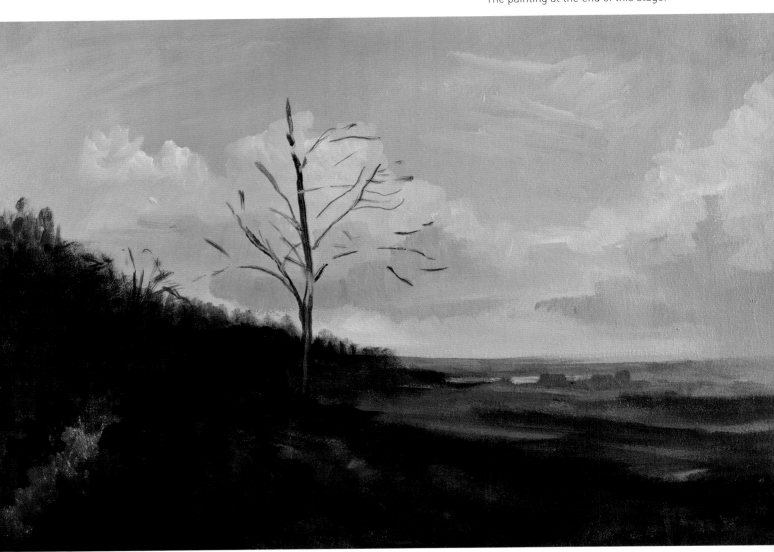

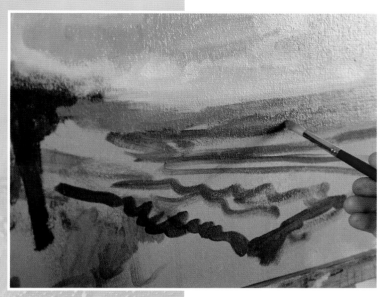

Snow on the horizon

Start to block in the colours around the horizon line using a mix of ultramarine and Prussian blue. These blues will help to create a sense of distance. We can then add white on top of the blue to create the sense of distant snow-covered fields.

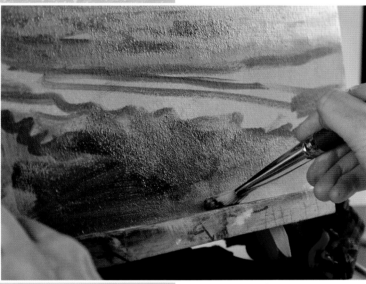

Cool green underlayer

The mix of Payne's grey and forest green are used to create the basic ground for the foreground. This is to create some contrast later on, when blues and whites are introduced to the foreground.

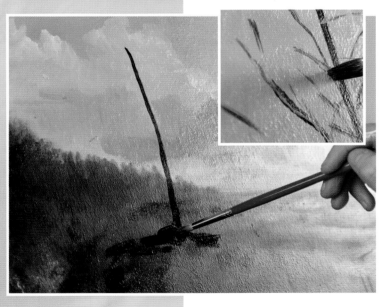

The tree

The first stroke is used to establish the core trunk of the tree, which will serve as an anchor from which to build the tree's overall structure. I tend to begin with the larger branches first and then gradually work down to the smaller marks, which are added with a small brush.

4 The sky and clouds

- **Suggest light snowfall** on the fields using the size 4 filbert to apply an off-white mix of a little palette grey (see page 17) added to titanium white.

- **Create streak marks** on the field using the same white-blue and burnt umber mix, adding a little cobalt blue to neutralise the colour somewhat.

- **Leaving gaps for** the dark tone underneath to show through, develop snow on the foreground using larger heavier strokes of the same mix. Use the shape and direction of the brushstrokes to direct the eye and create the furrows.

- **Refine the shapes** and contours established earlier using the size 4 filbert, and an off-grey mix of palette grey and titanium white. Use almost pure white in the foreground.

- **Warm the trees** on the right-hand side with a glaze of raw sienna and the size 10 filbert.

- **Add highlights to** the snow with titanium white applied thinly with the size 4 round, then begin to develop the fine branches in the foreground tree using the size 1 round.

- **Dip the sharpened** end of an old brush in pure burnt umber to add broken lines in the branches of the main tree, and also to scratch out detail from the dark area on the left-hand side.

Snowfall on the fields
Use very little paint and light horizontal strokes to just catch the texture of the board.

The painting at the end of this stage.

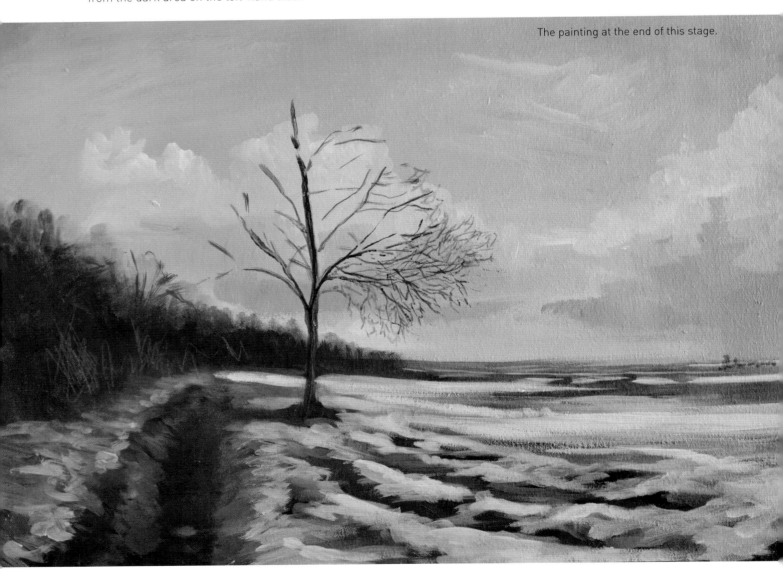

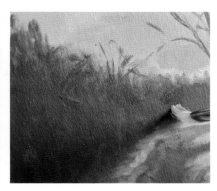

Structure on the fields

Overlaying a heavier version of the white-blue mix on the field suggests shape and lets you draw the viewer's eye into the picture. Use the blade and corner of the size 4 filbert brush for a variety of marks.

Cool shadows

Add Payne's grey and ultramarine blue to the mix for the cooler shadows in the furrow on the left-hand side of the picture. The strokes you make with the brush should reinforce the shape.

Warming the trees

A dilute glaze of raw sienna warms the area without obscuring the form. It also strengthens the contrast between the snow and treeline, making the white-blue appear even cooler in contrast.

Fine marks

Changing to a smaller brush is not always necessary, but makes details like these fine branches easier.

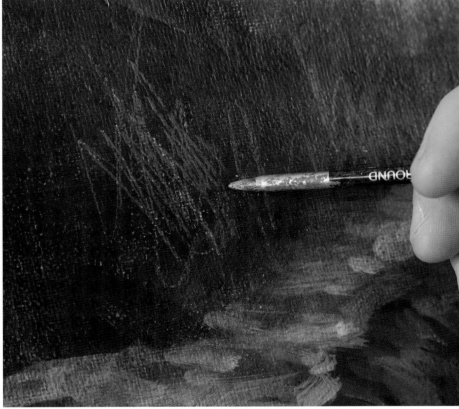

Scratching out

The sharpened end of an old brush can be used to scrape away paint at the base of the left-hand trees to add texture and suggest undergrowth.

The spring

landscape

Into the landscape with paint

I enjoy every season – to a painter each one has its own merits – but it is always exciting when that season starts to give way to the next. New opportunities present themselves and you can adapt your way of working. For me, the spring allows me to emerge from the studio and once more begin to work in the landscape. It is a time of year that I am thankful for the changing of the seasons. Just as winter starts to become oppressive, you begin to notice little changes which fill you with hope.

Early spring days are often not particularly warm, and so prolonged outdoor painting sessions can still be chilly and uncomfortable. However, beginning the season by heading out and making some quick studies is a good idea. Having not painted outside for the winter months you may be a little rusty – certainly I find sketching outdoors helps me to get back into the swing of using my paints.

For these quick sketches, I often re-prime old canvas boards or paint over old paintings that have not quite worked – it seems a shame to waste new pristine materials on these initial forays. I am never too sentimental when it comes to old work, and some of my painting panels may have as many as ten previous paintings sealed underneath the layers of primer.

March 3rd

There is, for the first time this year, the faintest whiff of spring in the air. The clocks haven't yet changed, but the days are noticeably longer, providing some much-needed afternoon light in the studio. The trees are still bare and spindly, but that will soon begin to change, with bright buds and blossom appearing.

I have had a busy period over the winter. It is a great time to tie up loose ends and plan new projects. I have been painting plenty in the studio, working from sketches and photographs built up from the previous year and completing some lingering commissions. The weather is yet to warm up but the longer working days mean that I am able to begin some *plein air* painting. I have a few locations in mind and a few new subjects to tackle.

In a moment of either inspiration or madness I decided to construct a new pochade box (this can be seen on page 35) to take out into the landscape. The result is a folding and reasonably lightweight piece of kit that I can put in a backpack and attach to my camera tripod for stability. It should work in theory, but I'm eager to try it out in the landscape.

As I have new gear to test, I decide to stay local for painting outdoors, making some very quick landscape studies about a mile from my house. With the promise of warmer weather and lighter nights, I'm very much looking forward to getting back out into the landscape.

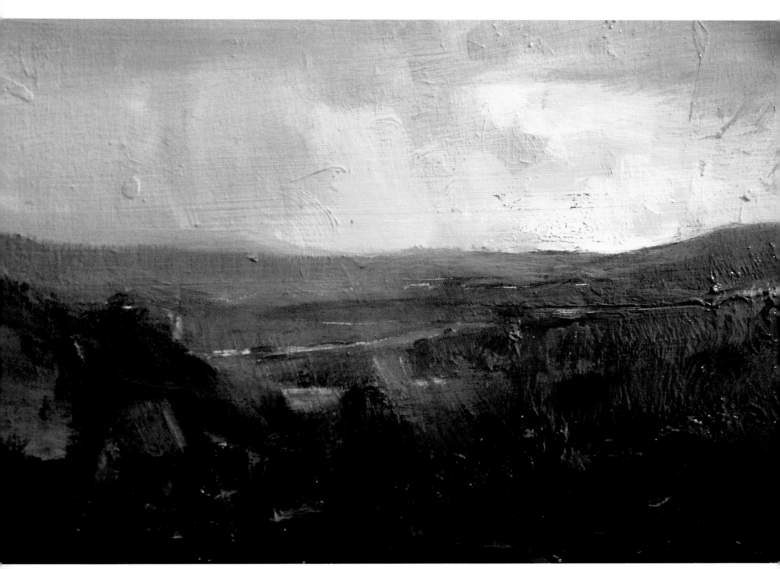

Nearby subjects

Landscape study

This quick study was created on a painting holiday in Tuscany. The quickly-changing light meant that I could not afford to be too precious and had to work quickly on a small canvas to complete the picture.

Spring days can still be short, and the weather is often chilly or unpredictable. Rather than plan for long trips or an ambitious all-day painting session outdoors, which might prove frustrating or uncomfortable, I often keep some nearby subjects in mind for those days where I can't be sure the rain will hold off. Studies or paintings made within easy walking distance of your house – or even in your garden – are a great way to take advantage of an unexpectedly promising day.

Opposite:

Spring trees study

This small study – it measures just 12.5 x 17.5cm (5 x 7in) – was painted in early spring. Rather than face the tree dead on, I decided that I would look up into the branches. The painting took around forty minutes; I rather like the almost abstract quality it has.

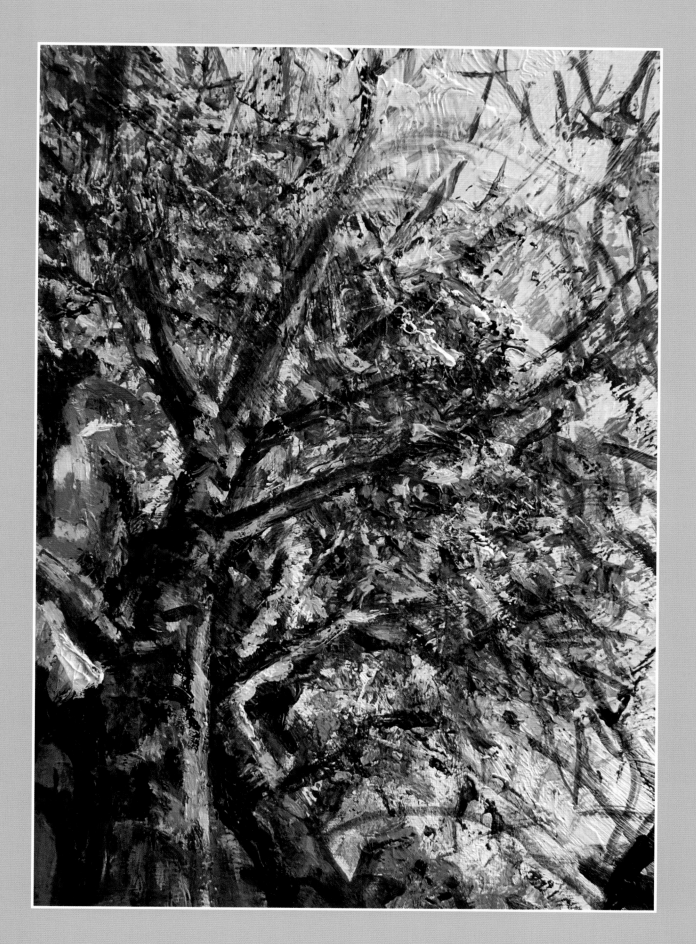

Making quick studies

Spring is the perfect time to pop outside for a couple of hours and get reacquainted with your painting materials. As a rule, I tend to spend around an hour on quick studies in paint. This is an ideal amount of time to work. It allows for a sustained period of concentration but forces you to work quite quickly. It is also handy if the weather is taking some time to warm up, as an hour is not too long to be outside in the landscape.

I rarely view these quick sketches in paint as finished works or even studies for larger paintings. Instead, they are mostly for exercise and to get back into the swing of things after the long winter. Some of these quick studies, however, can turn out to be real gems. I think the lack of pressure certainly helps with this.

Working outside on studies like this refines your skill at working quickly and loosely. I often forget just how fast the light can move and change in the early spring, but the principles of painting outdoors soon come flooding back during those short sessions.

March 19th

This week I have been into the back garden for the first time this year. It's not a pretty sight – I'm not much of a gardener and my paving slabs have succumbed to a flurry of weeds over the winter months. They sprout from every crack and crevice in the garden. A wooden chair lies upturned and the place generally looks quite sorry for itself. While I will not be entering the Chelsea Flower Show anytime soon, there is something about the garden in this rather wild state that appeals to me.

I decide it is warm enough to entertain a couple of hours painting outdoors, and so coax my easel down the stairs and out into the garden. This is a rather spur-of-the-moment decision and I don't have time to prepare any painting boards. Perhaps half an hour is lost rummaging through boxes of canvas boards to find a surface that is not just a suitable size but also clear enough to paint on. I like to give new life to old canvas boards, and find two such boards in my past paintings pile. Their sorry state seems oddly appropriate for the condition of the garden, and so I set to work.

My garden paintings don't amount to much more than simple studies, but I thoroughly enjoy the process and vow to return to the same spot over the coming months. This will also allow me to chart the progress and changes in the garden over the spring and – conveniently – gives me an excuse not to tidy up.

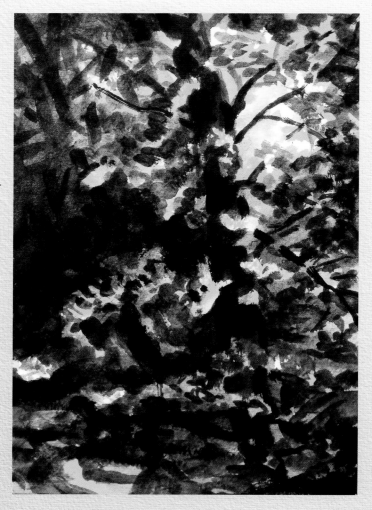

Where to find subject matter

I know some artists who have a still life permanently set up in the corner of their studios, allowing them to dip in and out as inspiration strikes and time allows. Such paintings can be built up over several weeks or months without any pressure. The same can be true of an outdoor space, garden or patio or view from a window.

Try and find a spot in the house to which you can return in order to work. The main benefit is that you will always have a readily available subject for those days when the weather is foul, or work in the studio is proving frustrating: you can simply switch over to this area for a no-pressure break.

My garden provides me with a handy subject matter that allows me to work from life but with all the comforts and benefits of my studio. Aside from taking the easel downstairs I don't have to strain too much to complete the paintings and can also come and go as I please. I would recommend having a place in the house or garden that you can use in this way – an ultra-convenient source of subject matter which means that you can work from life without the worry about transporting materials.

Garden Corner

This painting was an attempt to capture some of the chaos of my garden, and it actually ended up becoming a small, almost abstract painting. I focussed closely on a yellow wheelbarrow and assorted pots and bags that lay abandoned nearby to create this busy composition.

Skies and clouds

Now we are venturing outside to paint, it is about time we looked more closely at skies. Perhaps more than anything else, the sky defines the mood and atmosphere of any landscape – it is where the source of light sits, after all. It is therefore crucial to the success of any landscape painting that you are well-versed in the rendering of skies.

I will never tire of paintings skies; there is something powerful about these backdrops to our everyday comings and goings. In addition to being a great way to practise with your paints and brushes, they are also fantastically varied. They are also very convenient as source material for quick studies from life – whatever the weather, and wherever you are, a view of the sky is rarely more than a few paces away.

The exercises on the following pages should get you back into the swing of painting after the long winter, with no sense of pressure.

Clear blue sky

Choosing the right brush can make working on your sky a lot easier. Bigger is better. I favour a large flat synthetic blender brush, but when I first started painting I used an old shaving brush to paint my clouds. Its large soft head and stubby handle gave me lots of control. Decorating brushes can also be surprisingly useful, but buy a good-quality one to avoid your picture being full of stray bristles.

1 Mist the surface and use the 25mm (1in) texture brush to paint the whole surface with fairly thick titanium white. The paint should deposit smoothly on the damp surface; you should feel little resistance from the board.

2 Without cleaning your brush, pick up a little ultramarine blue. Starting from the top, touch the colour onto the wet surface; then blend the paints together.

3 Vary the direction of the brushstrokes as you work to avoid artificial lines or breaks, and employ the water sprayer to ensure the paint remains damp and workable. This helps to prevent adding unintentional texture.

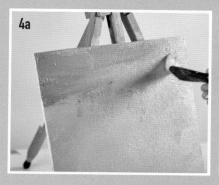

4 Strengthen the blue by adding more paint in the top third. Repeat as necessary until you have built up a blue gradient.

The finished sky

Cloudy sky

Flat brush heads can be remarkably versatile for painting skies. They allow you to quickly fill in a surface area, can be pushed into the paint to blend and manipulate large areas, and the brush corners can also be used to pick out the edges of clouds.

1 Paint a clear sky as described on the previous pages, then pick up pure titanium white on the 25mm (1in) flat brush. Use dabbing motions to make a very loose outline of the cloud shape on the still-wet blue sky. Draw the colour from the outline into the body of the cloud.

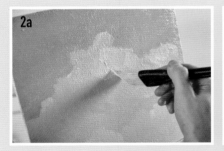 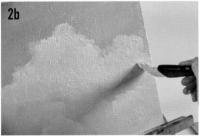 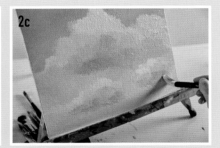

2 Add more titanium white to build up the highlights and develop the form. Pick up a hint of burnt umber on the brush. This will mix with the colour on the brush and add some warmth. Apply these touches towards the bottom of the cloud body. Add a hint of Payne's grey for the inkier bases of the clouds.

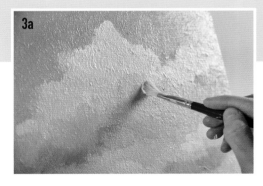

3 For final highlights, swap to a smaller size 8 filbert and add touches of pure titanium white with heavier impasto touches.

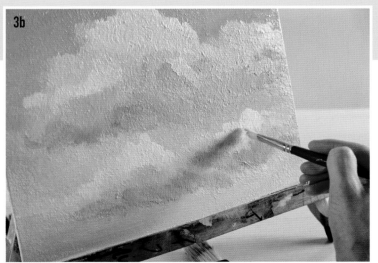

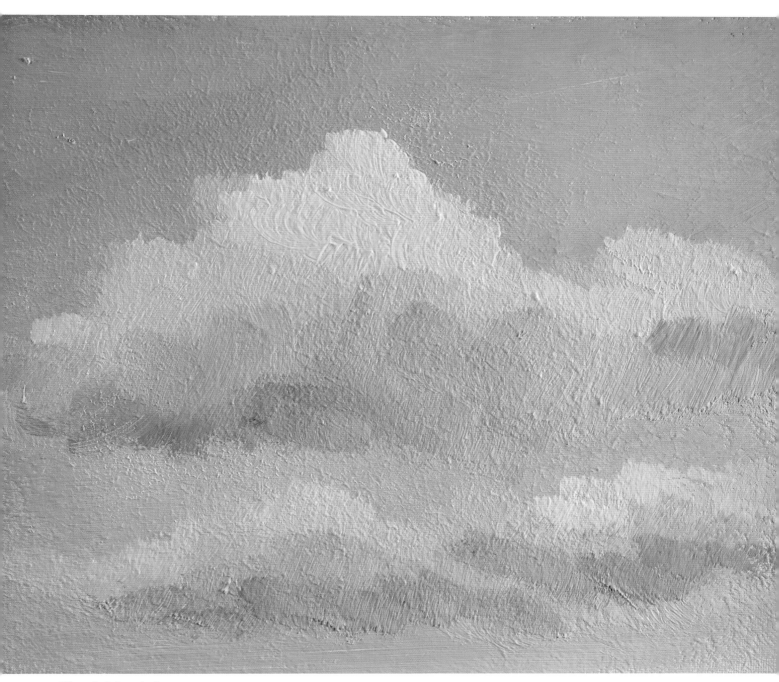

The finished sky

Sunset from Canwick.

With the quick spring studies and basic sky exercises under your belt, you might want to take on something a little more ambitious, like this sunset over the historic city of Lincoln, where I live in the UK.

I have painted views of Lincoln Cathedral from afar many times before. The iconic outline can be spotted against the skyline from up to thirty miles away on a clear day. Its prominent and identifiable shape make it an excellent compositional device – much as Dutch landscape painters used windmills and the like to add some visual interest to their low horizon lines.

As the canvas was relatively small I used a size 0 round brush to complete the outline of the cathedral. I worked steadily to keep my hands still and took constant breaks in order to build up an accurate representation of the cathedral's silhouette.

April 4th

I am not usually a great fan of painting sunsets – it seems ever harder to avoid the dazzling colours and silhouettes looking clichéd and over-romanticised. As I drove home in late March, however, I caught a glimpse of Lincoln Cathedral against the rusty oranges of the setting sun. Something about the harsh black outline made me want to attempt this in paint.

Armed with a camera I returned to my vantage point in the early evening. I was rewarded with a truly stunning sunset and some workable photographs of the skyline to take back to the studio.

Today I drive to a familiar vantage point to make some further sketches. My idea is to create two paintings, one in acrylics and one digitally using an iPad.

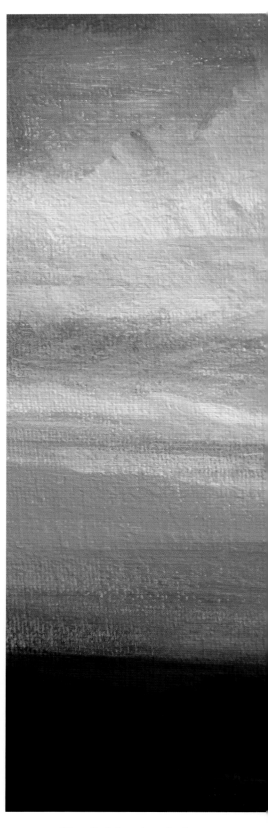

The finished painting
20 x 15cm (8 x 6in)

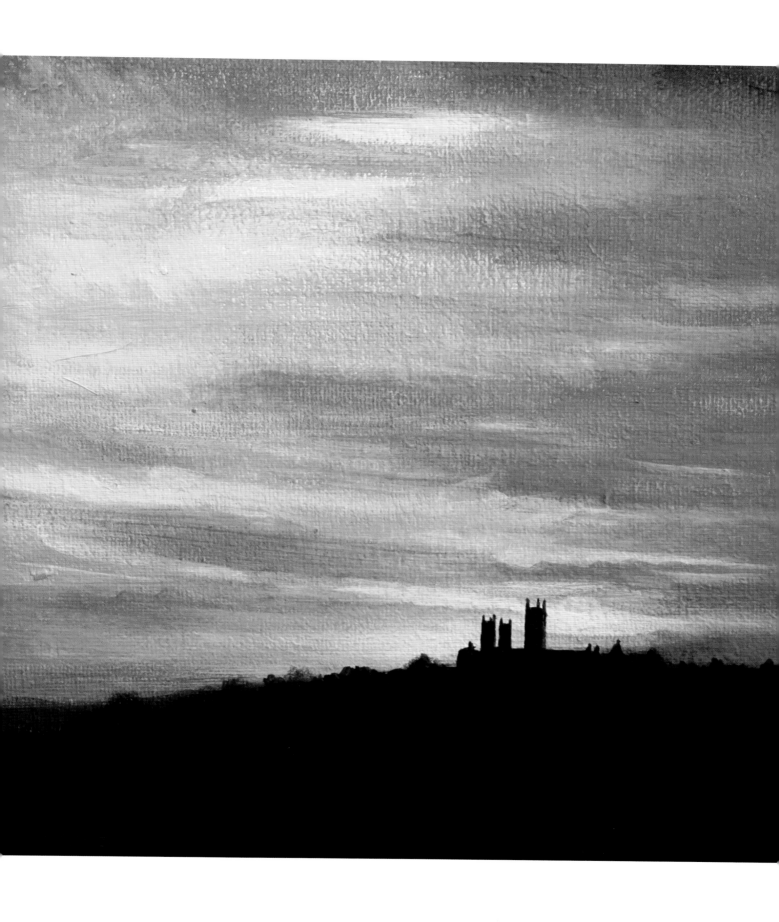

Painting *Sunset from Canwick*

A good sunset can be a great way of learning about mixing and using bright colours in a landscape painting. If using bright colours in the sky such as this, it is important to remember to keep your colour mixes nice and clean to avoid the sky looking muddy. It is usually best to start with the lighter colours first and work your way towards the darks, as shown here. With acrylics, you can always go back and add the brightest highlights at a later stage if it proves necessary.

As with any painting of the sky, the overall look of the painting will be affected when you introduce the darker colours of the foreground. You may need to revisit the sky at a later stage in order to balance out the whole image.

The sky was built up gradually and carefully to achieve the bright glowing colours of the sunset. I was keen to create the strong contrast of the cathedral against the skyline, but did not want to use black as I felt it would overpower the picture and make it look a little dead. Instead I built up the foreground slowly using warm mixes of burnt sienna and Payne's grey to add more visual interest.

1 Apply titanium white using a 25mm (1in) texture brush to begin, then introduce Naples yellow to the lower half of the sky and any other areas you want to appear warm. Strengthen the colour around the sun itself.

2 Create a peach mix by adding a touch of cadmium red to the Naples yellow and white mix, then apply it with horizontal strokes of the brush blade. Enrich the peach mix by adding more cadmium red and some cadmium yellow, but do not oversaturate the colour.

 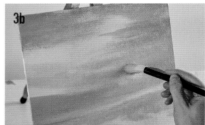

3 Develop the darker areas using a warm grey mixed from Naples yellow and a little Payne's grey. Add ultramarine blue for a darker grey.

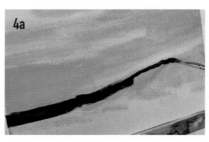 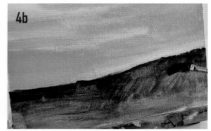

4 Mix burnt umber, ultramarine blue and Payne's grey to make a stronger dark. Use a size 4 filbert brush top block in the silhouette of the ground. Note how much this changes the balance.

5 Add highlights using bold strokes of various combinations of titanium white and cadmium yellow, applying the colour with the size 4 filbert.

An alternative approach

As I mentioned in my journal entry, I was also keen to complete a digital study of the same scene. Using a tablet to create a digital painting can be an ideal way of testing out different colour relationships quickly and easily. I worked on this digital painting alongside my acrylic painting and it allowed me to experiment with the brightness and intensity of the colours that I was going to use in the acrylic version of the sunset.

The digital version thus started life as a very simple sketch to get the colours right, but I felt it was going well and decided to continue working on it until I ended up with a more refined final image shown here.

Sunset from Canwick

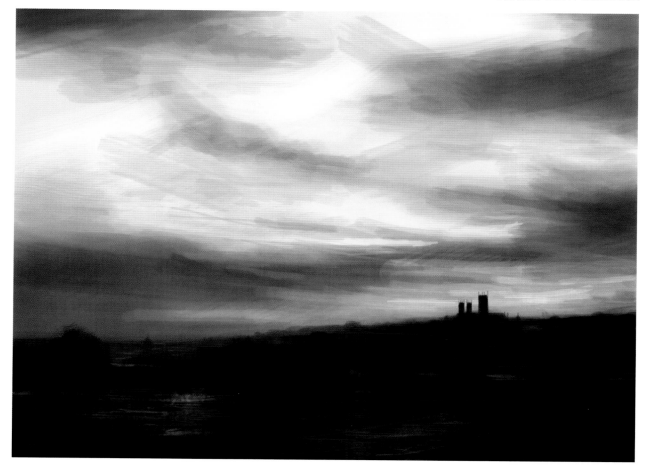

Spring Trees

I have always been fascinated by trees: so solid and permanent, yet always changing. As a novice painter I avoided them like the plague, and those that I did attempt were either lollipops or overgrown shrubs. The trouble, I think, is that we often mistake trees for being very uniform shapes, when in fact they are as varied and interesting as people; changing their foliage with the seasons, just as we change clothes. If any part of your day involves a regular walk past trees you start to notice these things. The texture on the bark, the lean of the branches, the shape of the leaves – all these add up to give a tree a tremendous amount of character.

Having avoided painting trees in the early stages of my career, there came a time when I realised enough was enough. A few years ago I decided to conquer my tree phobia and paint some in-depth close-ups of single trees. The task of painting these trees became much more like that of painting a portrait, as I struggled to convey the complexity of each individual subject.

These exercises taught me to identify and understand the structure of a tree, the growth of the roots and the patterns and shapes formed by the branches. Most art instructional guides will tell you the same, but before you start to worry about the leaves and foliage, you really need to get a grasp of the underlying structure. These days, I have several favourite trees nearby that I like to visit from time to time – much like catching up with old friends.

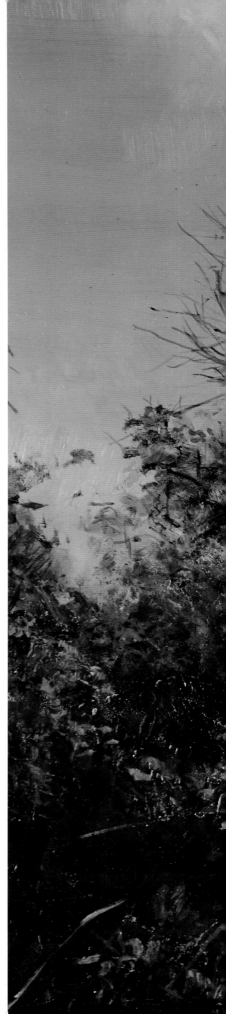

The finished painting
50 x 50cm (19¾ x 19¾in)

April 12th

On this bright spring day, I visited a fairly unassuming tree in some parkland close to my studio. I have not painted this particular tree before but have noticed it on various walks. As with any new subject, my first thought was to make some quick drawings and thumbnail sketches to familiarise myself with the subject and play around with ideas for composition.

I made a fairly lengthy drawing on the spot (pictured below) and then returned to the studio to work out a composition for a possible painting. As this painting is going to focus solely on the one tree and very little else, I decide to opt for a square panel. I don't often use a square composition, but on this occasion it seems fitting. It also lends itself to the shape of this particular tree.

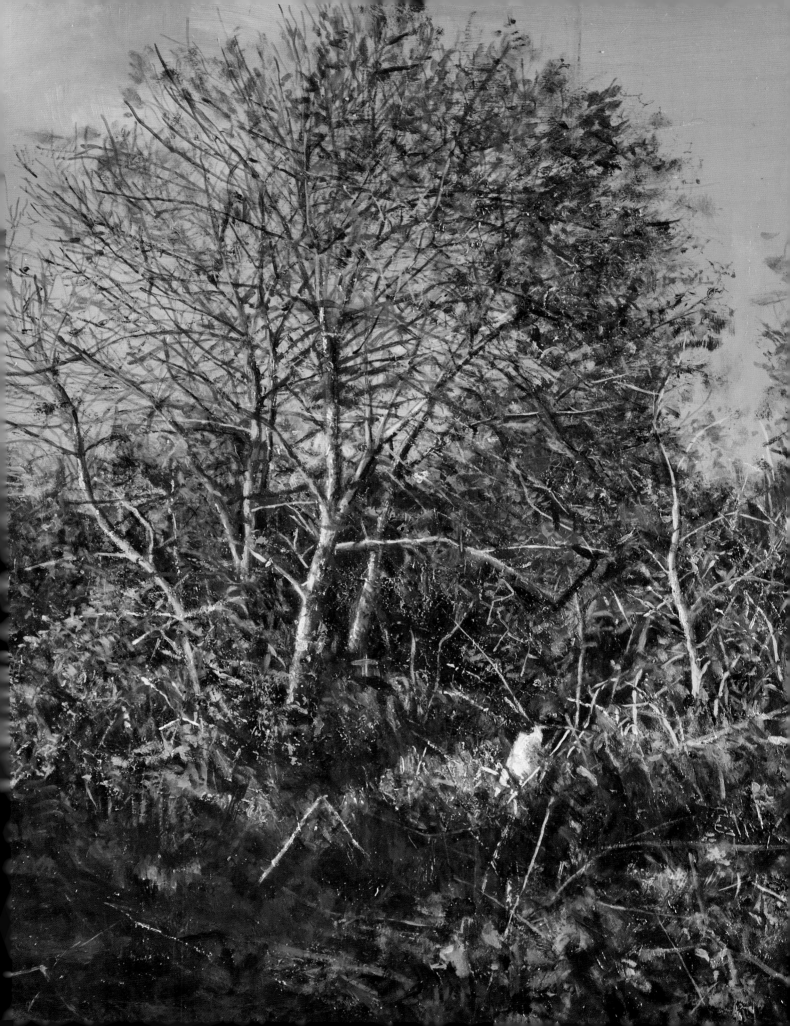

Painting *Spring Trees*

This painting was all about the tree and I really wanted it to fill the entire canvas. I am glad that I opted for the square composition. It is a slightly unusual choice for me, but I think it works here.

With so many branches still visible this early in the year, I built the pattern of the tree up quite slowly aiming to follow the natural contours and flow of the tree. It can be challenging not to get lost at times with this approach, but it helps to give the tree a more three-dimensional look.

Incorporating gloss medium

I wanted the paint to have a richness and almost oil-like look. To achieve this I mixed small amounts of gloss medium with all of my colours. This meant that all the paint I mixed had a richness and higher gloss levels than usual. You can see here the resulting glossy surface area that this creates.

Fine details

I used a range of small brushes to build up the finer branches and twigs. You may need to add extra water or some clear medium to your branch mixes in order to help them flow.

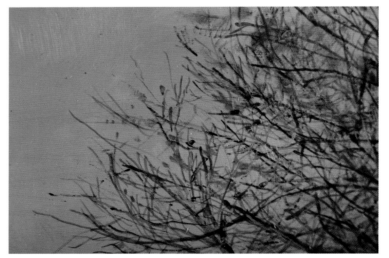

Creating contrast

With so many greens in the bottom half of the picture, I needed some contrast. A mix of Naples yellow and titanium white was used to create the highlight colour used to suggest twigs and branches, and even the rock in the foreground shown here.

An alternative approach

This tree was painted during the change in seasons between late spring and early summer, the time at which trees tend to fill out quickly and display a range of vibrant greens. I chose this tree as a subject as it was almost complete foliage – thus presenting a real challenge. I built the foliage up in a series of thin layers, gradually allowing the paint to get thicker as I progressed.

The Lime Tree

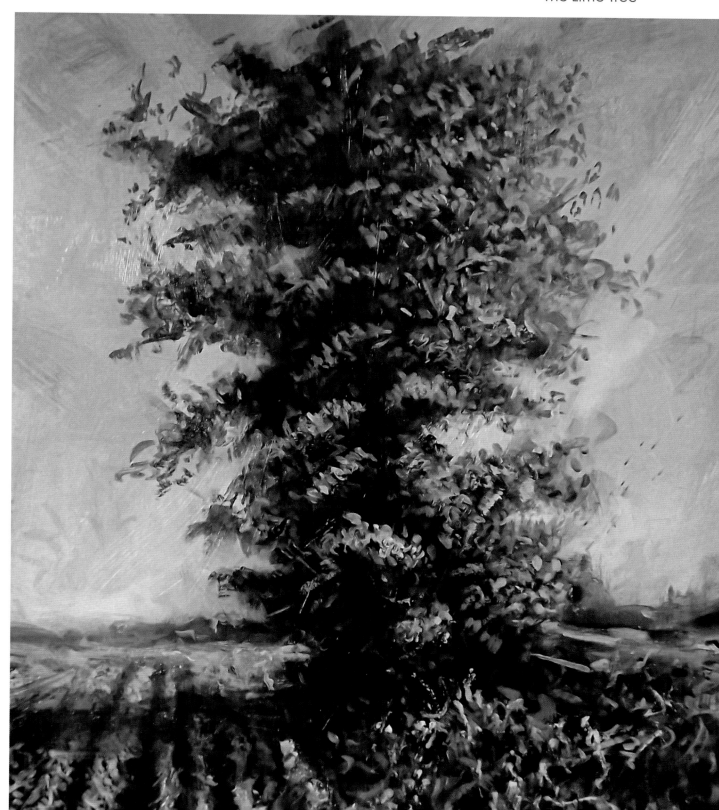

Light

Light is an incredibly
important aspect of landscape
painting. It affects every
single aspect of how the
view appears to us and,
more importantly, it helps
to create a sense of mood or
atmosphere. Therefore, in
order to be able to paint a
successful landscape painting
you need to pay close attention
to that light, how it moves
across the landscape, how it
affects the colours and how it
portrays the time of day.

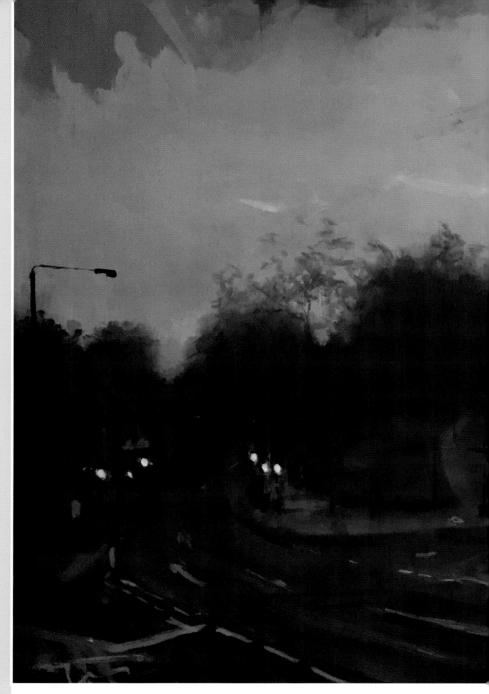

Light and colour

If you are really lucky as a landscape painter, you will come across
moments where the elements seem to collaborate for your benefit.
This painting was an example of one of those moments.

Having entered a competition to paint the delightful spa town of
Buxton in the UK, I was keen that I wanted my painting to stand out
from the crowd. I decided to visit Buxton and get up incredibly early
in order to see the town before it had woken up. I rose just after
five in the morning and set out with my camera, a sketchbook and
a mug of coffee. It was a truly magical spring morning. As the sun
began to rise, the sky was lit up with array of beautiful soft, pink
clouds which contrasted perfectly with the dark architecture of
the buildings below. The colours were striking and unusual in the
early morning light, and I knew instantly that this would make for a
fantastic painting.

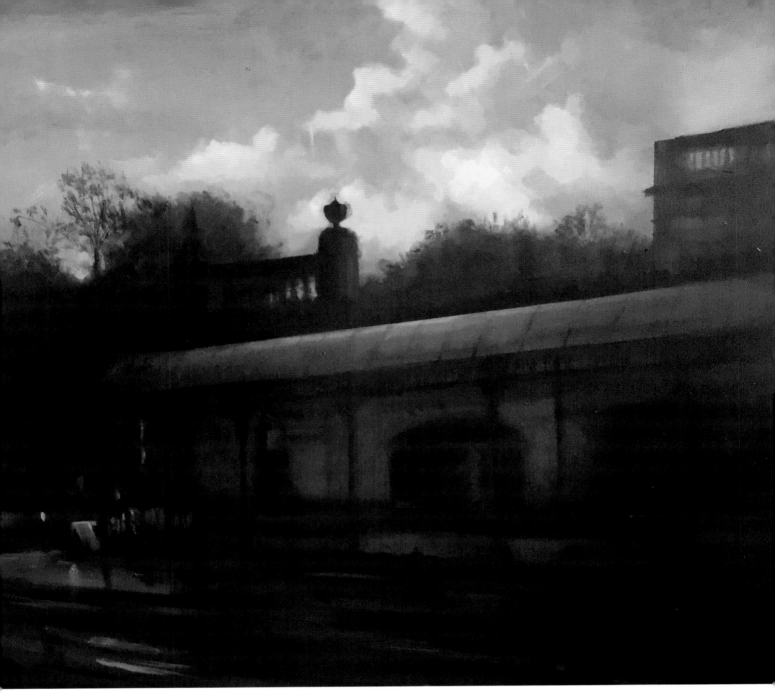

Buxton Dawn

100 x 60cm (39¼ x 23½in)

Back in the studio I opted for an almost panoramic composition, choosing a long painting board that had been gathering dust in the studio for some time. I primed the board using a very dark grey, to help keep the colours in a fairly low key and to create that sense of the darkness before the dawn. I was also conscious that in order to make the soft, pink clouds really sing out from the image that I would need to tone down all the other colours accordingly.

The green lights on the left-hand side of the painting are a set of traffic lights. I wanted to include these vibrant glowing artificial lights to interrupt the dark shapes and colours on the left-hand side of the picture and also to balance with the pink clouds in the top right.

This picture is a great example of how getting up particularly early and working in the swiftly-changing light of the morning can provide great rewards and give even a familiar area an entirely different atmosphere. Clear, fresh spring days are ideal for this sort of trip.

Changing light

Light can prove challenging to the landscape painter as it is constantly moving and changing. This becomes particularly evident when working *en plein air*. Do not take it for granted that the light conditions will remain the same for the duration of your painting. I have known the light to change incredibly quickly out in the landscape, particularly during the early days of spring when you first venture outside to paint.

In order to understand light I would really recommend visiting landscapes at lots of different times of day, this way you can get a real sense of how the light affects the landscape and also make notes and studies of what light looks like during different periods.

Time of day

Busy schedules often mean it is easier for us to paint in the middle of the day, but only painting during this time can mean we miss some of the most spectacular light. As a rule, the most extreme atmospheric conditions can occur during the sunrise and sunset. This does not mean you need to paint sunrises and sunsets specifically, but you should definitely be aware of the different times of day if you are going to be a landscape painter.

Dawn can be a magical time of day, the sense that the world is just waking up and the peace and tranquillity provide a fantastic environment in which to work. I have always found it particularly exciting to be up before the sun has risen and to watch the incredible changes that take place in the sky as this happens.

In the other extreme we have sunsets. Obviously, we all know that the setting sun can provide our dazzling array of effects and a sunset can be a truly stunning spectacle to observe. The problem for the landscape painter is trying to create that same dazzling effect on canvas. This can be incredibly difficult to achieve and, in my opinion, some sunset paintings can look a little corny. The intensity and vibrancy of the colours can make it quite difficult to translate the sunset into paint without it seeming garish or over the top. My suggestion would be to look not just at the setting sun as an event but also to pay attention to the light from the early evening onwards. Sometimes it is the periods before and after the actual setting of the sun that can be the most interesting.

Ultimately, the time of day that you choose to work will come down to personal preference and your schedule, but if you find you are looking for an injection of atmosphere into your work then I would definitely suggest getting out at different times of the day and experience the effects of the light.

April 30th

A painting trip to Pignano in Italy has given me the opportunity to use the hours around dawn and dusk for some concentrated painting. The clear blue skies in the daytime are great for the sun-starved holidaymaker, but the light as the sun rises and sets gives the most interesting effects on the landscape for the artist. Each end of the day brings with it different challenges and opportunities.

I have been amazed each and every day just how different the light appears and how the time of day affected the atmosphere of the scene from our doorway. I decided to make a painting at dawn and a painting following the sunset (shown opposite).

Of course, it is not just the light and practicalities that appeal. It is the ritual and act of welcoming the new day or seeing it out that are truly precious.

Opposite (top):

Pignano at Dawn

Painted at four in the morning as the first shafts of light appeared over the horizon, this painting shows the light changing in the sky as the sun rises. It was created using an incredibly limited palette of blues, greys and blacks.

Opposite (bottom):

Pignano by Night

This painting, a companion to *Pignano at Dawn*, shows the landscape immediately after the sun had set. I avoided the really intense colours of the actual sunset, choosing instead to show how a warm orange glow fills the sky, remaining into the early night. The foreground is predominantly dark so I was keen to show some contrasting distant lights in the far-off mountains.

Stapleford Wood

Working in woodland areas as the leaves appear on the trees can be a challenge. Space can be limited or awkward, making transporting and unloading kit problematic. The second issue is often the light – working under a canopy of new leaves moving in the spring breeze means that the sunlight is often dappled and dances around on your canvas as you work. This can be distracting and means that your surface can swing between being shaded and illuminated throughout the course of the painting. My advice is to find somewhere comfortable to work that offers either constant shade or sunlight.

May 11th

It's a busy time of year. The weather is good and I'm finding time for lots of *plein air* painting. I have been working mostly on some expansive landscape views, large vistas with big skies and low horizon lines. These paintings are going well but I am in need of a change of scenery and subject matter – from time to time, I find jumping to something radically different for a break refreshing and revitalising.

Today the antidote to these big landscapes is to get lost in the woods. I say this half jokingly – as I do in fact nearly get lost. I may need to start leaving a trail of crumbs when I go out painting.

The woods in question are about an hour's drive from my house. I am drawn to working in this woodland for the chaos of the composition. I find it intriguing to zoom right into my subject matter, filling the canvas with foliage. This almost abstract arrangement is enormously satisfying to me. The wall of branches, twigs and leaves with little holes punched in allowing the light to shine through from behind. The danger, I suppose, is getting lost in the chaos. It's important to keep an idea of the basic construction of the picture in mind at all times and to not be overwhelmed by the amount of foliage. A drawing or sketch can be a good way of doing this.

The finished painting
80 x 60cm (31½ x 23½in)

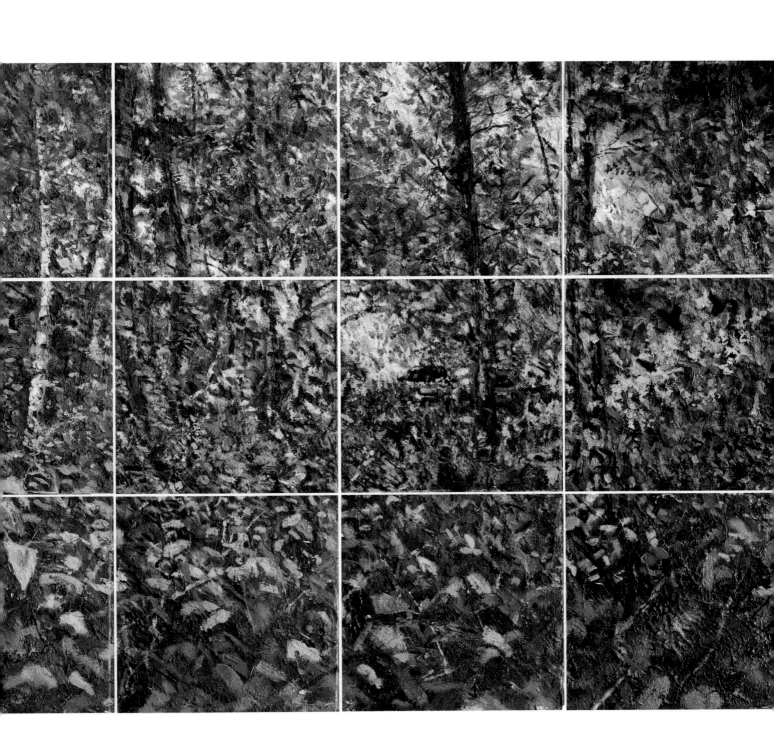

Painting *Stapleford Wood*

My aim was to show the effect of light coming through the trees and I referred closely to my smaller acrylic sketches done on location, in order to achieve this. It can be quite a challenge with a painting like this to find enough separate mixes of green to read as the various different types of foliage. To get around this I premixed several different shades of green before starting the final painting, ensuring that I had a wide variety to cover all bases.

It is hard to miss that the painting is divided into a series of square boxes. This grid effect is formed of a number of separate painting panels. Unsure of how large I wanted the piece, I worked on the small panels which allowed me to expand the image as I was working on it. It started simply as the nine central panels (see right), but I decided that the picture would benefit from a more panoramic format, and so I added a further three panels to each side. I quite enjoy how the use of separate panels divides the picture up and adds to the semi-abstract quality of the painting.

The original nine-panel composition.

Warm ochre glaze

I often start a painting by blocking in the general composition using burnt umber paint, but in this case I felt that it would be too dark for the scene in question. I decided instead to use yellow ochre to create warmth in the painting and to give the impression of light flooding in from behind the trees. This quick blocking in was completed on location, working quickly to establish the outlines of the trees and the areas of light and dark.

Compositional drawing

This ink drawing allowed me to flesh out some compositional ideas and to get a better sense of the structure of the overall painting. The marks were laid down quickly using a fine H pencil and then worked into using ink marker pens.

Foliage

This close-up of a foreground panel shows how layering different greens on top of one another builds to create the impression of foliage. It can be a slow process to build a painting up in this way, but it really does help to create a sense of denseness. The more time you can spend building this the better.

Focal point

The outline of two cars that could be seen in the distance peep through the trees in the centre of the image. Because the picture consisted of mostly different greens I felt it was important to introduce a couple of bright colours – blue and red – to catch the viewer's eye.

Additional colours for the spring palette

Spring is an ideal time to introduce a few new colours to your palette. It can be a very exciting time of year with lots of rapid changes to the surroundings. It is therefore worth looking at introducing a few new colours, especially if you are going to be working outdoors. The fresh and clean colours of spring lend themselves to some great new brighter colours for your palette.

Sap green

Sap green appears to be quite cool and dark but the undertone is warm and vibrant. Historically, this paint was made from the unripe berries of the buckthorn shrub, which produce a yellow juice or sap. This yellowish pigment was used to dye cloth and to make the paint called sap green.

There are a handful of varieties of the shrub, and so the exact hue can vary from manufacturer to manufacturer. For preference, I use Daler-Rowney's Sap Green 375, which is useful as the basis for brighter green mixes than those possible with the forest green on my basic palette.

Sap green

Naples yellow light

One of the first pigments produced synthetically, it is sometimes known as 'antimony yellow'. Extensively used by the Old Masters, genuine Naples yellow is toxic owing to the lead it contained, so the modern versions are instead made with a mix of less toxic pigments. As with sap green, the exact hue of Naples yellow varies considerably from one manufacturer to another – ranging from an earthy, reddish-yellow pigment to a bright, light yellow.

I tend to use Winsor & Newton's Naples yellow light for the opacity and permanence of its attractive hue.

Naples yellow light

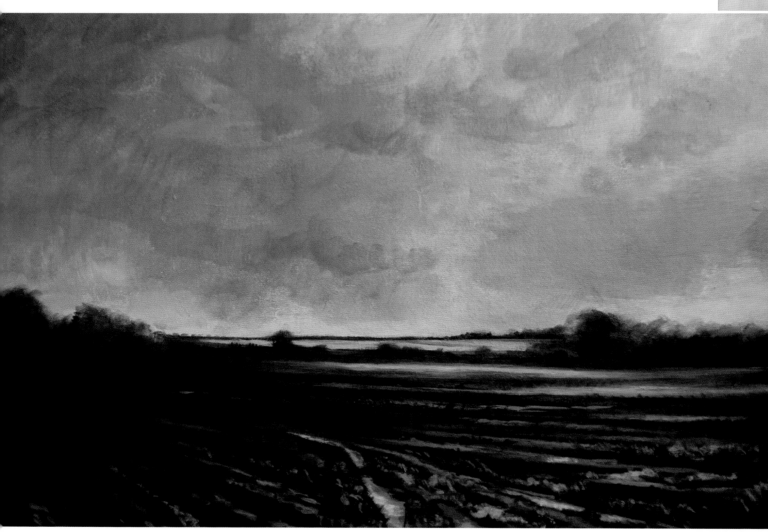

The finished painting

Edlington Fields

Sometimes seemingly run-of-the-mill subject matters make the most interesting paintings – it can't all be dramatic mountains and blazing sunsets, can it? Sometimes it just takes something to open your eyes to a scene or viewpoint and then you can never forget it. I had such an epiphany during a walk on some local farmland.

On any other day of the year, this farmland – little more than a series of muddy fields – would certainly not be the sort of place that I would come for inspiration. The change in thinking came when walking through the land one spring day, during the early evening. I have mentioned before that the light can do strange things at this time of day. On this particular day the light was ethereal and soft, transforming the otherwise ordinary farmland view into something quite beautiful. The light lasted perhaps fifteen minutes at most, but it was enough to plant the seed for the following painting.

You will need

62 x 40cm (24½ x 15¾) piece of plywood

White matt emulsion and small roller

Paints: basic palette (see pages 16–17) plus palette grey (see page 17)

Brushes: size 8 filbert, 25mm (1in) flat, size 4 filbert

Spray bottle

✓ Key marks

- **Prime the surface** with white matt emulsion using the small roller and allow to dry.

- **Thin burnt umber** with water, then use loose, scrubby marks to loosely block in the foreground, leaving a lighter area on the right-hand side.

- **Mix three greys:** one 'pure' palette grey, one tinged blue with the addition of ultramarine blue and one tinted with ultramarine blue and titanium white.

- **Use pure titanium** white to block in the lightest areas in the sky.

Early accuracy

Spending time to consider the tones means that you can start the painting without having to continually check your reference.

Chromatic greys

These three grey mixes – palette grey, cool grey and light grey – will provide nuanced tones to alter your colours and keep a coherent feel to the whole painting. Mix up plenty of each and keep them isolated on your palette.

The painting at the end of this stage.

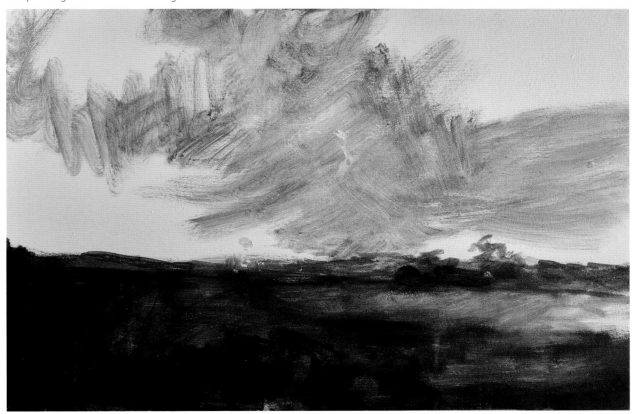

𝟤 The sky and distance

- **Work over the** clouds using the 25mm (1in) flat brush and the palette grey mixed with a little titanium white. Use circular scrubbing marks to add in darker areas of the cool grey mix, scumbling the paint over the surface. Vary the palette grey mixes with more ultramarine blue and the addition of a little Payne's grey.

- **Shape the clouds** with lighter-toned touches, aiming to suggest them coming forward in the painting by creating contrast in tone.

- **Define the edges** of the clouds with light mixes of grey.

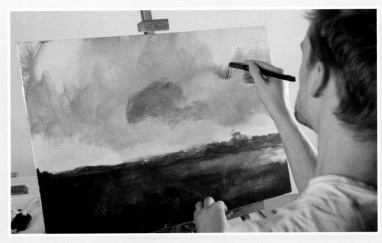

First marks in the sky
Leave a little of the pure titanium white showing when working over the clouds with the palette grey mixes. If some of the burnt umber shows through the scumbling, don't worry – build it in.

The painting at the end of this stage.

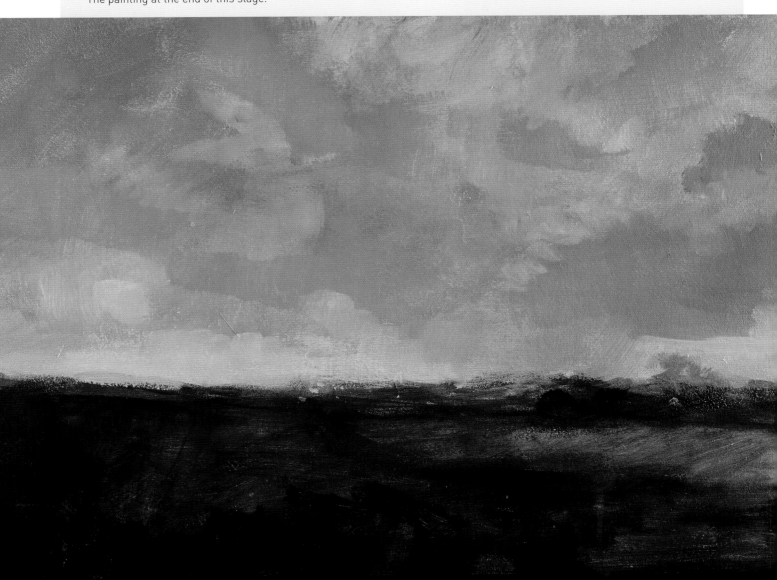

Darker greys

Despite being painted on top of the white base layer, these dark grey areas appear further back in the painting because they are darker in tone. This is due to the effects of aerial perspective (see page 120).

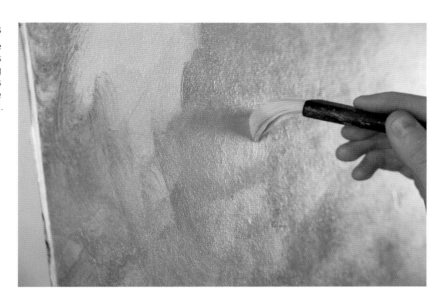

Shaping

The subtle changes in tone require you to work relatively boldly to suggest the shapes of the clouds without creating unrealistic hard edges. Use scumbling to soften your working.

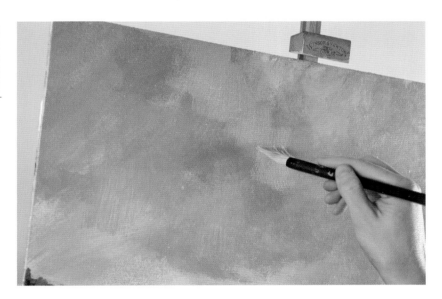

Highlights

Adding titanium white to any of the mixes (but not yet using pure titanium white) will create a natural variety of light tones.

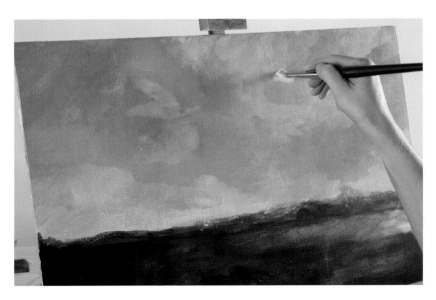

3 The land and foreground

- **Mix forest green** with the cool grey mix (palette grey and ultramarine blue). Use the size 8 round to establish the horizon line with smooth, controlled horizontal strokes.

- **Change to the** size 4 filbert. Add Payne's grey and more forest green to the mix and use short, controlled stabbing strokes to paint in the larger trees along the horizon line and in the midground. Work over the foreground with darker versions of the mix, particularly in the corners.

- **Wet a clean** size 4 filbert and scrub the wet paint around the furrows to lift out the paint, revealing hints of the underlying matt emulsion. Use the filbert to add the light grey mix on the foreground, beginning to hint at texture in the fields and suggesting ploughlines and tyre tracks. Add burnt umber for shading and variety.

- **The standing water** in the furrows should be added at this point using the light grey mix and the size 4 filbert.

- **Mix acid green** from cadmium yellow, titanium white and a hint of ultramarine blue and paint in the distant field just below the horizon. As you advance, dilute the mix to reduce its coverage and apply it using light horizontal strokes.

- **On the lower** right, use more considered dabbing marks.

- **Add darker hues** around the light green areas to further enhance the contrast in tone between the soil and acid-green spring growth. Add forest green to deepen the colour initially, then add Payne's grey as well.

- **Stipple touches of** the dark green mix (forest green and Payne's grey) to break up larger areas. As before, concentrate on the corners and foreground.

- **Develop the highlights** across the vegetation using the light greens on your palette and the light palette grey.

Mixing

This picture of my palette shows how the bulk of each mix is kept separate, but flows into other mixes nearby. This is part of how I ensure the overall palette of the painting remains coherent.

The painting at the end of this stage.

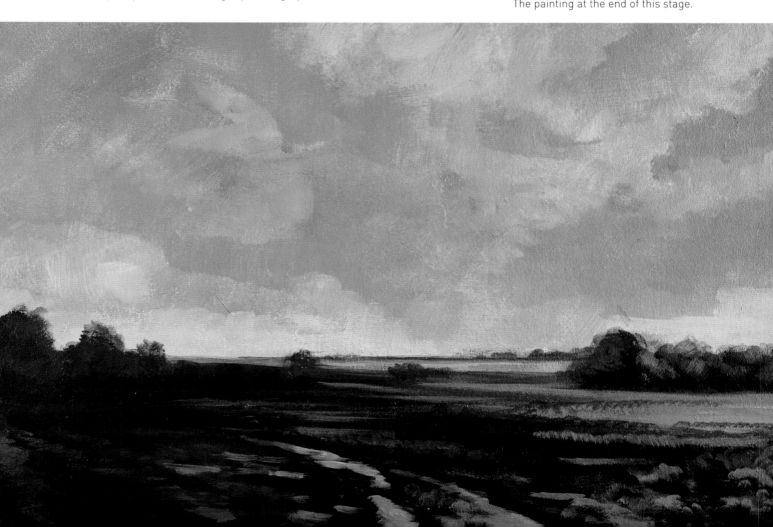

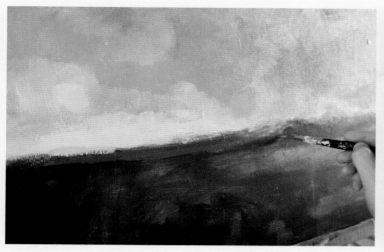

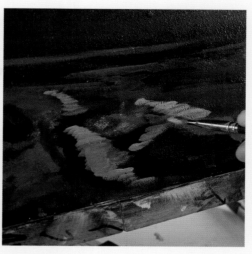

Horizon

The mix used for the horizon combines the cool grey of the sky with forest green, which is later used in the foreground. This combination helps to give a cohesive feel to the painting as a whole.

Standing water

Use the corner of the size 4 filbert to add the marks on the water. Keep the strokes short and horizontal to suggest flat, still water.

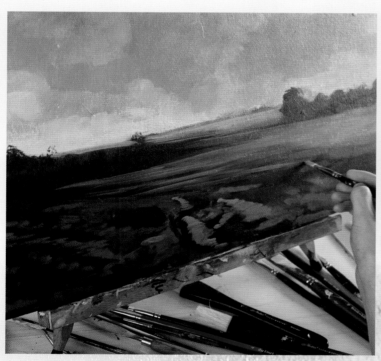

Foreground texture

Dabbing marks quickly build up to suggest a group of individual plants in the foreground.

Sunshine

The acid green overlays the brown mud, bringing brightness and energy to the landscape without appearing over-exaggerated. The variety of marks and consistency of the paint helps to create a glowing effect of direct spring light.

⁴ Finishing

- **Mix titanium white** with palette grey and use the blade of the size 4 filbert to add horizontal highlights to the furrows and standing water.

- **Mix palette grey** with yellow ochre for earthy highlights, and add texture and interest to the foreground furrows. Use the tip of the brush to draw short, trailing strokes.

- **Add cadmium yellow** and titanium white to the earthy highlight mix and use this new mix to add sunlit highlights on the trees.

The painting at the end of this stage.

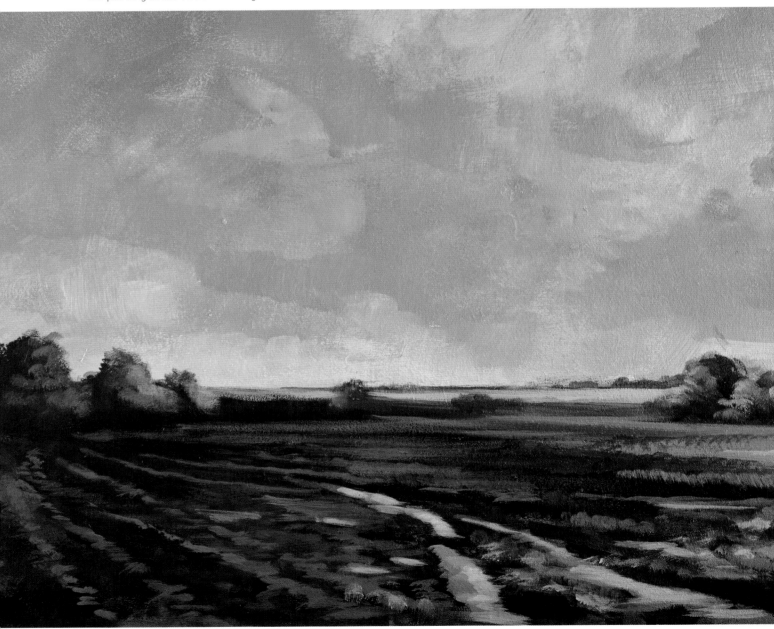

Water

Water is highly reflective, so when adding highlights in the puddles of standing water, aim to match the tint in the clouds fairly closely. If you have some of the mix left over from painting the sky remaining on the palette, this part is particularly easy!

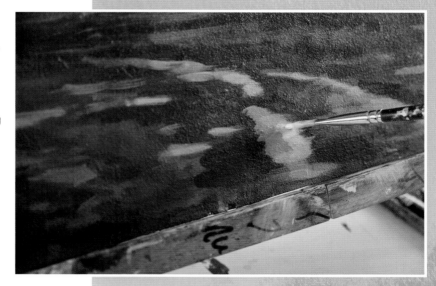

Broken earth

The foreground, being closer to the viewer, should hold more detail than the background, where the visual field softens.

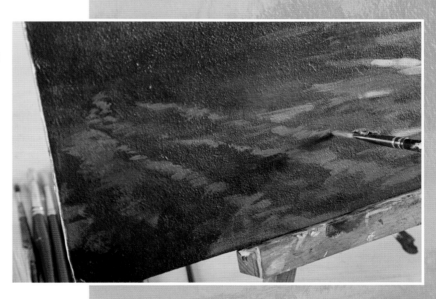

Highlights

When adding highlights, pay attention to the light source. Whatever part you are highlighting, the brightest highlights should be closest to the light source and facing it.

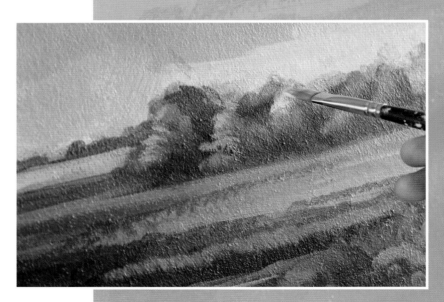

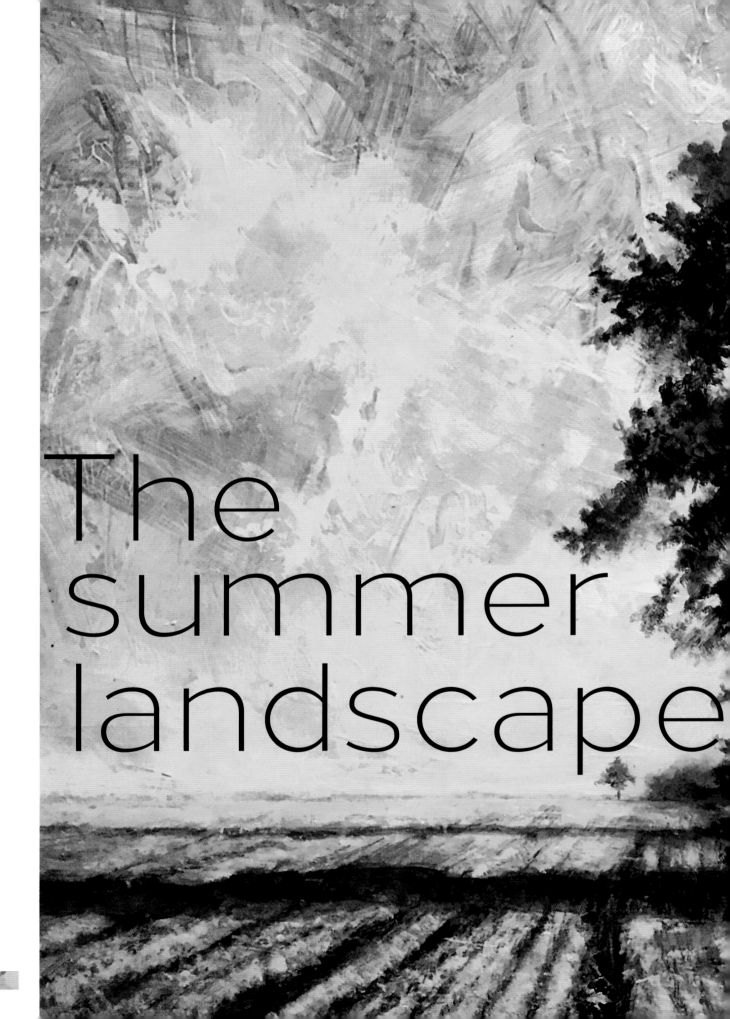

The summer landscape

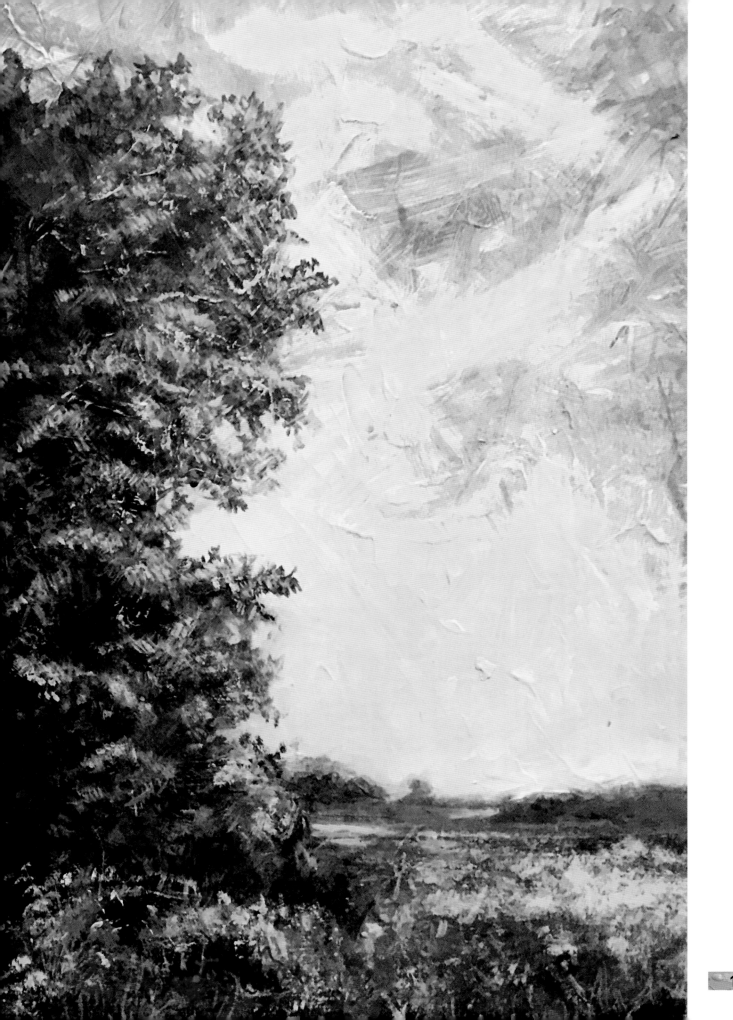

Life in the landscape

I enjoy living in the UK, where each season has a distinct character, as this makes for a dazzlingly varied array of source material. The start of summer is my busiest period, but it is also at this time of year that I feel truly glad to be working in the landscape. It is a very exciting time to be working. Having had the spring to brush up and plan my work I am now in a position to spend the majority of my time travelling and painting out of doors.

If you really do not fancy painting outside in anything but the perfect conditions then the summer is the time of year where you are most likely to be rewarded with some good weather and the chance to finally get out of the house and embrace nature.

Summer painting

In painting terms, there are many advantages to working outside at this time of year. An immediate advantage is the improvement in the weather. Warmer temperatures make standing outside for longer much more of a pleasure, and a successful day of painting on a good summer's day is particularly rewarding – even if you have to factor in the added weight of suncream! Warmer weather allows us to move on from the sketches and rapid studies made during the spring to make larger and more complex works out of doors. The better temperatures make this a much more forgiving task, and when you are not worried about getting cold you can really focus on the task in hand.

As mentioned earlier, viewing your subject matter at different times of the day gives you experience of different atmospheric effects, which you might like to include in your work. In the summer, the sun rises early and sets later. Longer days give you many more hours of working light and time in which to complete paintings, whether in the studio or outside. It becomes possible to set up your easel and complete several different paintings over the course of the day, assigning each one its own time of day and lighting conditions.

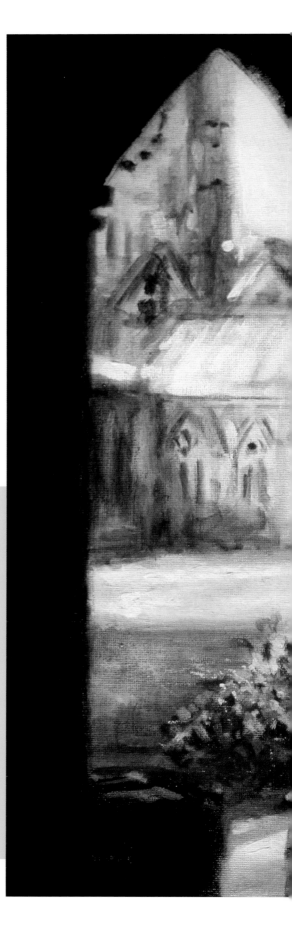

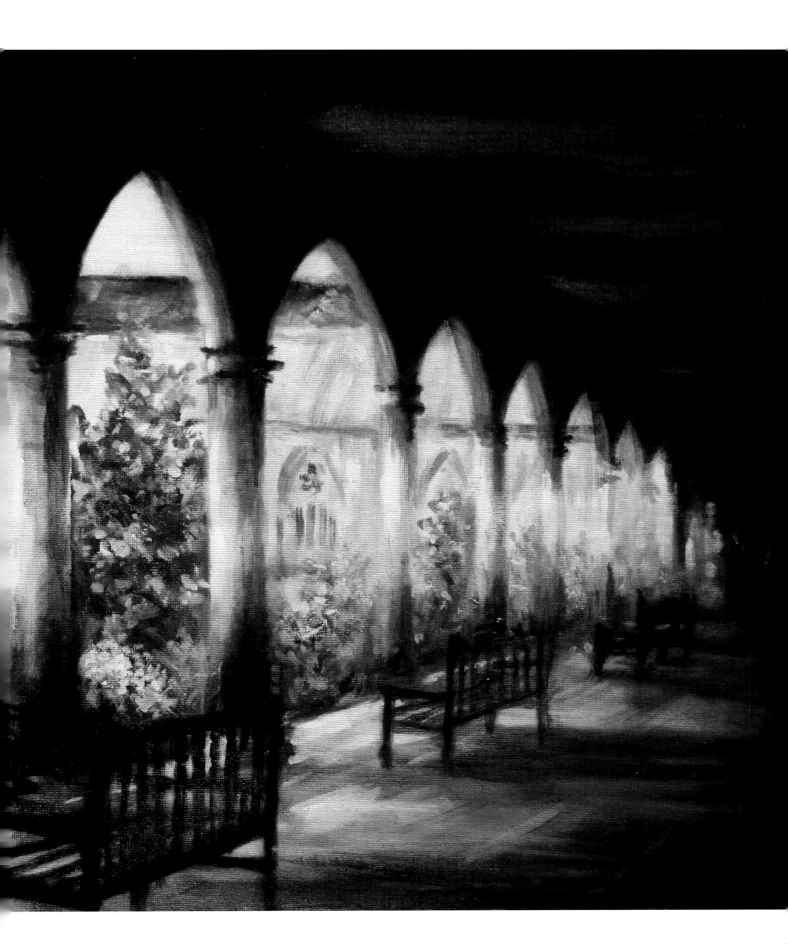

Travel

For many of us summer brings the opportunity for travel. Whether travelling domestically or abroad, going to new places is an incredible way of gaining inspiration and finding new painting sites. When travelling during the summer I keep my camera, tablet and a selection of paintbrushes in the car at all times, just in case I come across a view or landscape that I think might make for a good subject.

If you are jetting off on holiday that too can be a fantastic way of gaining new inspiration and taking ideas home for further paintings. Even the closest foreign destinations can appear exotic when compared with our everyday surroundings, and it is wonderful to get to know a place through drawing and painting, especially if you have never been there before.

When travelling abroad I usually try and make at least a few quick drawings as a way of introducing myself to the place. They also serve as a powerful record of the memories of that place. On a practical note, I have never encountered any problems taking painting materials on an aeroplane, but I recommend making sure they are well labelled and packed according to the individual airline's safety instructions (usually within a suitcase in the hold). Acrylics are certainly a safe travelling option as they are non-toxic and you only need a source of water to get going.

Sketching during the summer months ensures I have raw material for later in the year.

Looking ahead

In addition to lots of painting outdoors, another reason the summer months are so busy for me is that I also start to prepare for the winter, in a rather squirrel-like fashion. Gathering lots of source material during the better weather helps to ensure that I can sustain my painting practice through the colder months, where I cannot get outside as much as I would like.

During the summer months, I take a great deal of photographs, fill sketchbooks and make small reference paintings that can all be reused and feed into my work at a later date. You can never really have too much source material, and it is incredible how looking back you sometimes come across a photograph or drawing from some time ago that suddenly gives you the inspiration for a new painting.

Enjoy the experience

Being in the landscape does not necessarily mean that you need to be actively working. The act of painting and drawing can create an unwarranted sense of pressure. Remember that creating a painting or sketch is not necessary to savour the experiences of a landscape.

If you do not have any materials with you, don't panic. Instead, simply walk through the landscape. Enjoy it and take it in. You may not realise it at the time, but this is a fantastic way to soak up information and create useful memories. If you have an interest in nature and the landscape you will find opportunities to be in amongst it and to experience it first-hand. It is through these experiences that one's familiarity with and ability to describe the landscape through art becomes stronger and more finely attuned.

City painting

Some might assume that big cities don't provide much in the way of inspiration to the landscape painter, but this is not always the case. When living in London, I would often find inspiration strolling through the city's many parks, rarely embarking on many full paintings but instead making sketches and small studies that worked well. In addition to this, I had incredible access to many galleries, allowing me to see many inspirational paintings by my heroes first hand.

Where to paint in the city

If you do live in a city and your concrete surroundings become overbearing, there are ways to overcome this. Most cities have large communal parks and green areas that can provide relief; and of course you can tackle a cityscape in its own right.

My real landscape painting breakthrough in London came when I found two incredible locations that allowed me to capture the vistas I was after. The first was the view from the Royal Observatory at Greenwich and the second the view from Primrose Hill in North London. Greenwich is a well known vantage point and Turner created a spectacular landscape painting of the view, looking down towards the Old Royal Naval College with the sweep of the river curling towards the city in the distance. I have completed a couple of paintings from this viewpoint.

The second location that worked for me was the view of London from Primrose Hill. Primrose Hill in North London extends from Regent's Park and offers an incredible view of the city, the various landmarks laid out before you along the horizon line. I like this view for two reasons: firstly, it's a green landscape with an interesting topography and foliage, and secondly it includes the incredible panoramic view of London and its unmistakable landmarks. This was the perfect opportunity to merge my love of landscape painting with living in a busy urban environment.

Gallery inspiration

Most cities will have at least one art gallery that you can investigate for inspiration. I have always found looking at other people's artwork as helpful as the act of painting when developing ideas. Looking at art is nourishing. As well helping to generate your own ideas, to some extent it allows you to see how the painting has been created.

We become so used to seeing images of paintings online and in books, but this flattens them and makes them look incredibly detailed – almost fussy. Looking at a reproduction can give us some basic information about a painting, but you lose any sense of the artwork's tactile qualities and forget that the image has actually been created out of raw, physical materials.

I can remember being incredibly shocked the first time I looked at some of Constable's paintings in the flesh. I had seen lots of the artist's work in books and online and had assumed that they had all been rendered in incredible detail and smooth brushstrokes. The reality was quite different – the surfaces were thick and heavily churned up, areas that looked incredibly detailed in photographs were simply deft swipes of the brush or palette knife. I could not believe my eyes. The painting had such an incredible sense of the artist's hand and movements. It was breathtaking, and I felt inspired.

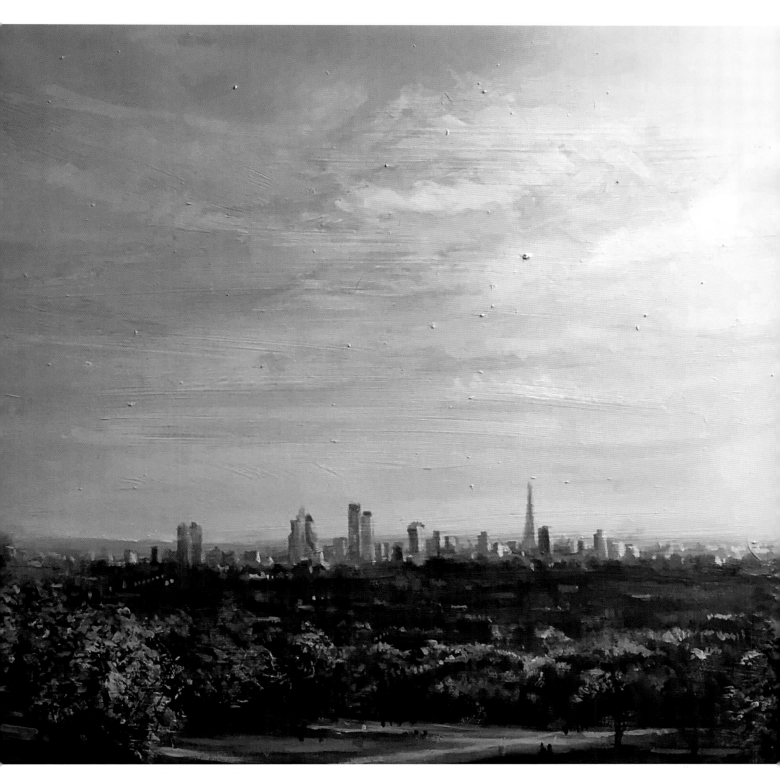

London from Alexandra Palace

72 x 45cm (28¼ x 17¾in)

London from Primrose Hill

This painting of London from Primrose Hill is quite a complex and challenging subject matter to take on. It was initially difficult to find the right balance between atmosphere and detail and I was concerned about portraying such famous and recognisable landmarks such as those on the skyline of London, for fear they would become too dominant.

This was because I was keen to create a cityscape that still was primarily a natural-looking landscape painting, with the focus firmly upon the sky and effects of the light, rather than a portrait of the city. Finding the balance was the challenge for this urban landscape.

The finished painting
130 x 90cm (51 x 35½in)

June 2nd

Today I'm in the studio, working on blocking in a new painting of Primrose Hill. This will begin life as a fairly simple landscape painting as I deal with the sky and major areas of the land first. The temptation is to concentrate on the buildings along the horizon line, but I am determined not to fall into the trap of overemphasising them or painting them in too much detail. I've done this before and the buildings ended up sticking out like a sore thumb.

I force myself to remember that they are in the distance and try to treat them in the same way as any other part of the landscape, by reducing them down to their basic shapes. The one thing I would say is that with such well-known landmarks it is important to pay attention to their scale and shape. A building such as St. Paul's Cathedral or The Shard will immediately show up if shown at the wrong scale in relation to the buildings around them.

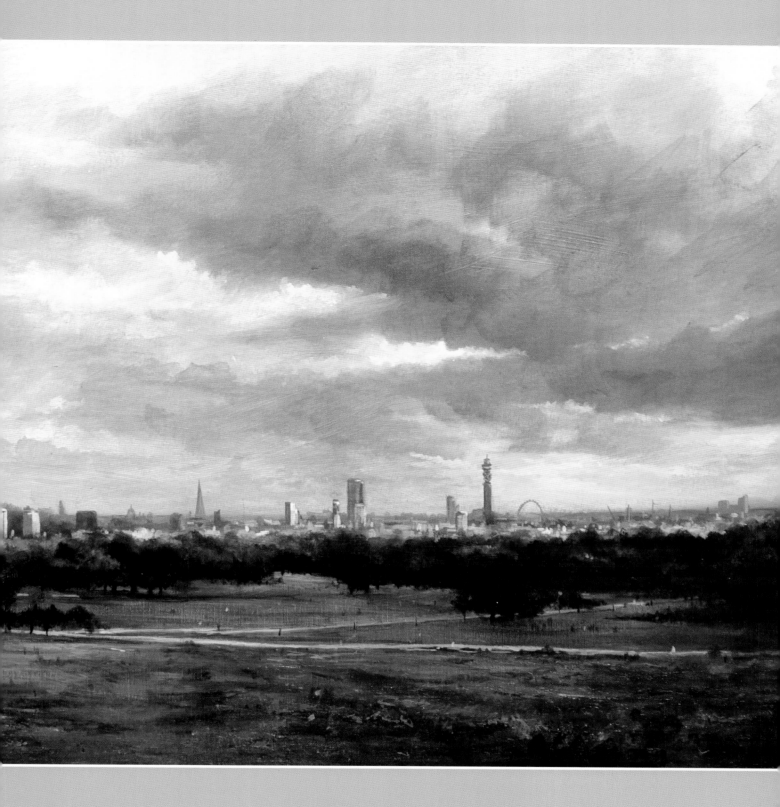

Painting *London from Primrose Hill*

The challenge for this cityscape was striking the right balance between atmosphere and fine detail. Initially I was worried about portraying such famous and recognisable landmarks such as those on the skyline of London, as I wanted a natural-looking landscape painting where I could still focus upon the sky and effects of the light, without the buildings becoming overdominant.

For this reason, the sky was the first area of the painting to be blocked in, with the warm light around the horizon line contrasting with the darker greys towards the top of the sky. It was only once the sky was fully painted in and dry that I could begin the difficult task of blocking in the buildings on the horizon line.

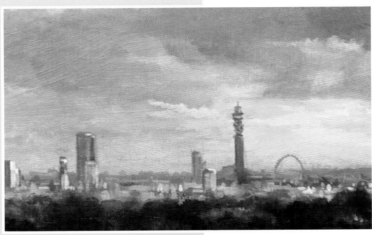

Skyline

Creating an accurate rendition of the London skyline is a task that requires patience. I referred to both sketches and photographs of the scene in order to build up the accurate representation. I very lightly marked in the outlines and positions of the different buildings using a H pencil before starting to carefully paint them using a size 0 round brush. I mixed clear medium with the paint for the buildings in order to give me a good flow of paint that helped me to smoothly mark in the outlines of the various buildings.

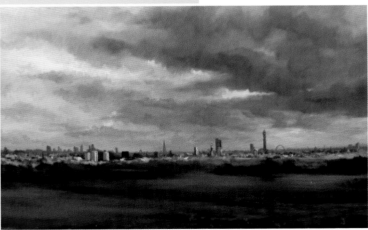

Working order

With the distant buildings in place, the remainder of the foreground was relatively simple. Having completed the horizon line I simply blocked in the bottom half of the painting using a solid mix of green. This mix was created with a combination of sap green mixed with a little burnt umber.

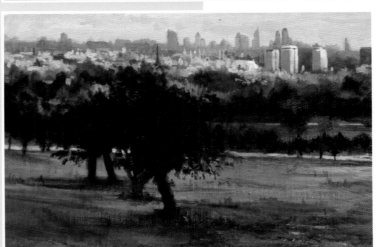

Foreground details

Despite the detailed and busy horizon line, the composition still needed some elements in the foreground to anchor the painting and to give it a sense of weight. The larger trees in the bottom left (pictured) help to do this by providing contrast and also a sense of scale to the image.

An alternative approach

This cityscape shows the view from across London, looking back in the opposite direction. Travelling to Greenwich I climbed the steep hill that leads up to the Royal Observatory. From here I had incredible views across London including the sweep of the river heading west. The outline of Canary Wharf and old Greenwich Naval barracks were visible in the foreground.

For a change in light and atmosphere I made several visits to the location, but ultimately opted to make a painting based on the hour around sunset when I felt the colours were particularly beautiful and that the silhouettes of the London skyline were very powerful.

London from Greenwich Observatory

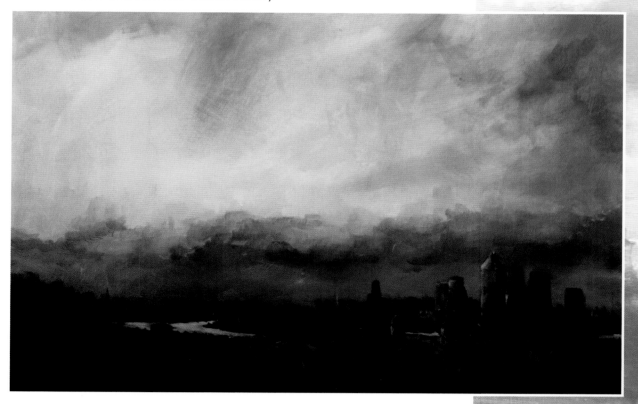

Summer and colour

The extended working time offered by the summer months means that I often try and push myself in terms of the content of my paintings. The longer working hours and ability to work outside in more comfort offers a more prolonged period in which to paint and study different atmospheric effects.

Summer techniques

During a summer trip to Tuscany in Italy, I was struck by how different the same landscape could look on consecutive days. The paintings shown here were produced over three consecutive days from the same vantage point. Towards the end of each day, just around sunset, I would make the same walk into the landscape and set up to paint in the same spot: a rock that was high up and looked out into the distance over the Tuscan landscape. Each day had very different light effects and therefore a very different colour scheme.

I wanted to work quickly and freely with the paint in order to capture the fleeting effects following the sunset, and so all three paintings were created with heavily diluted acrylic paints, using the paint more like watercolour. This approach can produce surprisingly strong results.

In warmer temperatures, the drying time of acrylics can rapidly increase. Rather than struggle to use the paint in the same way as during cooler spring days, it is best to embrace this fact and use your paints more heavily diluted. You can always reinforce the colour by working over them once they have dried, if necessary, but you may find that you like the novel results this approach gives.

If you are planning to dilute your paint heavily, I recommend using a branded acrylic paper – the slightly smoother surface will make it much easier to work on than watercolour paper, which can be too absorbent for use with acrylics.

The sky on this evening was an almost steely blue-grey that really emphasised the blue in the mountains. I used a mixture of cobalt and cerulean blue to create the distant mountains.

A striking sunset left in its wake a burning orange sky. I used a mix of cadmium orange and cadmium red to show the intensity of the colours.

The lighting effects were less dramatic on this day in terms of colour, but this made for a very beautiful soft sky with some light orange clouds high above the distant mountains. I used a much more muted palette to complete this piece.

Additional colours for the summer palette

I also find the summer an ideal time to broaden the range of colours in my palette. I often also need to increase the range of different greens that I have available to use as well as perhaps relying more upon the brighter cadmium colours.

Chrome oxide green

This paint usually finds its way into my summer palette. It is a mid yellowish green with a similar yellow-green undertone. It is a neutral and very opaque green that I particularly like because it mixes very well with brighter cadmium colours – ideal for the summer season.

Chrome oxide green

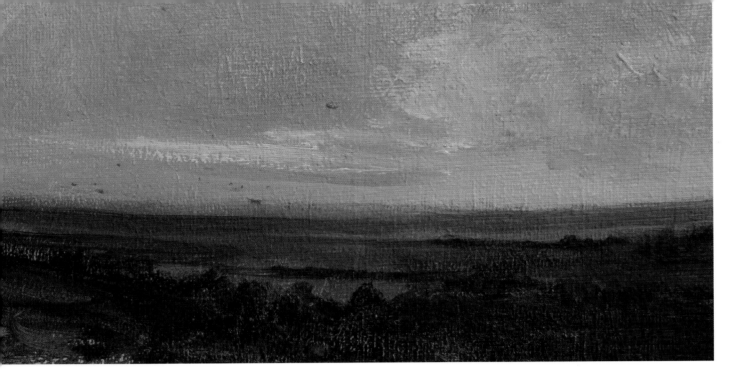

Perspective and distance

The very mention of the word 'perspective' can be daunting to any artistic newcomers, bringing to mind visions of rulers and lots of lines, but the underlying concepts are actually very easy to get to grips with. Perspective is a very important aspect of landscape painting, as it is what allows us to create the impression of depth in our painting – a sense that the flat, two-dimensional surface is a three-dimensional world.

Linear perspective

Linear perspective explains why objects appear smaller in the distance, and why two parallel lines will appear to get closer together as they move into the distance. The classic illustration of this principle is a road or track which gradually narrows until it disappears to a 'vanishing point'. The objects that we place in the foreground of the picture play an important role in giving the scene a sense of scale and tell us where we, the viewer, are positioned in the painting. Likewise, in order to create a realistic sense of distance and scale it is important to make smaller marks towards the back of the painting – i.e. towards the horizon line.

Aerial perspective

Objects that are further away from us lose contrast, colour intensity and detail due to the effects of light and water vapour in the atmosphere. This effect is called aerial perspective. Distant objects also appear to shift in colour towards the bluer end of the spectrum as red wavelengths of light scatter. This explains why distant objects such as mountains and hills appear to be blue.

Achieving depth in your painting

Colour and distance

Colour can be very important in creating a realistic sense of depth in your paintings. Using more blue in mixes for distant objects and reserving warmer colours for the foreground will simulate the effects of aerial perspective. When working on a painting that shows the far distance, emphasise colours at the cooler, bluer end of the spectrum around the horizon line and distance. With the same principle in mind, use stronger, warmer colours in the foreground to bring this area forwards.

If you are working on a painting and feel it still lacks depth, consider adding a light blue glaze over your horizon line to send it further back into the distance, or strengthening the tone in the foreground to create contrast. I often use similar colours for the horizon as I do in the sky: this creates a smoother transition from the sky down into the distant foreground; mimicking the loss of contrast on the horizon.

Scale

Most landscapes will have objects in them that can help us to describe scale and distance, such as trees, hedges, houses or people. Thinking about linear perspective helps enormously when it comes to placing objects like these in your painting. Distant trees, for example, can be described by using very small marks – the size and relative lack of detail help to create the suggestion that they are a long way away. Using this approach in combination with bluer paint mixes will maximise the effect of distance.

Including objects in the foreground can be an excellent way of adding to the sense of depth, as they provide contrast with the distant objects. Having a few larger, more detailed foreground objects also helps to tell us where the viewer is looking from and adds a sense of weight to the foreground. Having a range of objects overlap will also help to add a sense of depth to your work.

Leading the eye

The position in which you place objects can also determine the way that the viewer's eye is led through the painting, which relates back to composition (see pages 50–53). For example, you may compose your painting around a rough zigzag shape by adding a broken wall in the bottom right-hand corner of your painting that leads the eye to a small house on the middle left, and then back to a distant church spire sitting on the horizon line.

In some paintings, having a reference to a winding path of some sort can also be very helpful in leading the viewer's eye through the picture. This could be a winding lane, a river or stream or simply tracks left in the ground. Anything that helps to take the viewer's eye on a journey will really enhance the sense of depth in a painting.

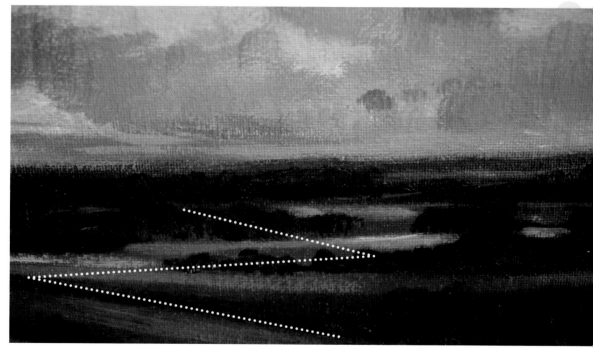

The dotted line in this example highlights the zigzag composition that leads the eye across the light-coloured fields and helps to create a sense of depth. Note that the distant trees are smaller and less detailed, and are painted with a mix of green that includes more blue.

Lake District

The spring has allowed us to brush up our *plein air* painting skills, and the warmer weather means you should now feel able to tackle some more adventurous subjects outdoors.

This example was made on a considerably larger sized board than those I used out in the landscape earlier in the year. Small boards are fantastic when the weather is still very changeable, but they can feel a little cramped when you really get into the flow of painting on a perfect summer's day.

Working larger outside does not always pay off. Larger panels are logistically harder to work with and you can feel somewhat pushed to complete them in one sitting. Even in fair weather, the ever-changing light and shadow can make it hard to complete the larger panels in one session.

However, when the conditions, subject and mood are just right, the results of working on a large canvas outside are particularly rewarding.

June 10th

Having lived most of my life in a very level county or in the middle of a city, hills and mountains always come as something of a shock to me. Practice makes perfect, however, and so I leapt at the chance to spend a few days painting in the mountainous Lake District in the UK.

The trip is eye-opening and introduces me to an entirely new landscape – one that I've not really visited or worked from before. The Lake District provided a wealth of inspiration and I filled a new sketchbook with assorted scribbles and came back clutching a series of successful finished paintings. Some work perfectly well as is, and the others will provide some perfect fuel for consideration back in the studio.

The finished painting
82 x 66cm (32¼ x 26in)

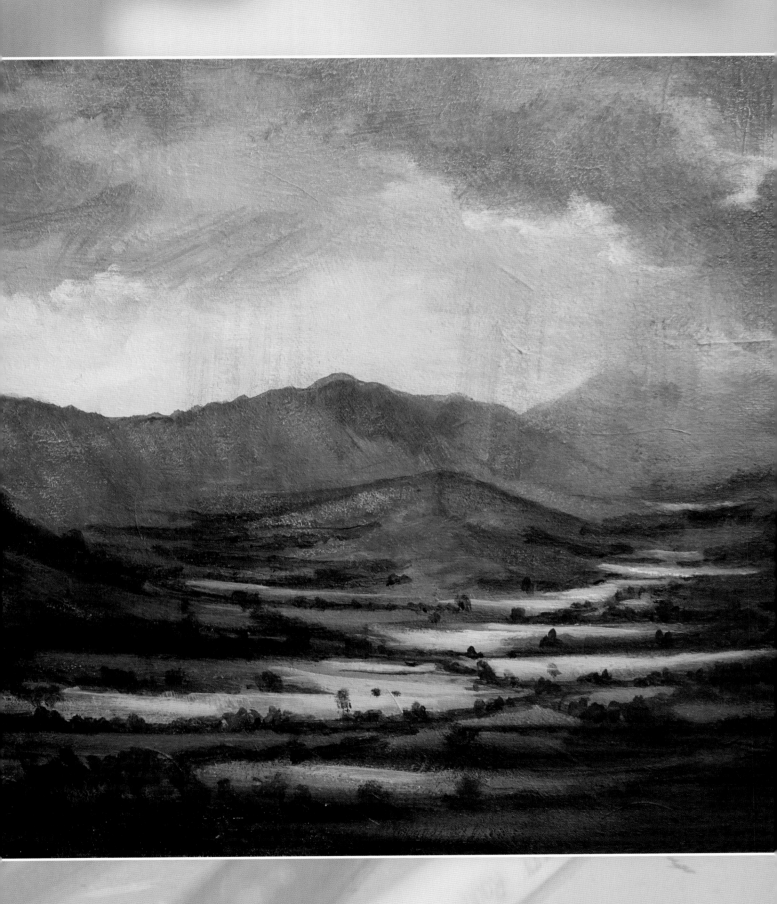

Painting *Lake District*

A grand subject such as the Lake District seems to demand a grand gestural painting, and that's what I set out to do.

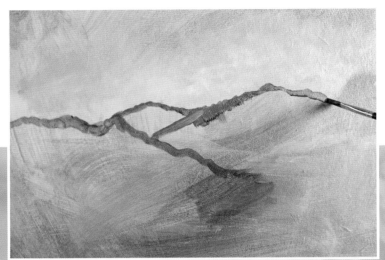

Ridgeline

Using fluid paint, the size 4 filbert was drawn in smooth strokes to establish the ridge. Note the use of bluish tones (in contrast with the warm underlayer) to suggest distance.

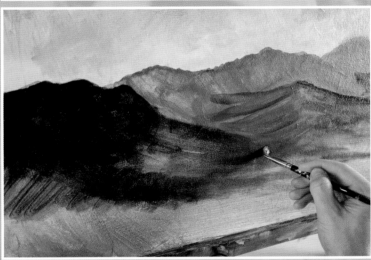

Contours

A fairly dry mix of Payne's grey, palette grey (see page 17) and ultramarine blue was dragged carefully across the background in curves to leave strokes that described the contours of the hill. The same approach was used in the foreground, the only difference being the mix – a darker version that incorporated more Payne's grey and less ultramarine blue was used here.

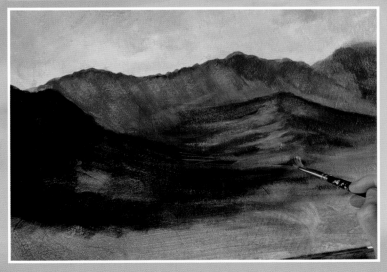

Overlaying for texture

Scumbling fluid paint left some of the underlying tonal wash visible, which was used to suggest rocky textures. This effect can be built up effectively by adding the green grass of the hillside, applying the paint with the same descriptive strokes.

Light on the landscape

A band of sunlight helps to lift the foreground fields, throwing the dark mountains into relief. Rendered with a warm yellow mix, this draws the eye and leads it from the dark foreground up through the painting and towards the distant blue mountains, where the crests are lost in cloud.

Aerial perspective

The use of blue tones to suggest distance is taken to its extreme on the ridgeline at the rear right-hand side, where the same colours used in the sky are used on the crest. I blended the paint upwards into the sky with a large brush to ensure a smooth transition – avoiding any small streaks is important, or it can 'read' as detail.

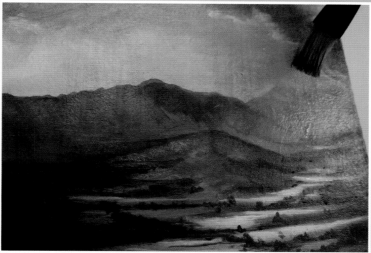

Creating a sense of scale

The trees and bushes of the hedgerows help to break up the fields and create distance. Smaller touches of the brush are used further away, and foreground trees and hedges are also shown in more detail.

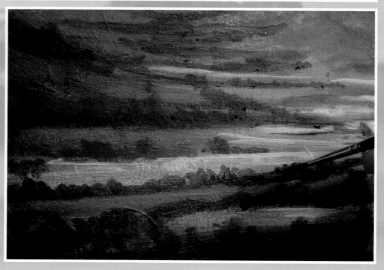

Cornfield

This painting began its life as a commission that was to feature the white house (the owner's property) in the distance but not be a close-up painting of the building. The painting thus features plenty of sky and a sense of the surrounding area. As a result, it's a fantastic example of how to create a sense of distance.

The painting looks down across a golden cornfield with the white house in the distance, nestled amongst the trees. The sky was rendered very much as a classic English landscape sky with beautiful rolling white and grey clouds.

July 18th

I've been looking at Constable lately, I need his help you see. If I'm ever struggling with a painting I can usually be found rummaging through my bookshelves, desperately seeking that one book or image that can present a way forward.

My current sticking point is a commission piece. In painting terms, it isn't enormously complex – a summer sky with cornfield below – but I can't get it to work. The sky has undergone various transformations already, but it is the light on the cornfield that is proving a struggle.

On days such as this I find it helpful to make smaller studies on separate panels or offcuts of canvas – sort of 'workings out' that allow me to try different approaches and ideas. It does not always solve the problem but can be helpful, even if it only serves as a welcome distraction.

I eventually resolve the problem but the painting still lacks depth somehow. Perhaps some texture medium will offer me a way out?

The finished painting
70 x 45cm (27½ x 17¾in)

Painting *Cornfield*

The sky of the painting came together reasonably quickly, but the foreground proved to be a challenge. Despite being in the distance, I still wanted to lead the viewer's eye firmly back to the white house.

 This painting took perseverance, but eventually it came together through the combination of some techniques to suggest distance. The finishing touch was to block in the house very loosely using a mixture of white and palette grey then use a small size 0 brush to add a suggestion of detail to the building – not to 'super detail' it, but enough that it catches the eye.

Sky

I created this sky using the basic sky painting principles on pages 78–79. Laying down a soft mid blue across the entire canvas, I used a 25mm (1in) blender brush to work on the soft white and grey clouds. I wanted to get a slight sense of movement in the sky, partly inspired by looking at Constable's work

Field

To create the cornfield in the foreground I began by laying down a dark burnt umber as a base layer – this was very important as it provided contrast when I came to add the golden brushstrokes describing the corn itself. I also had to consider the sense of scale when applying these brushstrokes so that the field appeared to recede into the distance convincingly.

Texture

To bring the foreground forwards, I mixed some texture medium with my paint to add a slight impasto effect. I also used the sharpened end of a brush to scratch into the immediate foreground, (see page 21) helping to heighten the overall texture.

An alternative approach

It can be hard to avoid the trap of making a cloudy English sky look
a bit twee, and so before tackling the final painting I tested the
composition, tonal values and colours I intended to use in this rapidly
executed paint sketch.

I was keen to use a large brush to get a sense of the movement and
drama in the clouds – from experience I know that this makes them
incredibly fun to paint. I opted for an energetic approach with lots of
fast brushwork, an approach which really paid off. Making this study
helped to test out the technique, which reassured me it would work.
This helped to ensure that some of that energy made its way into the
final painting.

Cornfield (preparatory sketch)

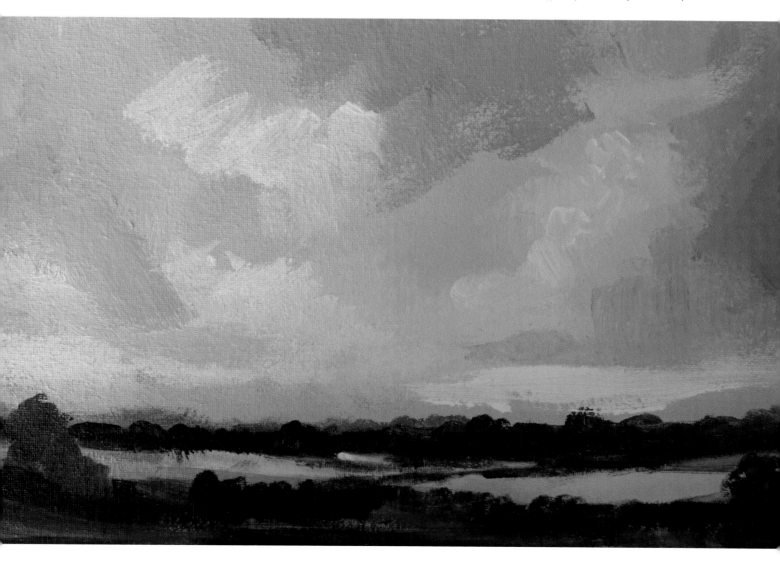

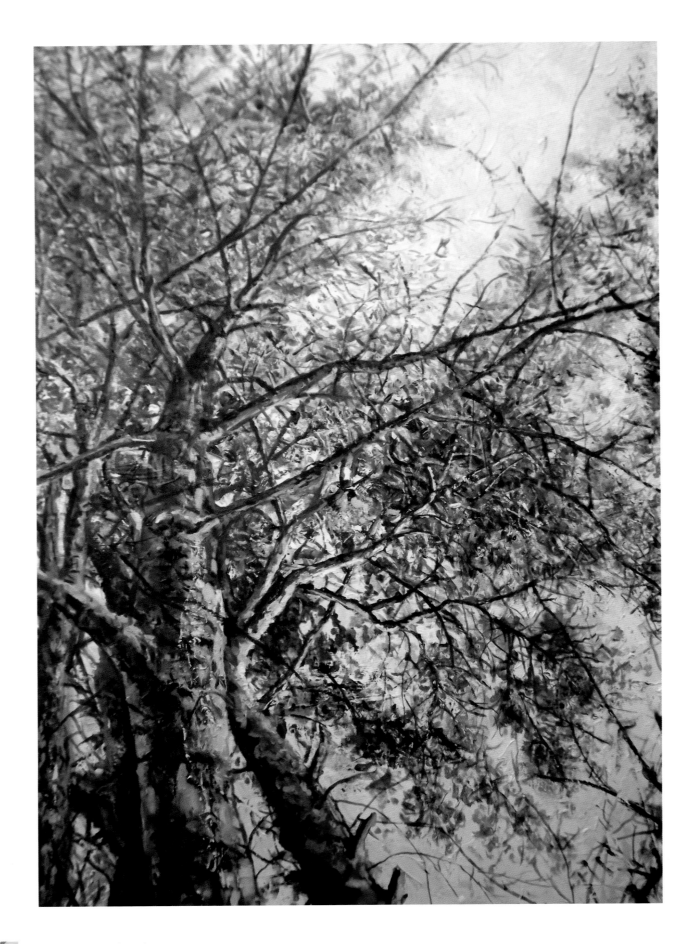

Trees

The summer is an ideal time of year to really get to grips with painting foliage, trees and grasses. As I mentioned earlier, I used to be terrified of painting trees, but gradually I got there and now find trees one of the things that I love to paint most.

Trees have an enormous amount of character, and I believe it is very important to show something of this in your painting.

Challenges and opportunities

Trees pose similar problems to clouds, in that they can appear to be generally similar, but each one has its own clear shape and identity. It is relatively simple to paint distant trees and bushes with small dabs of the brush, allowing the movement of the bristles to represent their shape, but when doing a close-up or more in-depth painting of a tree it is worth paying close attention to the tree's specific shape and physical properties. The exercise then becomes much more like that of painting a portrait; picking out the tree's identity becomes both relaxing and very rewarding.

From a compositional point of view, trees can be used to provide your image with very useful notations of scale and size, and you can use foliage as a means of filling your landscape paintings and guiding the viewer's eye through the picture. Trees can also make significant changes to the overall colour and feel of a painting, so don't underestimate quite how much impact they can have on your work.

Some time ago I picked up a book of trees from a secondhand shop. I found this a useful companion to my painting as it allowed me to study the shapes and colours of different species as well as strengthening my understanding of how trees grow and change with age.

Of course, nothing beats direct first-hand experience and so I try, wherever possible, to sketch or at least photograph any trees or foliage that I find interesting and that may be useful for future paintings.

Opposite:

Scottish Trees

90 x 50cm (35½ x 19¾in)

During a painting trip, I looked up into the canopy of the trees above me and thought it would make for a fascinating image. I was particularly interested in the way that the trunk disappeared into the sky as it got further away from me – an example of perspective at work. I deliberately made my brushstrokes softer and more blurred towards the top of the image to give the impression of leaves being further away from the viewer. Having painted lots of trees face on, this painting from a slightly different viewpoint was as interesting to paint as the result is to look at.

Tree structure

It is always worth considering the underlying structure of any tree. The branches and trunk define the shape and size of the tree and provide it with a sense of weight and stability in your painting. I often start a painting of a tree by establishing this underlying structure first, roughly blocking in the main branches to act as a useful armature that I can then build the detail of the tree upon.

Remember also that trees are three-dimensional. Aim to include a sense of shadow and highlight into any tree that you paint to help add to this three-dimensional effect – whether it is a close-up of an individual tree or a group of distant trees, use of colour and tone to suggest the tree's shape can really help.

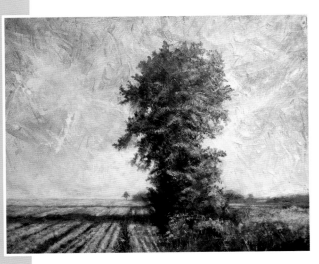

Lime Tree
Occasionally you come across a tree that stands on its own and is full of character. This lime tree is a great example of this and deserved to take centre stage in this painting.

Trees in Kensington Gardens
This very small study was made using quite heavily diluted acrylic paint. The painting took perhaps ten minutes at most and was an attempt to capture the movement in the trees on what was an incredibly windy and wet day. Notice how the foreground trees are larger and have more contrast in tone than those further back.

Kensington Garden Grass
Painting foliage does not necessarily mean painting the entire tree. In this painting, I focused on an incredibly small patch of grass in a public park.

This close-up shows the array of different marks and colours that were used to build up the painting.

I started by covering the entire surface of my board in a rich forest green to provide a deep, dark backdrop. From here I used a variety of greens mixed on my palette for the individual blades of grass.

The resulting brushmarks appear chaotic and the painting becomes almost abstract – something that I was very interested in at the time – but when you step back, the marks come together to create the impression of this small patch of grass.

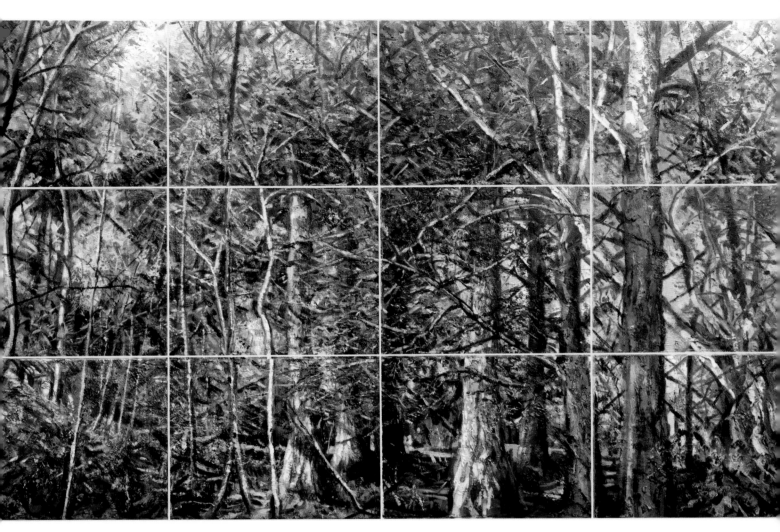

Trees, colour and the year

We are all familiar with the beauty of autumn, when the leaves start to change colour. This is a prime example of how trees can allow the artist to really experiment with different colour mixes and moods in a painting. Later on, branches and twigs start to show as the leaves fall, and this brings more challenges and opportunities. Personally, I think that trees can be at their most beautiful in the winter. The painting above is a close-up of a variety of types of tree in Scotland. I was amazed by the array of colours that were present deep in the winter and attempted to work these into the painting. The bare trunks also gave me ample opportunity to experiment with textures.

While the trunks and branches may well be obscured in spring or summer, painting trees at this time can be an excellent exercise in mixing greens, as the array of fresh and dry colours in the mass of foliage during these seasons requires very clean colour mixes that stand out against one another.

Trees in Dumfries
90 x 60cm (35½ x 23¾in)

One-day paintings

As mentioned earlier, the summer months offer a little more stability in weather, and thus the freedom to spend longer working outdoors. It is during these times that I might stray further afield and attempt more ambitious projects.

Ambitions and reality

It can be hard to start and complete a painting from start to finish outside over the course of a day – even on the most tranquil days the light will change and move. Nevertheless, even paintings that amount to little more than quick sketches and studies are very useful to your practice, as they allow you to work out ideas for composition, light and colour. The weather and season can be limiting, cutting short paintings before they are finished or completed to the level you would like, but do persevere – the effort will be well worth it.

Figures in one-day paintings

When including people in a *plein air* painting, it can be tempting to overcomplicate them, using up valuable time and often resulting in over-rendered and fussy details that add little to the painting.

As I made the painting shown to the right, the people in front of me were constantly moving. In order to include them without them appearing distinct from the rest of the painting, I represented them with simple dabs of colour – exactly as I treated the trees.

August 3rd

A good friend has introduced me to a new painting surface – an aluminium composite known as Dibond. It is the same material that road signs are made from, and my friend has already used it to great effect.

It is essentially two thin sheets of aluminium with a foam core. This makes it incredibly strong but also lightweight – two qualities that make it very suitable for working with out of doors.

I find I particularly enjoy using it *en plein air*, and am determined to make the most of it in the remaining summer days.

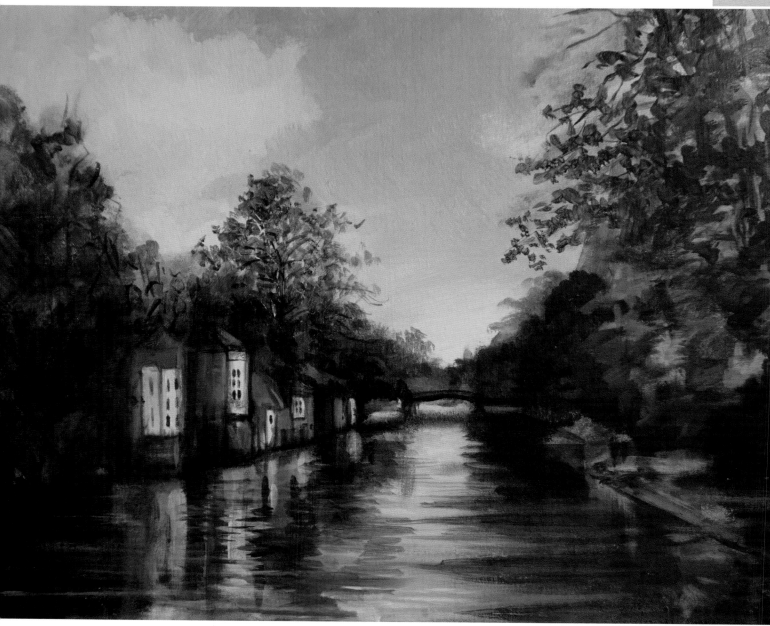

By the Canal

The filming of my television show, *Fraser & Friends*, takes me around the UK, peeking into the studios of contemporary artists, asking them questions and then painting on location with them. I find it enormously rewarding, as it is actually quite rare for artists to find the time to visit one another. Being able to go out and paint on location is even more of a bonus.

It is a jewel of a summer's day when I visit Denise Allen in Hertfordshire. Denise chose a fantastic location to paint in a local town called Ware. The painting for camera was quite a hurried affair but went well nonetheless. Having returned home from the filming trip I decide to have another stab at the painting, working on the larger version shown here.

You will need

56 x 38cm (22 x 15in) canvas board

Grey matt emulsion and small roller

Paints: basic palette (see page 16–17) plus cobalt blue

Brushes: 25mm (1in) texture brush, size 10 filbert, size 8 filbert, size 4 filbert

Spray bottle

✓ Key marks

- **Prime the surface** with grey matt emulsion using the small roller and allow to dry.

- **Block the foreground** in with the size 10 filbert using burnt umber diluted with water. Use quick scrubby marks to establish the basic shapes and tones of the canal and buildings.

- **Add basic outlines** of the trees using the same dilute burnt umber.

V-shaped composition

The composition is based around the canal, the banks of which form an inverted 'v' shape that leads the eye to the horizon.

Trees

The key marks for the trees are intentionally left very loose – the nature of painting foliage makes it largely pointless to spend a great deal of time early on. Instead, they will be built up in lots of layers.

The painting at the end of this stage.

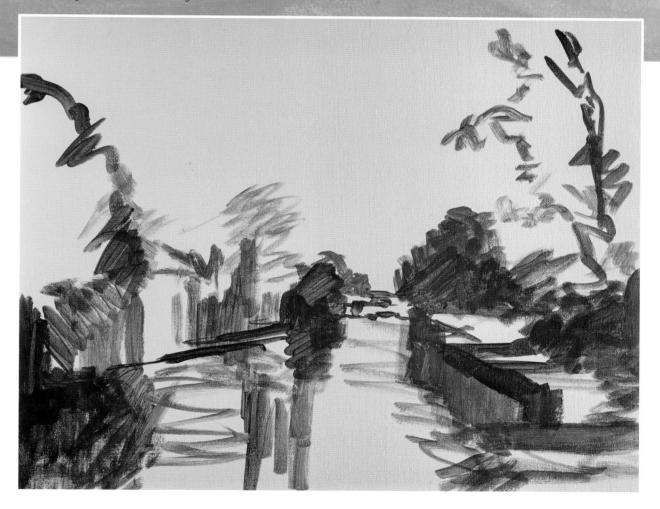

2 The sky and distance

- **Paint the sky** using titanium white with a hint of cadmium yellow along with the 25mm (1in) texture brush. Work over the whole sky, then add cobalt blue to the mix on your palette and blend it into the lower part of the sky.

- **Paint the reflection** of the sky in the canal using the same colours and quick horizontal strokes. Add more cobalt blue to the mix for the foreground water, then use this same mix to strengthen the top of the sky, applying the paint quickly and loosely.

- **Work titanium white** into the wet sky as clouds, using vigorous circular strokes of the brush.

The painting at the end of this stage.

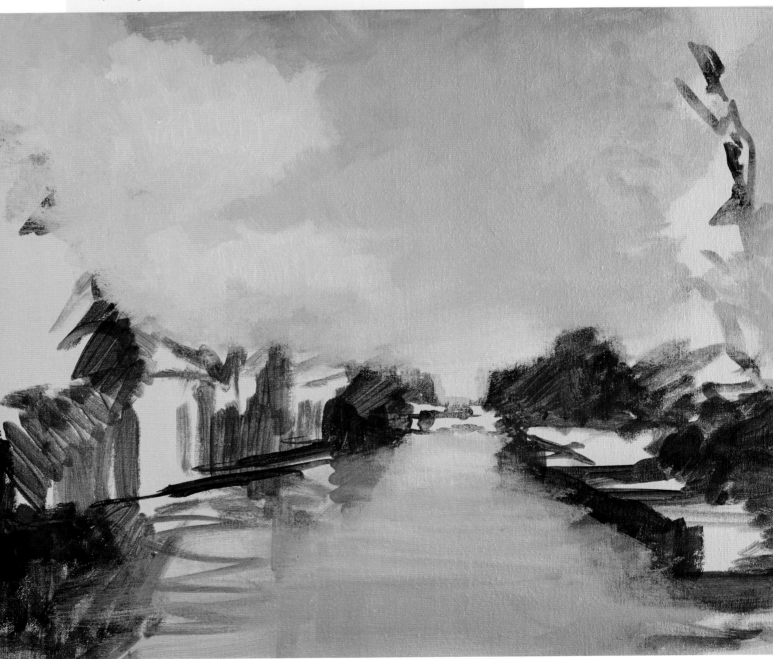

Blending

The blue is worked into the white while it remains wet, in order to create a soft effect with interest but no hard edges or lines.

Clouds

Work right up to and over the outlines of the trees with the sky colours.

Framing

The canal reflects the sky, so the dark area at the top of the sky is mirrored at the bottom of the picture in the foreground water. This also suggests a visual 'frame' of darker tone that serves to draw the viewer's eye into the painting, building on the V-shaped composition mentioned earlier.

3 Foliage and midground

- **Prepare green mixes** as follows: cadmium yellow, forest green and palette grey (see page 17); yellow ochre, forest green and palette grey; Payne's grey and forest green; and yellow ochre, forest green, palette grey and Naples yellow.

- **Establish the greens** across the painting using the mixes on the palette and the size 10 filbert. Start with the darker mixes, applying undiluted paint to the trees and bank of the canal using vigorous movements, and diluting the mixes (either by adding water to the mix on the palette or using the spray bottle to wet the surface in the appropriate area) for the reflections on the water. Use the midtones in the foliage on the upper right.

- **Continue applying midtones** to the trees in the midground, changing to a size 4 filbert to apply the paint. Use lighter tints for the trees closer to the foreground.

The painting at the end of this stage.

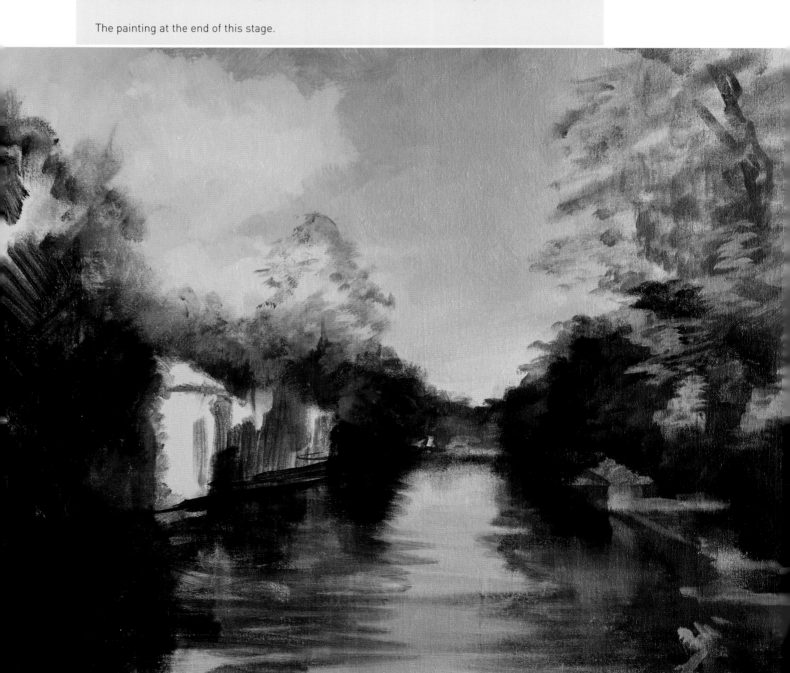

Greens

When working with lots of different mixes, it is a good idea to keep them separate. I use a felt-tip pen to draw a temporary grid onto my glass palette, but you could keep your mixes in separate wells of the palette or simply leave more space between them.

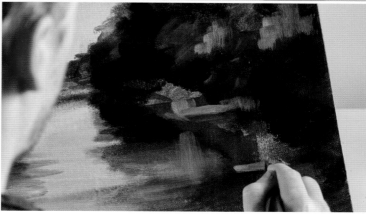

Strong contrasts

Summer shadows are often intense due to the strong sunlight and the dense foliage on the trees, so don't be surprised if you use a lot of dark greens at this stage.

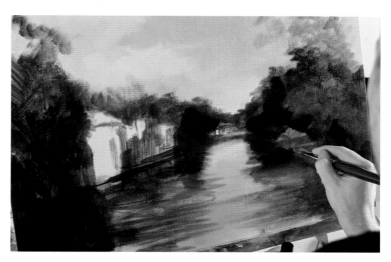

Canal groundwork

At this point, the effect of the composition starts to become clear, with the dark sides framing lighter water and the midtones of the horizon drawing the eye to the centre.

Note that the canal is not completely resolved at this stage, but working in the greens while the blue remains workable will help to create convincing reflections later.

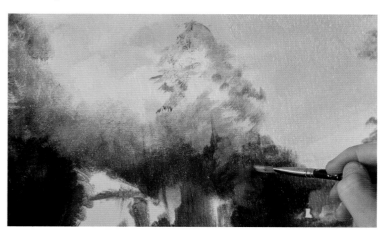

Summer trees

Unlike trees in winter, the placement of branches in summer trees is not critical, as the mass of leaves will cover the whole area. Instead, treat the midtone areas as simple blocks of colour and aim for the overall impression of foliage.

4 Buildings and refinement

- **Paint the buildings** using flat strokes of the size 4 filbert to apply various combinations of Naples yellow and palette grey.

- **Once the buildings** are established, scout around the picture for anywhere else the grey-yellow mixes can be used. Not only does this save you later mixing more of a particular colour, but it helps to balance the picture and avoid overemphasising any particular element.

- **Reflections of vertical** elements, such as the buildings, should be added with light vertical strokes at this stage. They will be worked over again at a later stage, which will blend them into the painting a little.

- **Dilute the dark** green mix (Payne's grey and forest green) and use light scribbling marks to hint at the structure of the trees in the foreground and midground of the painting.

The painting at the end of this stage.

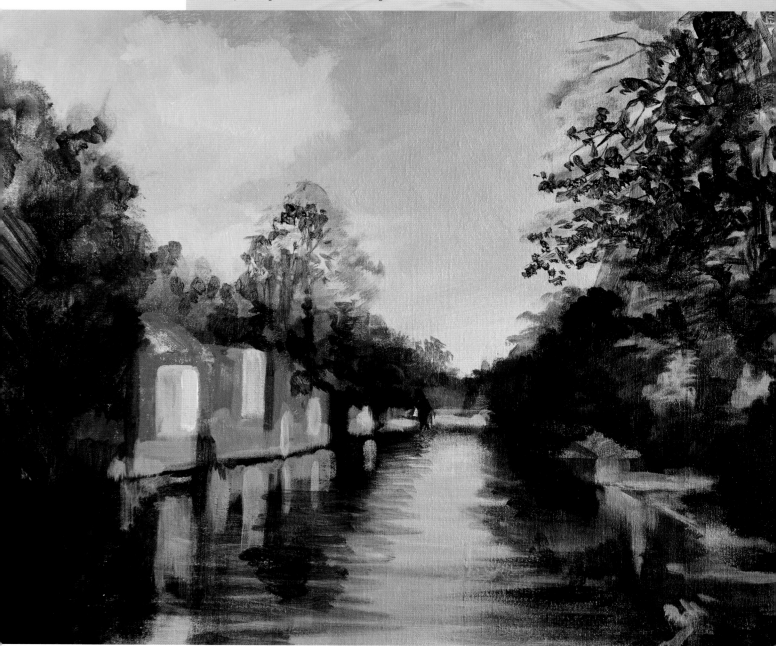

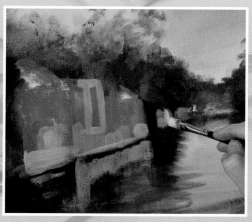

Buildings

Treat the buildings simply as part of the landscape – you are not aiming for architectural accuracy. That said, fairly clean, straight lines will help describe the forms. Use the blade and corner of the brush for straight line work.

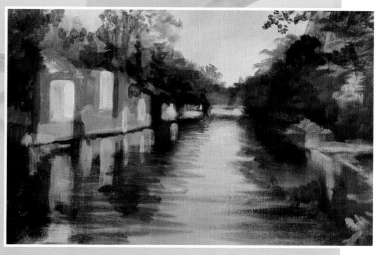

Building reflections

Strong verticals, such as some tree trunks and the buildings in this example, are an exception to the horizontal strokes used for most reflections.

En plein air

The difficulties of painting on location are somewhat exacerbated by having a film crew with you, time is a major factor and we are usually working to the dreaded 'schedule'. On this occasion, however, I cannot complain. Part of the appeal of taking part in *Fraser & Friends* is that I genuinely have no idea of what I am going to be painting in each episode. I found myself set up alongside Ware's famous riverside gazebos, and thoroughly enjoyed myself.

This is a shot of my easel in position during the filming of my initial *plein air* painting. You can see I have opted to work on a fairly small painting surface, which allowed me to cover the whole subject quickly – an important consideration given the time restrictions. This version proved to be a great record of what it was like to be in that spot at that time of day. This initial study, coupled with some additional reference photographs, provided the basis for this demonstration.

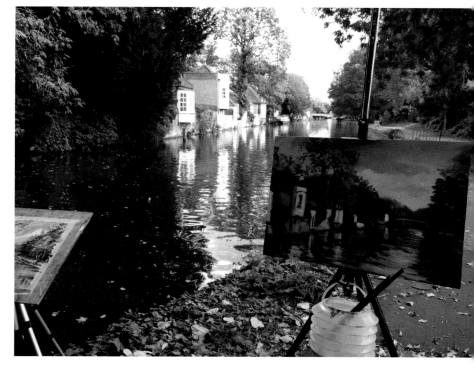

5 Detailing and finishing

- **Add highlights across** the painting with careful touches of the size 4 and size 8 filbert brushes, using pure titanium white and a mix of Payne's grey and palette grey.

- **Add reflections in** the water using the size 4 filbert and the same colour as the object being reflected, plus dark green – see 'Reflections' on the opposite page for an example.

- **Use the same** brush to add broader light horizontal strokes of the light and dark mixes on your palette across the water's surface, paying attention to what is above the area – i.e. what is being reflected – to help guide your colour choice.

- **Use various combinations** of cadmium yellow, Naples yellow and forest green to develop the trees and foliage. Apply the mixes to the tree with dabbing touches of the size 4 round, then wet the brush and use the dilute mix to hint at the foliage in the reflections.

The painting at the end of this stage.

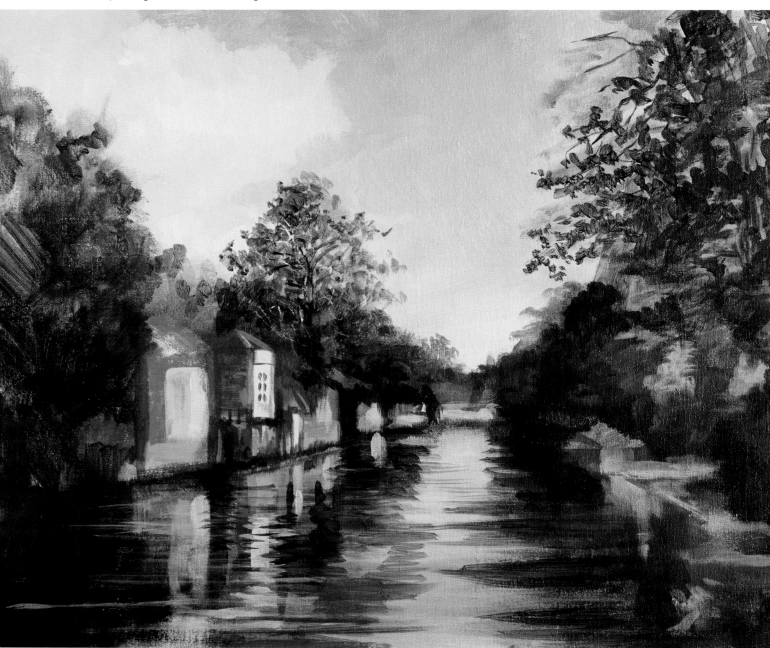

Reflections

Use the flat of the size 4 filbert brush to apply a light stroke below the areas (the white window visible at the top of the left-hand image, in this example), then wipe excess paint off the brush and draw the blade horizontally through the stroke. Next, pick up a dark mix (the same as that used initially in the water) on the same brush and add horizontal touches.

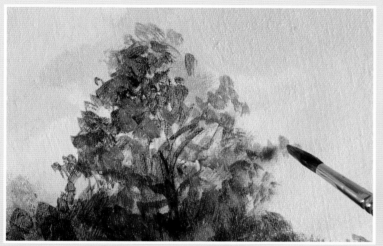

Foliage

Vary the pressure and angle you use on the brush to apply the paint to the foliage, as well as the exact hue you use, in order to avoid artificial symmetry and repetition.

Foreground texture

While the paint is wet, use the sharpened back end of a brush to scratch out some branch forms for additional interest and texture in the foreground trees.

Contrast

After a busy summer of painting with lots of vibrant greens and blues, it is surprisingly refreshing to return to a more muted palette of greys and browns, such as that used here. To ensure the painting keeps a sense of brightness and sunlight, it is important to add strong contrasts in tone.

This image really comes to life when you add the green highlights into the canal – until then it can lack life, as the colours and tones are so similar and muted. The use of such a muted palette is important in order to really make the highlights stand out.

The
autumn

landscape

A time of change

A wonderful, visually exciting time of year, autumn can also be somewhat overwhelming. My sin is usually taking on too much work or starting overly ambitious projects that I don't get time to finish – the gap between October and Christmas seems to shrink every year.

Taking things steadily in the autumn will let you finish a few lingering projects from the summer while still leaving space for making the most of the remaining days you can paint outdoors.

Weather and colour

Accurately rendering the weather is something that the landscape painter must always bear in mind. The autumn is a good time of year to experiment with such elements in your painting, as the season's changeable weather means that you can witness an incredible array of conditions over a short space of time, ranging from rain, hail and fog to brooding thunderstorms.

Incorporating these into your work will help to give it personality and a sense of atmosphere. Learning to paint different types of weather conditions is also an excellent way of challenging yourself when you become more advanced, allowing you to experiment with various painting mediums and keeping the process of painting fresh and exiting. I try and keep a fairly good record of different weather types, either in the form of sketches or photographs on my computer. Some books, such as those covering different types of clouds, can also come in handy as reference.

It is, of course, also fine to enhance or improvise the weather conditions in any painting. I will often change a photographic reference with a sunny sky to a more brooding sky if I feel it will benefit the picture. I have also used different acrylic mediums to dramatically or subtly change the appearance of an old or finished painting, in many cases, giving it a new lease of life.

Painting rainfall

Seeing inky clouds breaking in the far distance and sending hazy, transparent blocks of grey heading down to the earth is an incredible thing to behold and an exciting weather condition to attempt in a painting. The trick to creating a sense of realism is to get the strange transparency that falling rain has while still capturing darkness and mood in the overall picture.

This can be achieved in several ways. The first might be to simply dilute some acrylic colour using water and lay it onto your clouds in order to create the effect. Diluting with water can sometimes reduce the intensity of the colours, so I tend to use a clear acrylic medium to achieve the same effect.

I made a painting from the photograph to the right. Once finished, I felt the artwork lacked some drama. I decided to add some falling rain to intensify the picture. When doing this its important to make sure that your glazing mix remains slightly transparent, allowing some of the existing colours in the sky to show through. The technique below could also be used in a number of different ways to change the look and feel of a finished painting.

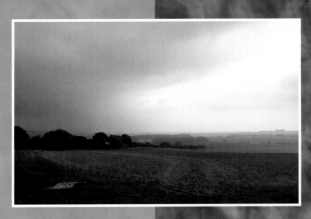

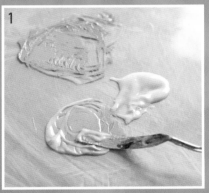
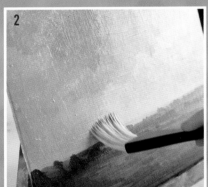
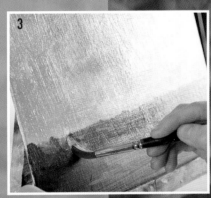

1 Mix the paints to get the colour you need, then add clear medium. You want to make the mix fairly dilute – a 1:1 ratio of paint to medium is a good starting guideline.

2 Apply the glaze in small amounts to the clouds using a large flat brush, then draw it downwards in smooth, even strokes up to and over the horizon line.

3 Clean the glaze from foreground objects using a clean dry brush.

4 Allow to dry, then repeat as necessary to build up the depth of tone and texture you want in your painting.

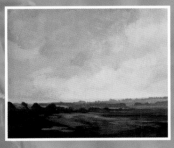

Compare the atmosphere of the original (above) with the version on the right, where moody rainclouds mass. The glaze adds a greater sense of drama and depth to the sky, hinting at incoming rain. The upper left hand corner has also been darkened to balance out the various darks in the foreground.

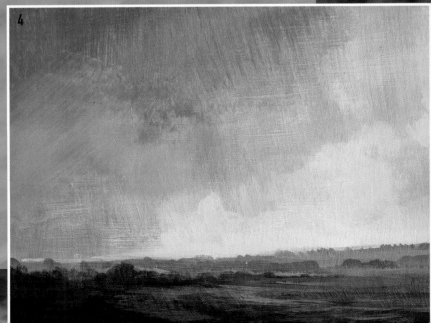

Canal Side

Early autumn can be a magical time of year, and it usually provides me with an abundance of landscape painting material. I am always particularly interested in the quality of the light – not an easy subject to render in paint but one that can make for some truly great work if you are lucky enough to catch it just right. It is the days in late September and early October that hold the most appeal, hovering as they do on the border between late summer and early autumn.

A lot of painters never stray beyond using a white painting surface, and this is a shame. Coloured grounds can make the job significantly easier and yield better results. My primary reason for using a coloured ground is that it makes the business of painting with tone much easier. Using a white ground can significantly throw off your ability to judge the tonal values as every colour that you put down will appear darker than the surface. Starting from a midtone, as with this example, makes it much easier to see where your lights and darks will fall and to emphasise them accordingly.

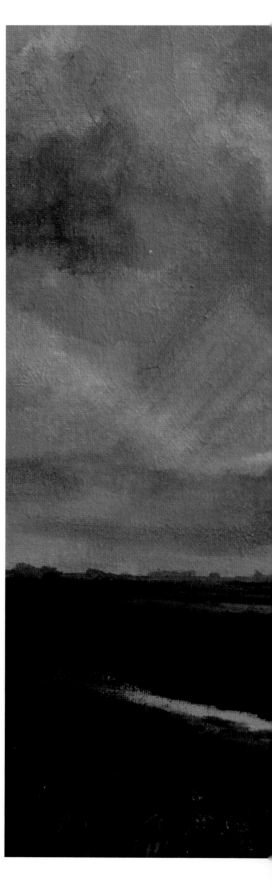

The finished painting

50 x 35cm (19¾ x 13¾in)

September 23rd

I have always loved September; I find it calming. The summer is only just over and autumn just around the corner. It can be a very changeable month in terms of weather too, and I try to make the best of my remaining outdoor painting time.

This week I find inspiration while on a bike ride with friends. It is a lucky case of being in the right place at the right time, and the scribbled sketches in a notebook and hastily taken photographs will provide just enough for the basis of a new painting. I'll readily admit that the composition is not particularly adventurous, but this painting will be all about atmosphere.

Having had a rather good British summer, I have been painting a lot of blue skies. This late September day brings some welcome contrast. There's the merest hint of blue in the sky today but other than that it's grey clouds all the way. Perhaps this painting will be a fond farewell to the blue skies of summer?

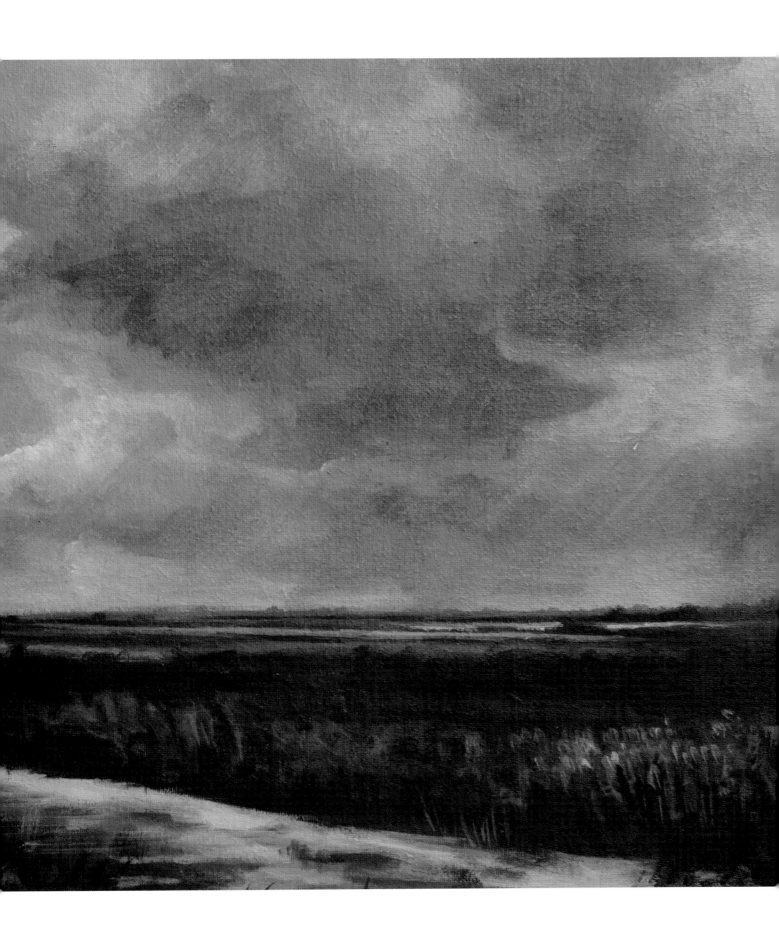

Painting *Canal Side*

My decision to work with a limited palette was a deliberate choice: I wanted to make sure that the highlights in the canal really stood out. I also decided to use a tonal ground, which allows for more leeway when it comes to the application of paint. Thin layers of paint over a white ground tend to look scruffy, whereas over a tonal ground they can conjure up a great sense of depth.

Working on a midtoned grey ground allowed me to lay down various translucent washes of acrylic colour to help build more convincing skies and atmospheric effects than would otherwise be possible.

Ground control

The colour you choose for a ground is entirely up to you but many artists choose their grounds according to the type of picture they wish to paint, perhaps choosing a warm ground for a painting dominated by cool colours.

When I talk of a midtone grey I simply mean one that lies in the middle of the tonal range: imagine the centre of a sliding scale from the blackest black to the whitest white.

My ground is usually either a pre-bought tonal grey or a palette grey mixed from leftover paint. I never mix greys purely with black and white as these are usually too cool and lack life.

Limited palette
The vast majority of this painting was completed using browns and greys before I gradually worked in blues and more greys to create the outline for my sky. Contrast was provided through the addition of rich burnt umber when blocking in the foreground.

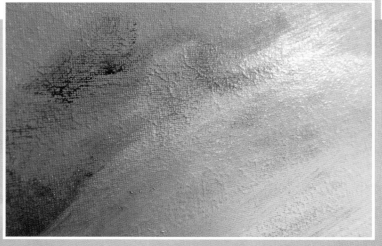

Grey ground
I worked directly onto a canvas board primed grey to give me a midtone to start upon. Working on the grey ground was helpful as it allowed me to build up the sky using glazes of acrylic colour. These thin, semi-transparent washes of colour allowed some of the grey board below to shine through, which adds to the atmospheric effects in the painting.

Pre-highlights
This detail shows the painting complete except for the highlights. This stage is satisfying to reach as it allows you to review the painting as a whole and then mix and apply your highlights accordingly. You can see that the water in the canal looks fairly cool, owing to the brown-grey mix used here. This is the base onto which the more vibrant green highlights for the water were applied.

An alternative approach

Having discovered the location while on a bike ride with my friends, I returned to the spot some days later to paint from life. I wanted to include this image to show you the contrast between a painting made on location in an hour or so and a painting made back in the studio environment that may have been worked upon for a day or more.

The painting, below, was executed quickly, as the clouds and light were changing constantly. It was also not the warmest of days. This painting is typical of many *plein air* paintings in that it has a good sense of energy and movement, but it is not quite right tonally – I feel it is a little over the top. To be specific, the central clouds are a little too dark, which means they are overpowering the rest of the image and appear slightly menacing. I also feel that the highlights in the water do not quite stand up and work on their own.

Paintings executed in the studio allow you to have more control over the balance of colours and tones. The balance is in making sure that you do not lose all of the vitality and energy that you would get when working out of doors when working under a little pressure – for time and light. There is certainly no right or wrong and I like to embrace the results that both working methods bring.

On location at Canal Side, Bardney

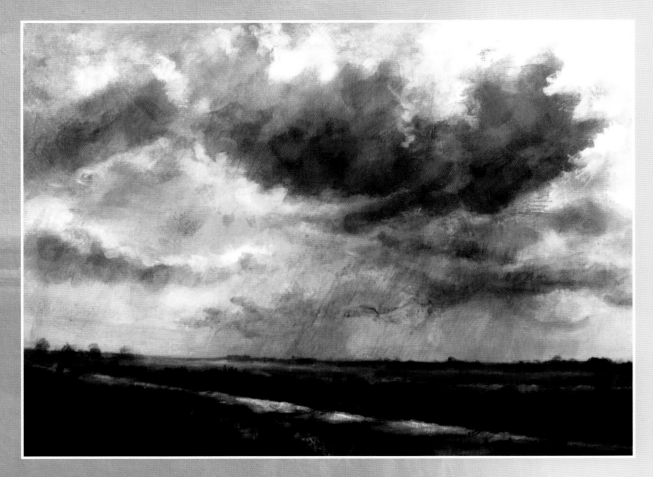

Whitby

Whitby is a charming place, a coastal town dominated by the ruins of its famous abbey. I have visited at various times of the year, but it seems to suit the colder months better – perhaps due to its gothic heritage.

From time to time the feeling creeps up on me that my painting has become a little 'tight' and ordered. When this happens I usually dispel it by looking at some of Turner's work. I could wax lyrical about describing how Turner's work has inspired me, but suffice to say that to any landscape painter he is surely the greatest. Turner had an ability to deftly render the world in a very economical and pure way.

As a young painter I used to pore over books on Turner, eking out as much information about the man and his technique as I possibly could. Something that really stuck were the descriptions of Turner's working methods. We tend to look at great art and assume that it was created in a logical manner by people that knew exactly what they were doing, but Turner's working method was anything but ordered – he would work on the whole canvas at a time, pushing paint around the surface, scraping, spitting and scrubbing. Many describe him working furiously and coming up with what looked like formless voids. The genius of Turner was his ability to render just enough to detail to conjure up the landscape he was depicting – and that is what we are aiming to emulate here.

The finished painting
40 x 25cm (15¾ x 9¾in)

October 14th

I have spent the day walking along the coastline and through the town of Whitby in East Yorkshire. It is a real horror of a day: windy, wet and cold. It does not help that I am woefully underdressed for the conditions. What is good, however, is that I am in a place that really seems to suit these weather conditions. The light here seems to alternate between bright and overcast on a regular basis. A variety of inky blue clouds brings rain that creates interesting greys over the sea. I am struck by how atmospheric these weather conditions are – it really makes me want to run home and paint.

Painting *Whitby*

Some scenes demand a more chaotic approach in place of any orderly step-by-step instructions. Once back in the studio I looked through some of my sketches made in Whitby, my favourite book on Turner open next to me as inspiration. The notes below are necessarily rather loose, as befits the intent behind the work.

Establishing the scene

The painting was scrubbed in quickly using a very limited palette and heavily diluted paint to establish the overall sense of the scene.

Thick over thin

With the overall sketch in place, I began to add the darks using much thicker acrylic paint. These darks were used to establish the skyline and dark passages in the bottom edge of the painting.

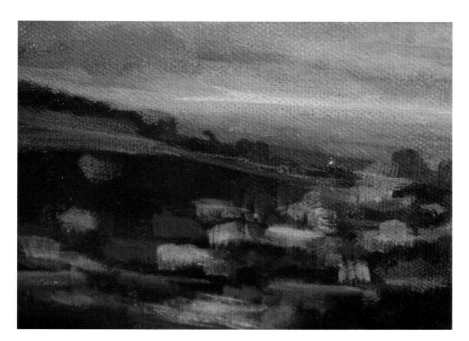

Lightness of touch

To avoid become bogged down with detail in this painting, I used short stabs of various colours to suggest only the general sense of the town below me. Final highlights were also added at this stage to contrast with the otherwise dark colour scheme.

Additional colours for the autumnal palette

The autumn brings with it an intense array of beautiful colours: reds, oranges and coppers. The trees and fields undergo a continuous cycle of change as green slowly gives way to golden browns and then, finally, bare branches. The autumn is a joy to paint, and the following colours can help to strengthen your core palette.

Cadmium orange

All of the cadmium colours are known for their brilliance, permanence and strong tinting power. They are ideal for creating very bold and punchy paintings, but as my work tends to be fairly subtle I use cadmium colours only sparingly. Cadmium orange provides a rich and brilliant orange ideal for use in autumn leaves and trees.

Quinacridone rose

Quinacridone rose is a powerful and slightly transparent rose pink. I do not use it very often, but find that it is well-suited to the autumnal palette as it can be used to make warm glazes. It also mixes well with other paints to make beautiful purples and oranges.

Cadmium orange

Quinacridone rose

Atmosphere and drama

It can hard to describe exactly what constitutes 'atmosphere' in a painting. I think it best to consider atmosphere as a certain mood or feeling created by a painting. This feeling should be one chosen by the artist and put across through the use of colour, texture, light or rhythm – or a combination of all of these – in the work.

What creates atmosphere?

When we think of atmosphere in the landscape we tend to think of rolling clouds, rain lashing mountainsides or storms. These are, of course, incredible things to behold, but these more extreme conditions are better described as adding drama rather than atmosphere. Your artwork does not need to contain extremes of weather or light in order to make it atmospheric.

Creating atmosphere is often a case of accurately capturing a moment or a time of day. I have talked a lot about routines, times of day and witnessing the landscape first hand. I think if you have witnessed a scene directly it makes it much easier to bring that experience to mind when painting and to inject some of that experience into your work.

At its root, atmosphere is a demonstration of the artist's ability to place the viewer into the world of the painting and to use paint in such a way that it reminds the viewer of a time when they too, have witnessed something similar. Art has the power to connect people in this way.

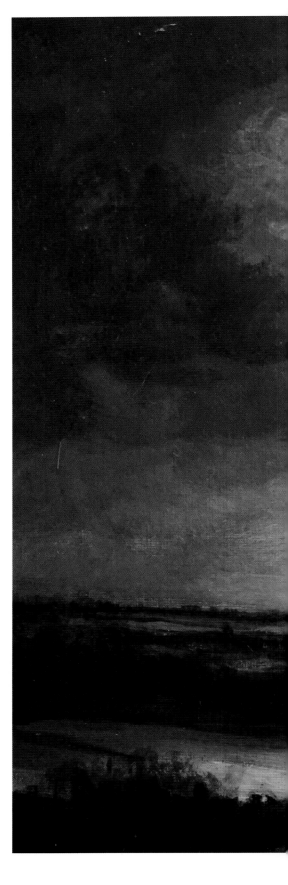

Fields at Wispington

50 x 35cm (19¾ x 13¾in)

While I wouldn't want to make my artwork look overly dramatic, it is good fun to indulge in a little drama from time to time by really pushing the elements discussed on the following pages to extremes, as with this painting.

This scene's dark rolling clouds contrast with lots of bright light in the foreground. I have used a fairly limited palette of midtones (blues, browns and greys) so the extreme highlights and shadows stand out.

The dramatic sweeping landscape here has a low horizon line, which helps to emphasise the power and drama in the sky and make the objects on the ground look small and insignificant. The gap in the clouds showing a hint of blue corresponds with the golden light on the fields below.

The texture also varies: thinner glazes and washes have been used in the sky and to create the dark shadows in the landscape, while in the foreground I have scratched into the surface of the painting with the end of a brush and used thicker paint.

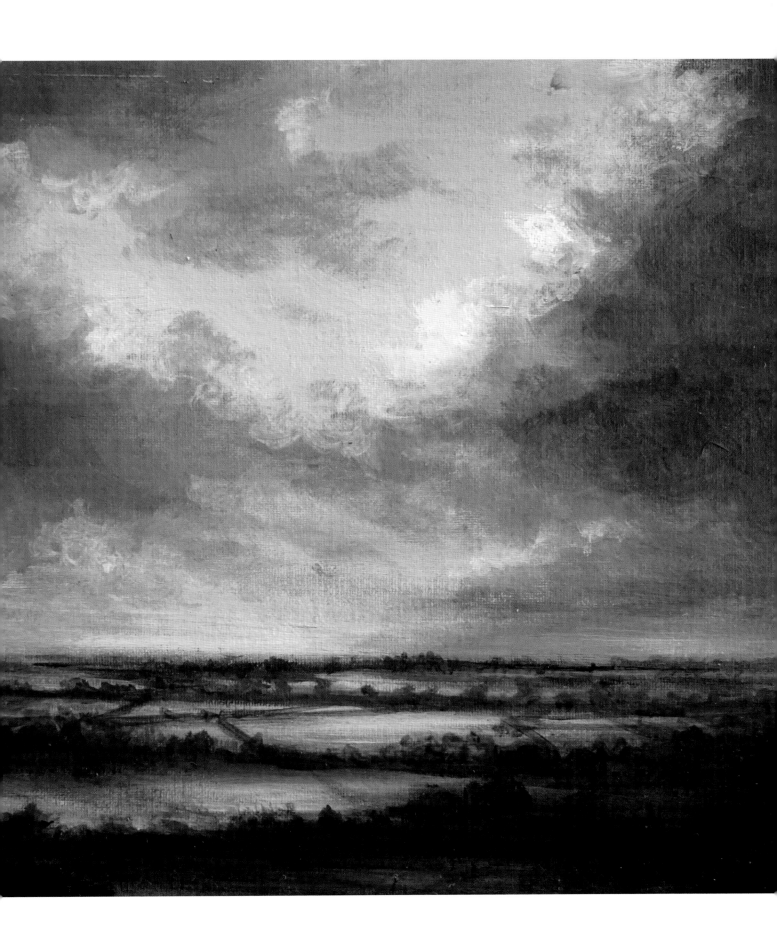

Interplay of light and shadow

This detail of *Fields at Wispington* shows extreme contrasts in tone, particularly on the horizon where the near-black land meets the near-white sky. This contrast between light and dark helps to create a strong sense of drama in the painting. The golden light has been laid on using a mix of yellow ochre and Naples yellow, giving the impression of sunlight hitting the ground.

How to develop atmosphere in your paintings

Colour

Use of colour can certainly contribute enormously to the mood of a painting – the intensity of a bright sunset is important to recreate, for example. Colour is a powerful tool and colour relationships can create some dazzling results in painting. Think about how the colours you have chosen reflect the scene you wish to paint. Is the intensity of colour there? Do the colours complement and work with each other?

Think about including small hints of colours – particularly complementary colours – in your composition. Some small hints of red in an otherwise green woodland scene will really bring everything to life. Similarly, subtle blues and purples might bring life to what would otherwise be a flat grey cloud.

Be careful when mixing colour. Keep mixes clean so that those colours really stand out – particularly for light-toned highlight colours.

Finally, remember that colour does not need to brash and bold in order to create atmosphere. Sometimes limiting the colours at your disposal can produce great results. A simple and muted palette can be just as effective in creating a sense of mood as a vibrant palette.

Tone

To me tone is perhaps more important than colour. Tone is created by how the light falls onto objects and refers to how dark or light something appears. Highlights and shadows become very important when we think about tone.

In any painting I pay close attention to my tones, as they are essential to accurately convey the sense of light, and therefore the atmosphere, in a painting. My aim is to ensure that my painting includes the full tonal range, from near-white to near-black.

In order to really make a painting work tonally I keep most of my colours in the middle of the tonal range, so that when I add my brightest highlights and my darkest darks they really stand out. Using a midtoned ground to paint upon will help you identify and balance the tones in your work.

You may find taking a black-and-white photograph of your subject helps to identify tone by stripping away the colour. This way you can check if you are hitting the more extreme highlights and darks.

Extreme tones

Avoid using pure white except for the very brightest of highlights. Likewise, try and avoid using black as a colour, as it can be somewhat overpowering and rarely occurs in the landscape.

Composition

An interesting and well-balanced composition will help to build atmosphere and mood in your work. Try to explore and practise different compositions within your work. This will stop you and your viewers becoming bored through repetition. A good composition should lead your eye into the painting and give you an accurate sense of the scene you are trying to depict. Quick thumbnail sketches are an excellent way to try out different compositions.

Not all landscape paintings have to have the same postcard-style layout. Think about altering your canvas sizes and ratios, maybe trying square or even circular canvases. Your viewpoint can also add a certain sense of drama – instead of looking straight ahead, try looking down into a valley or ravine, or looking up and make a painting entirely of the sky.

Brushwork

The way you apply paint and use your brush can really help convey your feelings about the subject you are depicting. Your brushwork adds an enormous amount of character to your painting and helps you to develop what will become your 'style'. Many artists are instantly recognisable from their brushwork alone.

Fast, energetic brushmarks can really help add drama and atmosphere to a landscape painting, these often come about naturally when you are working outdoors or to a time limit. While there is great skill in painting photorealism, I often feel that this type of work lacks a certain emotive power. I definitely think there is something to be said for being able to sum up a scene in the most economical way possible.

Consider looking at how great artists such as Turner created atmosphere through their brushwork. We are so used to seeing colour reproductions in books that we often forget that these paintings are physical objects made of frantic brushwork. Seeing paintings in the flesh is an excellent way to learn about brushwork.

Texture

Texture can really bring your paintings to life. A perfectly smooth painting can look a little boring. I much prefer to see the way that the artist has crafted and battled with the picture in order to bring it to life. Don't be afraid to experiment with the ways in which you move and apply the paint – I for one like to include both thick and thin passages within my paintings.

When working on the foreground I may use a palette knife or some texture medium to build up the layers of paint. This has the advantage of bringing the foreground closer to the view and giving it a greater sense of weight and presence. In contrast to this I may use thin glazes and washes of colour in my skies and around the horizon line. These can be used to recreate atmospheric effects such as fog or rain, or simply to make the sky seem lighter and more fluid.

Scratching out

This detail shows an example of how I have created texture in the foreground. The paint has been applied in different ways and thicknesses and I have also used the sharpened end of a brush to scratch into the surface of the paint. The range of textural marks used in the foreground are quite complex and suggest the illusion of complexity.

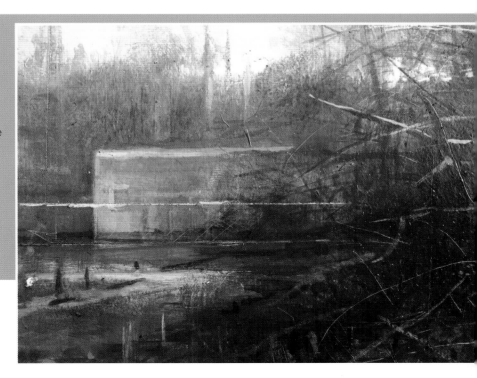

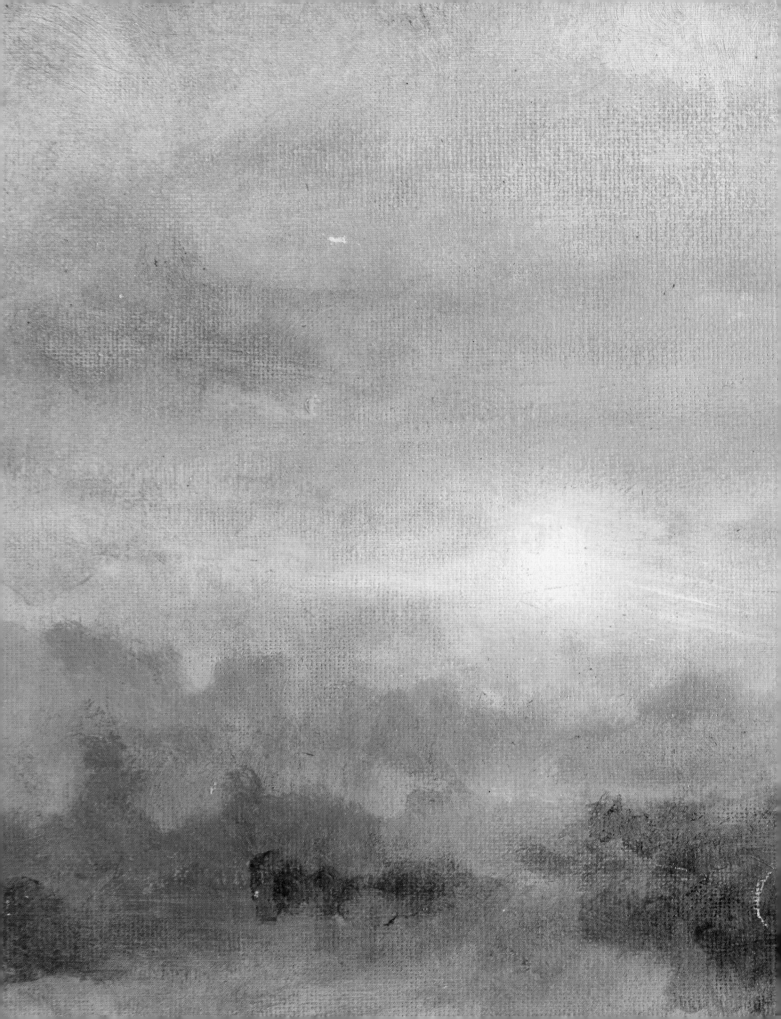

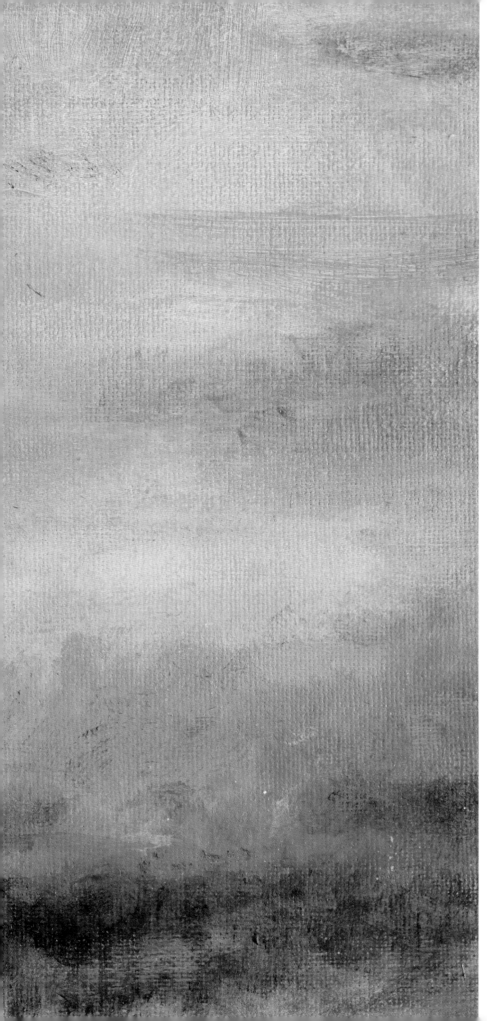

Sunrise, Lincolnshire

31 x 25.5cm (12 x 10in)

Created after witnessing a misty sunrise, this is a good example of a painting focussed upon a sense of atmosphere rather than accurately reproducing a scene. Although the painting does not have a clear subject, an interesting atmosphere is created through the use of colour and brushwork. The bright white highlight in the centre creates a strong tonal contrast and sense of light.

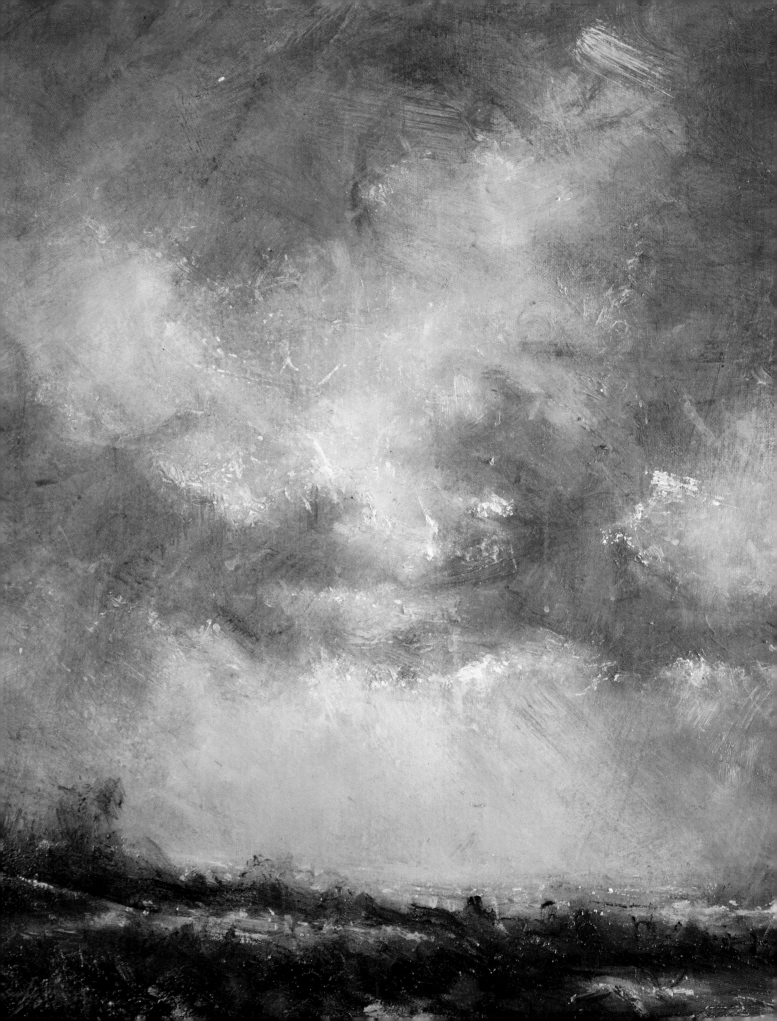

Storms

To witness a storm is to experience nature in all its terrifying glory, and hard to plan as seeing a thunderstorm is usually something of a rare novelty. Storms encompass a broad range of different weather conditions that make them the ideal subject matter if you are looking to paint with real drama and atmosphere.

I grew up looking at Turner's work and was hugely inspired by the power and magnitude of some of his paintings of storms. You could tell that Turner really relished extreme weather conditions – legend has it that he tied himself to the mast of a ship to witness the full force of a storm in person. I'm not suggesting that you go to that extreme, but if you are lucky enough to witness a storm make sure that you at least take a photograph for some valuable reference material.

Rain Clouds, Yorkshire

60 x 60cm (23½ x 23½in)

Some years ago, I was fortunate enough to witness a storm when walking on a holiday in the Yorkshire Dales. I did not have a camera at the time, and so the painting below is a recollection from memory. The painting was an experiment in creating atmospheric weather effects using acrylic paint.

Multiple layers of glazing were built up in the sky.

Dramatic contrasts in lighting help to create interest and impact.

Big energetic brushstrokes mimic the power and speed of the storm, and so help to represent it accurately.

St Hugh's Choir, Blue Light

As winter sets in, painting outdoors once more becomes out of question to all but the most hardened landscape painters. This is a time of year best kept for the comfort of the studio, in close proximity to a kettle. If, however, you do crave some painting from life, it is often worth setting up in an indoor environment. This could mean a still life in the studio or a finding a place where you can paint an interesting interior or the view from a window.

When working inside a large enclosed space like a church or cathedral, many of the lessons you have learned during the year still apply. You might think of the space as a particularly orderly landscape in order to get over any 'indoor jitters'. The sudden jump from working outdoors to working indoors can feel a little jarring – when we come up against complex or detailed subjects we all tend to panic somewhat and think that we need to capture every last bit of detail. I have learned the hard way that this never works and trying to render every element of a view can become a real trap. Aim to loosen up and focus on the light and atmosphere rather than obsess over details.

November 28th

The short winter days are here once more. Christmas is right around do the corner. This is a time of year that I usually slow down and concentrate on rounding up any outstanding paintings rather than beginning new projects.

I was resident artist at Lincoln Cathedral for a year in 2009 and know the building well. Slightly nostalgic, I decide to return for an indoor painting session. I'm biased, but it really is one of the UK's greatest buildings. During my residency I worked from a studio in the building, tucked away in an area of the cathedral called the triforium, a gallery that looks down over the St Hugh's Choir. It is hard not to be swept up in the atmosphere of such a beautiful building.

I remember my first tentative painting here – I floundered hopelessly when confronted with the architecture of the building. I had moved from the soft edges and gradients of the natural landscape to the perfect curves and straight lines of Gothic architecture, and I just couldn't make the paintings work. It took me weeks of working in the cathedral before I was able to loosen up and start making some decent paintings.

The light's steady progress throughout the cathedral during each day is really something to behold. The brilliance of the stained glass and interesting shadows created by the architecture made for some very dramatic views.

Despite my residency being over, I resolve to make repeated visits to this fantastic building during these colder months – I am always amazed by new compositions that I'd never thought to capture previously.

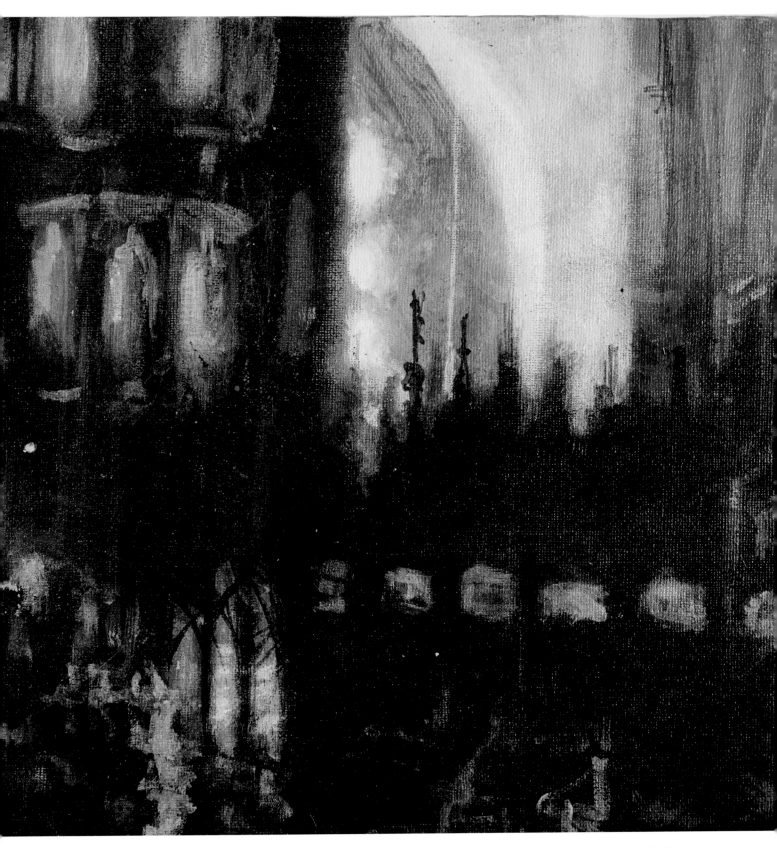

The finished painting
31 x 25cm (12 x 10in)

Painting *St Hugh's Choir, Blue Light*

I was drawn to the beautiful contrast between the dark wood of the choir stalls and the light flooding into the nave behind it. I wanted to create a painting that would show this extreme contrast and also allow me to pick up some of the rich textures and golds in the choir area.

Changing light

I started by establishing a very pale background using whites, ochres and blues to produce the sense of the cool light in the nave. The light in the cathedral moves constantly, so I found I had to revisit the spot at the same time on different days in order to make studies and get the effect right.

Hint at familiar detail

This painting is kept reasonably loose, with the focus on the contrast in the light, but I did want to hint at some of the architectural details. These were blocked in using a size 2 round brush and some heavily diluted burnt umber.

Gold paint

I wanted to hint at some of the reflections and rich details in the choir stalls, and so treated myself to some gold acrylic paint, which is used sparingly in this picture. The gold really shines out from the painting and creates nice accents against the dark colours used in the foreground.

An alternative approach

During my time in the cathedral I made several very fast paintings. These were made necessary by the constantly changing light and my need to loosen up and focus on the atmosphere rather than the detail.

The painting below is one such quick study, executed using only four colours and in about twenty minutes. It is an attempt to capture the late afternoon light and the mottled effect it creates on the cathedral floor. The dark shape in the centre is the silhouetted shape of a statue of Edward King (1829–1910), a former bishop at the cathedral.

I built the painting up using a limited palette of burnt umber, sienna, white and ochre – all earth colours, which helped to create the feeling of warmth and the tactile nature of the stone in the cathedral.

The Statue of Bishop King
28 x 20cm (11 x 8in)

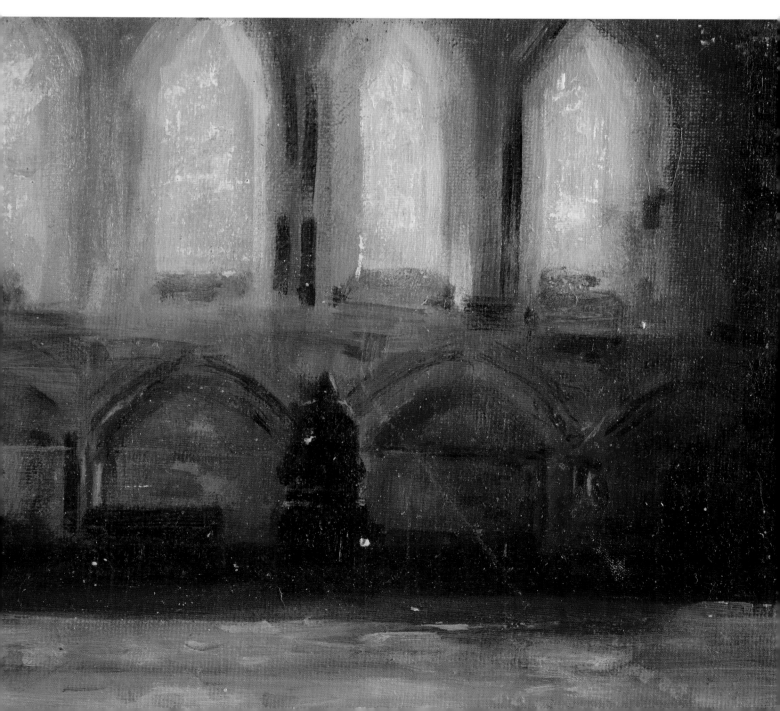

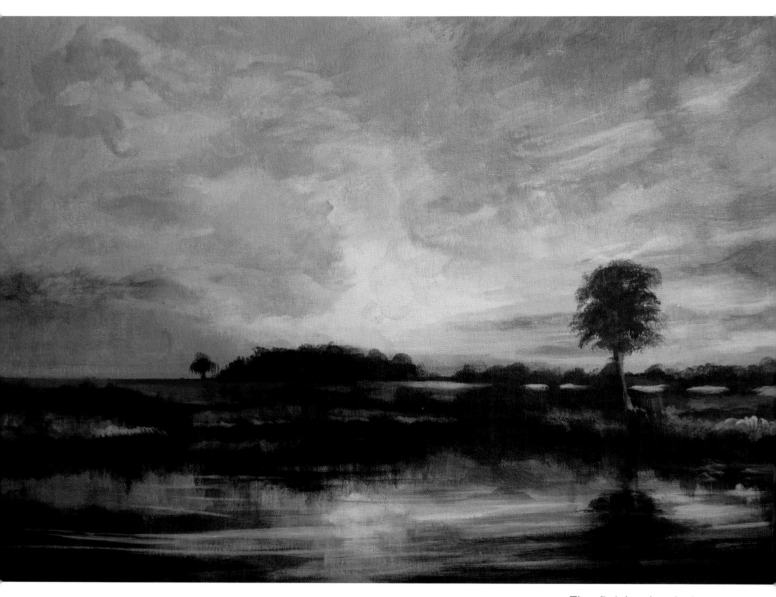

Autumn Light

This scene, with its beautiful pewter grey-tinged light reflected so beautifully in the water below, was a gift. I would love to tell you that the water is part of a beautiful lake or river, but it is in fact an open water reservoir on some farmland in the Lincolnshire Wolds. Nobody needs to know.

 This project is all about capturing early autumn light. The composition of the painting is simple, in order that the focus is on the light and colours – the real stars of the show. The challenge in this painting is really in tonal restraint, by which I mean it is important to build the picture with a series of relatively muted colours. This gives you the ability to really hold back with the brightest highlights until the very end. This will really help to achieve that sense of glow in the sky.

You will need

56 x 38cm (22 x 15in) canvas board

Grey matt emulsion and roller

Paints: basic palette (see pages 16–17) plus cobalt blue

Brushes: size 12 round, 25mm (1in) texture brush, sie 1 round, size 10 filbert, size 8 filbert, size 4 filbert

Spray bottle

1 Key marks

- **Establish basic shapes** using the size 12 round and burnt umber, after priming the surface with the small roller and grey emulsion.

- **Run a dark** band across to delineate the horizon and banks of the lake, along with the reflection of the tree on the right – but not the tree itself.

Underpainting
Establishing the tones, however loosely, early on in the painting process will ensure you know where the main elements will lie.

The painting at the end of this stage.

2 The sky and water

- **Block in the** centre of the sky using the 25mm (1in) texture brush and titanium white. Work in a mix of titanium white with hints of cobalt blue away from the centre. Add touches of palette grey and Naples yellow into the blue-white mix.

- **Paint the water** with similar but slightly darker mixes than the sky, particularly in the corners. Add more palette grey and some ultramarine blue to achieve the darker tones.

- **Your palette mixes** will likely spread and merge, giving you great midtones and varied mixes. Change to the size 10 flat to apply these mixes with more controlled touches – short, stabbing strokes to develop the broken-up clouds.

- **Mix palette grey** with permanent alizarin and ultramarine blue. Use the size 10 filbert to add this warmer, deeper grey to the lake. Further strengthen the corners of the composition by adding Payne's grey and more ultramarine blue to the same mix. Contrast this with a mix of palette grey and Naples yellow for the reflections of the clouds in the water.

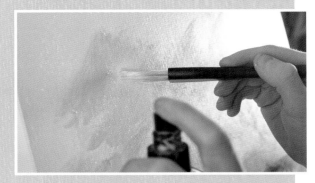

Spray bottle

Use the spray bottle to wet your brush occasionally as you work. This helps to create a softness in the sky without wetting the surface too much and causing the paint to drip.

The painting at the end of this stage.

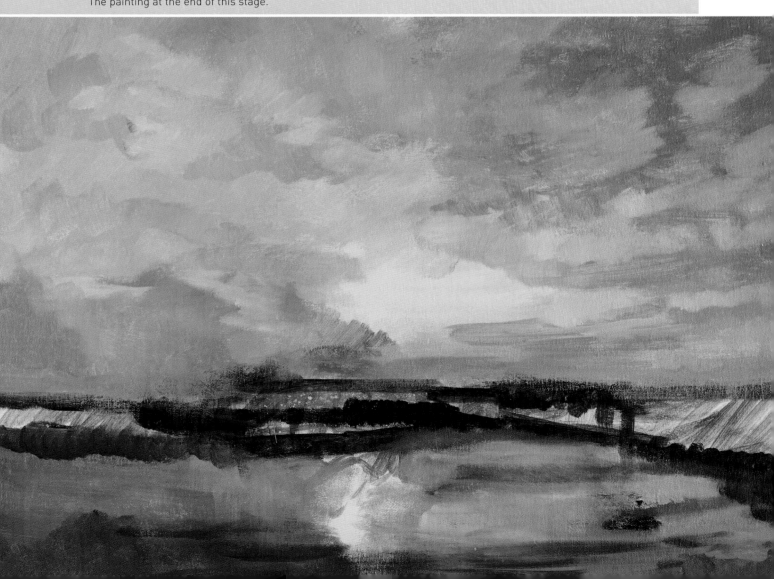

Reflections

Vary the mix you use and hop back and forth between the lake and sky so that the cool and neutral colours are shared between the two areas – just don't forget to make the water consistently slightly darker in each case.

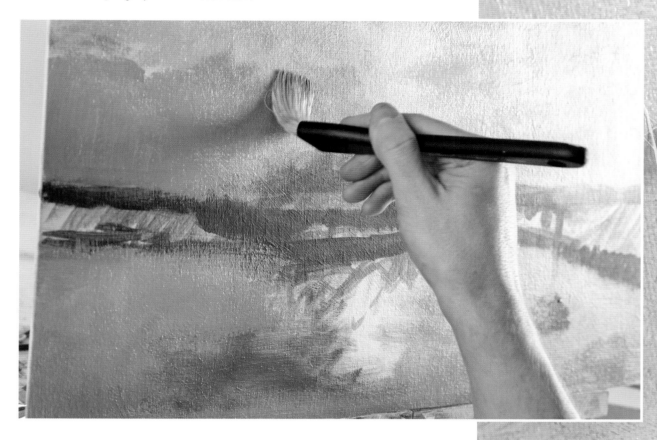

Tone

Note that the sky is deceptively dark away from the central area.

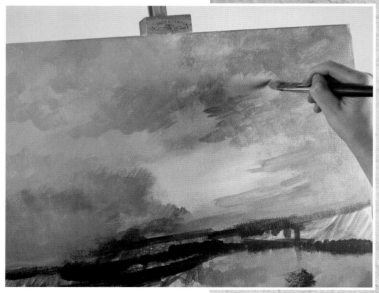

Clouds

Use of the size 10 flat allows you to build up more controlled marks with shorter, stabbing strokes.

3 Warmth and land

- **For the land,** mix yellow ochre with permanent alizarin and ultramarine blue to produce a chalky green. Block in the midtones using short, stabbing strokes of the size 8 filbert. Add more permanent alizarin and yellow ochre to create a rustier mix, and use this for the background field.

- **Add forest green** to some of the various mixes on your palette and make more carefully considered marks to create the dark areas on the land. Use short, rapid, downward strokes for the reflections. Once dry, dilute yellow ochre and use the size 4 filbert to add some small highlight glazes across the ground.

- **Add a tiny** hint of Naples yellow to titanium white and use the size 4 filbert to develop the light sunlit area in the centre of the sky. Dilute the mix and glaze the reflection of the area on the lake with a mix of light horizontal strokes and small circular strokes.

- **Add a hint** of cadmium red to the mix and continue to incrementally warm the sky with glazes. Work sensitively with the peach mixes and touches of Naples yellow and titanium white to develop the sky.

- **Mix titanium white** and ultramarine blue and apply this mix with the size 4 filbert for further development in the sky and water. Apply the paint with mainly horizontally strokes in the lake, and use freer, looser touches that follow and refine the shapes of the clouds in the sky.

- **Work back into** the dark areas, particularly in the water and the reflection of the large tree. Use cooler darks: mixes of Payne's grey and ultramarine blue in the water, then warm the mix by adding burnt umber to the trees on the horizon.

The painting at the end of this stage.

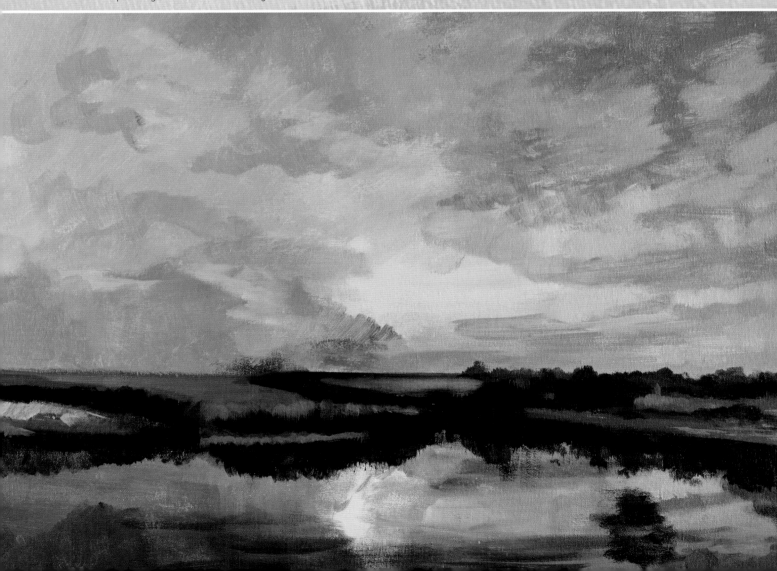

Horizon

Rather than a single colour, the horizon is broken up with lots of paints worked into one another, creating a smooth and varied base on which to work.

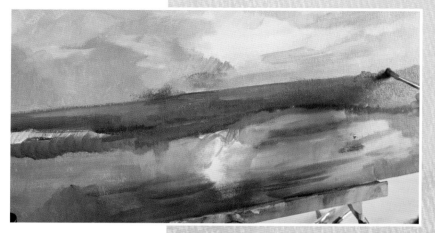

Focal point

The bright central area is important to the composition, so be careful not to overwork it.

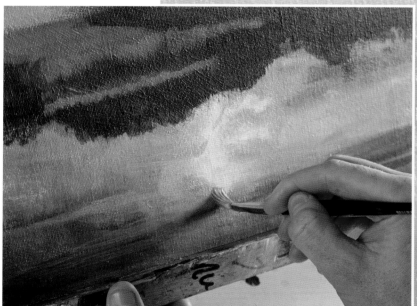

Warmth

These burnt umber glazes in the background are a good opportunity to talk about how warming glazes can effectively be used to draw the eye and prevent the background – naturally cooler than the foreground owing to the effects of aerial perspective – in a painting from becoming cold and uninviting.

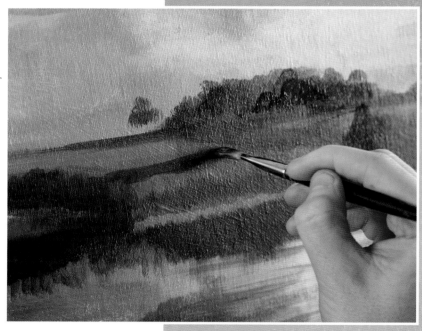

4 Details

- **Add the trunk** of the tree using the dark mix (Payne's grey and ultramarine blue) and the size 1 brush. Swap to the size 4 filbert and use light touches to build up the bulk of the foliage. Work from the central point outwards to build up the texture.

- **Add forest green** to the mix and overlay the foliage in places. Work from the central trunk outwards to build up the texture naturalistically and avoid leaving any sky visible near the centre of the tree.

- **Make a warm** mix of yellow ochre and cadmium red and paint the extreme highlights on the tree, then extend them for sunlit warmth, where appropriate, across the painting. Use the size 1 round for controlled application of the mix, and the size 4 filbert with almost dry paint for more subtle scumbling.

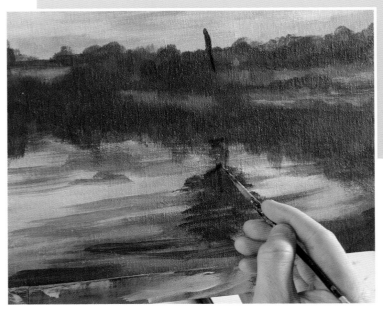

Tree trunk
The trunk does not need to be drawn in exquisite detail – but do be careful that it leans in the opposite direction to its reflection.

The painting at the end of this stage.

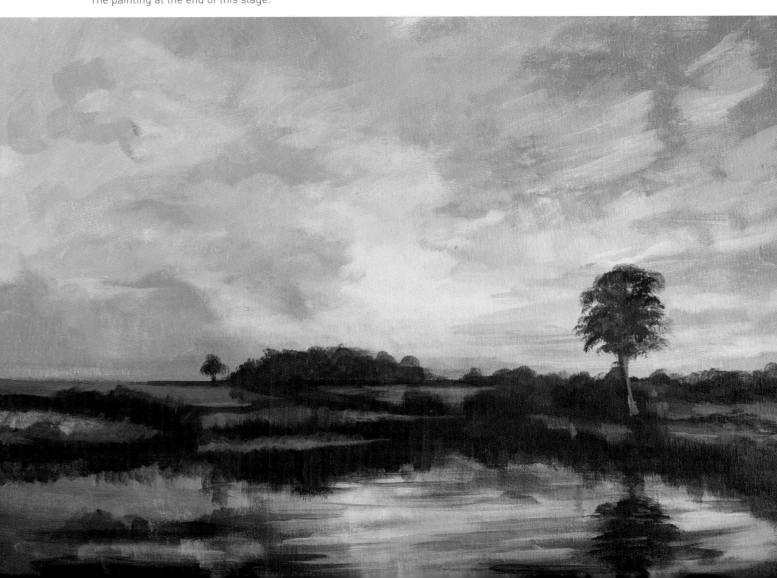

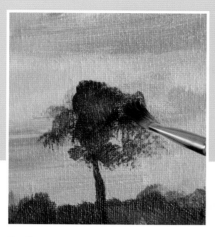 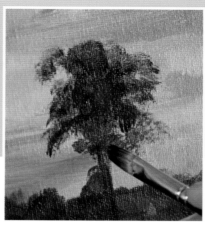 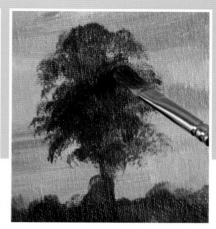

Foliage

Build up the foliage gradually, working from dense darks in the centre out to increasingly light green highlights as shown in this sequence.

I readily admit that the tree in this painting is erring towards the 'lollipop' category that I warned you against earlier in the book! However, in this case that was exactly what this tree happened to look like. Feel free to make it look a little more varied if you so wish.

Warm highlights

The side of the tree in direct sunlight is drawn in relatively simply – just a few marks on the left-hand side of the trunk. Note that the highlights are not overlaid on the trunk but instead add width to the tree.

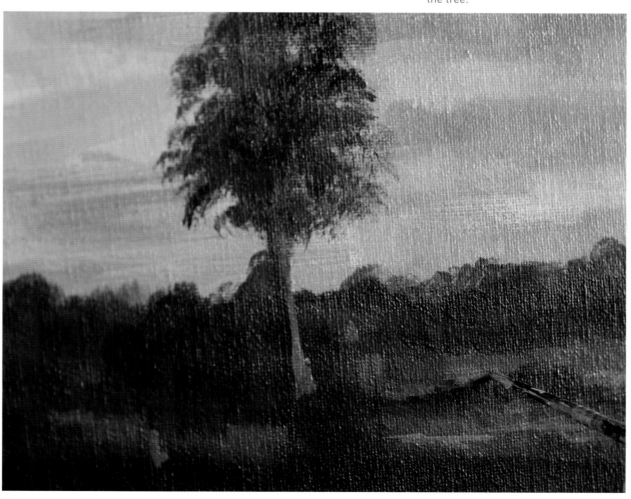

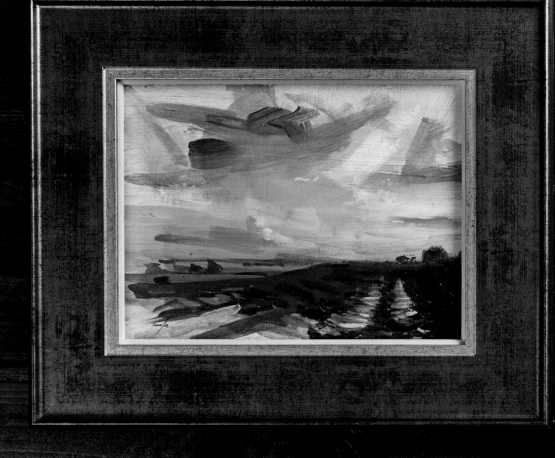

Finishing your work

The question 'how do you know when it is finished?' is one that most artists dread. Unfortunately, there is no simple answer to that question. Deciding when a work is done is no easy task. Having spent so much time with a work, you need to know that it is right. Sometimes making it right can be a painful process that means that the painting gets worse before it gets better. Ultimately, you have to be brave when you are painting, and if something isn't right you should attempt to rectify it. This takes courage of course, but is one of the best ways to learn and to avoid making similar mistakes in future.

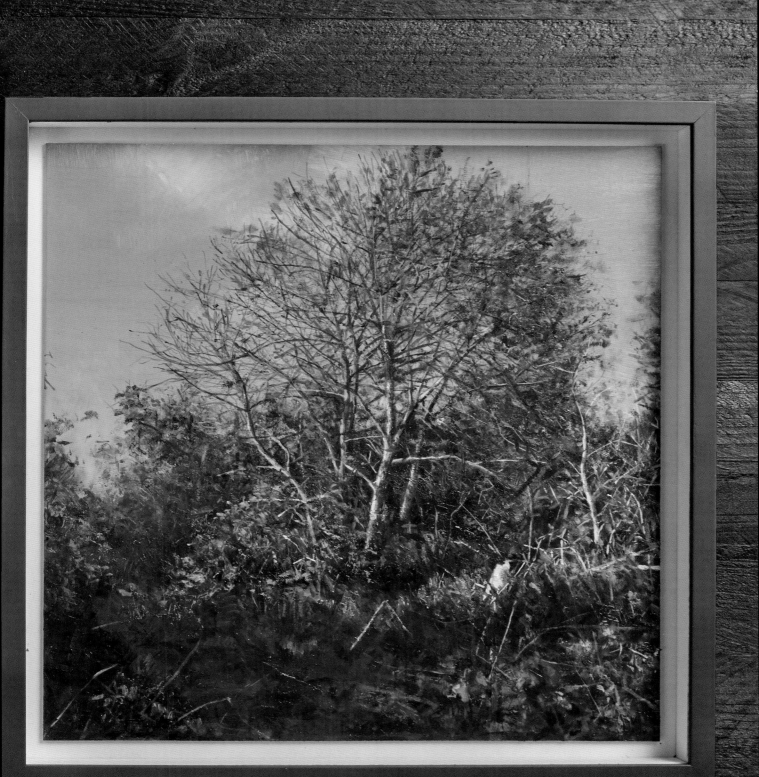

Judging a painting finished

I am very often guilty of changing things at the last minute and making minor tweaks or, to put it another way, fiddling with it. This is a habit that is simultaneously frustrating and essential, but you must at some point call a halt and declare a painting finished. The following is a list of rough guidelines that I have in mind when deciding whether a work is complete or not.

- Consider what it is about the subject that made you want to paint it in the first place and ask yourself if you have achieved a sense of that. Has the painting captured the mood or atmosphere that you set out to create? Does it evoke a sense of place, time or weather?

- Check the proportions and drawing are correct. Does the composition work? Is everything in the right place and to the right scale?

- Do the colours and tones work? It is important that your colours are harmonious and work with one another. I also like to check that my painting works tonally and includes contrast in highlights and shadows.

Ways of revising a finished painting

I often revisit old paintings and make additions and improvements. These may be older pieces that I feel do not quite work. I may end up scrapping them or painting over them, but it is always worth seeing if you can give them one last chance...

The first thing I consider is if I can add any highlights or shadows to increase the tonal intensity of the painting. Acrylics are very forgiving and easy to paint over, and a few clean, well-placed highlights can make a surprising difference to any work. Sometimes they seem to make everything fall into place. Similarly, some additional dark shadows can also be beneficial. I often find myself going back into clouds and making them slightly darker to bring them forwards in the painting or give them a greater sense of weight.

I may decide to use thin glazes of acrylic (usually a mixture of paint and clear medium) in order to suggest different weather conditions or to subtly alter the overall colours of a certain section of a picture. Page 149 shows this process in more detail.

I have always enjoyed finding ways of representing a viewpoint or subject that I have painted before, finding ways of showing it in a new light. There are several ways to do this. In the past I have reframed or cropped compositions, perhaps moving my focus to the right or left or including elements of a composition that I had left out in a previous painting. It is amazing how something as simple as this can truly alter the look and feel of a familiar viewpoint.

Aside from changing the compositional elements, I have also taken to visiting familiar places during the different seasons. Each season (and to some extent, each month of the year) can offer up new possibilities for a painting. Colours change, light changes and the trees and foliage bloom and shrink.

It is hard to be an artist and it can be frustrating at times. To keep yourself motivated, it is important to recognise and reward your progress and achievements while simultaneously striving to keep improving and pushing yourself out of your comfort zone.

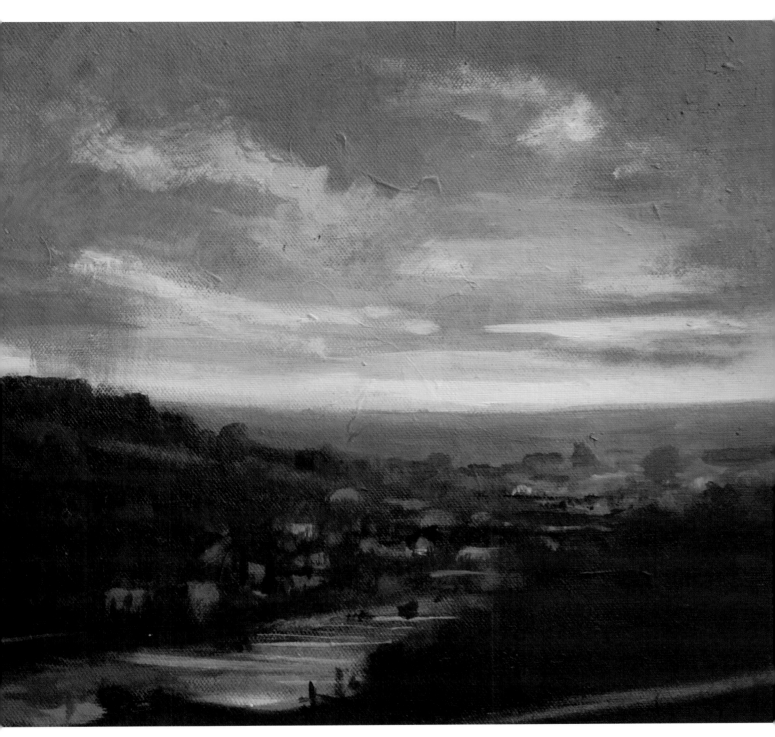

Whitby, Revisited

40 x 25cm (15¾ x 10in)

Upon revisiting *Whitby* (see page 155) I decided to expand upon the image and take
it further by reworking it. I felt that the painting did not have a strong enough sense
of light and drama. In order to remedy this I began to rework the painting. I started
by creating a much stronger light source with bolder contrast, then introduced
some more warmth by adding Naples yellow in bolder brushstrokes.
I also refined the lights and darks in the foreground of the picture, strengthened
the dark silhouette on the horizon line and refined the buildings.

Varnishing

One of the simplest ways to improve a finished painting is to varnish it. This offers not only protection but also helps to present the painting as a finished work. To my mind, it also offers a certain sense of closure to a painting, signifying that it is finally complete and allowing you to move on to the next project.

Exposure to light and dust can quickly damage a finished work. Varnishing offers a finished painting a useful protective barrier by sealing your hard work and protecting it against ultraviolet rays. It also provides a surface that is easier to dust and clean.

Different colours and brands of acrylics behave differently and dry with varying degrees of finish. I have often found that the gloss levels across the surface of a finished painting vary. Varnishing eliminates this problem and provides a uniform surface finish that can also bring the whole painting together, enriching the colours and adding a certain depth.

Varnishing materials

Varnish usually comes in a gloss, satin or matt finish. In nearly all cases I use a gloss varnish as I find this gives a richer finish and I prefer the overall surface of gloss when the painting is framed.

Most paint manufacturers produce their own types of varnish but you do not necessarily need to use a varnish from the manufacturer who makes your paint. It is best to opt for a varnish that is designed for use with acrylics.

Aerosol varnishes are available – these are simply sprayed onto the clean surface. If you opt for these, follow the manufacturer's instructions carefully. I prefer to use liquid varnish that can be brushed on, as these tend to be more hard-wearing and give a more painterly finish. A good varnishing brush will have a wide flat head reducing the number of brushstrokes you need to make across the surface of your picture. I keep this brush for varnishing alone and never use it for standard paint. It is also important that you wash and clean it thoroughly to avoid transferring any dust or dirt to the surface of your painting when applying the varnish.

Spray-on aerosol varnish, brush-on liquid varnish and a varnishing brush.

How to varnish

Before you varnish a work, ensure that it is completely dry and that any stray hairs, bristles or dust have been removed from the surface of your work. There are few things more annoying than varnishing a piece only to find a bristle trapped in the final layer.

There are many ways to go about the act of applying the varnish, and different artist have their own tried and tested methods to do this. These instructions assume that you are using a brush-on liquid varnish.

Before varnishing a work, lay down a protective surface to prevent any damage to your work surface caused by any stray drips. It is important that you are able to lay the painting down flat, as this helps to avoid any runs when applying the varnish. You may also wish to raise your painting slightly by using a stable platform as this avoids the varnish pooling at the edges of the painting and sticking to the surface below.

It is important to keep your tools and work area clean while you varnish. I always have a clean jar or pot in which to pour my varnish. Some varnishes require diluting with water while others can be used neat.

When you are ready to begin, dip your brush into the varnish and apply even strokes across the surface of your work. It is best to start at one end and work your way across the canvas, moving each stroke in the same direction. Ensure that there are no pools of varnish and that it forms a smooth, even coat.

Being a clear medium, it can be easy to miss areas when varnishing, only for them to show up later when the coat has dried. For this reason, it is worth looking at the painting from different angles when you have covered the entire surface to ensure there are no areas you have missed.

Some varnishes may require several coats. When you are content that you have finished, do not move the painting but leave it to dry for the recommended time in a place where it is unlikely to be disturbed.

The topmost image shows the varnish being applied with a large brush. The middle image shows the unvarnished version. Compare this with the improved gloss levels on the varnished painting at the bottom. More layers can also be applied to improve the gloss levels further.

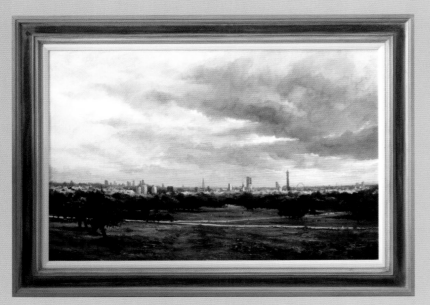

The moulding of this frame is fairly simple. Note that the colours echo those used in the painting itself. A white inner slip prevents the frame from visually interfering with the artwork.

Framing

I am asked quite regularly how to frame acrylic paintings. There are no particular rules when it comes to framing. It is, to a large extent, a matter of personal taste. However, if you intend to show or exhibit your work, framing is something that needs a little consideration.

I never used to pay much attention to framing, picking up cheap second-hand frames in charity shops or budget stores. While these served a purpose in allowing me to present my work, to say that they were not a good fit for the paintings would be an understatement. These days, I like to think that a good frame adds value rather than costs money.

Moulding

The moulding refers to the main part of the frame, the wooden or plastic border that surrounds your work. It is worth thinking about the width of your moulding in relation to your painting. Generally, the larger the painting, the larger the moulding, although some very small paintings benefit from a very wide moulding.

The range of moulding types available is quite staggering, so I recommend that you shop around before committing to anything in particular. Styles range from ultra-modern and minimalist to antique and distressed. Cheaper mouldings tend to be made from plastic or composite materials, with the more expensive mouldings being made from real wood.

When selecting a moulding, try and let the painting do the talking. It is easy to overpower a painting with an ill-chosen frame. Aim to find a frame that complements the work and shows it in its best light. Consider the colours or colour themes in your work and select a moulding that has accents of those colours.

Slips

A slip is essentially a smaller frame that divides the painting and the main moulding, similar to a mount around a photograph. An inner slip usually contrasts with the main moulding and is lighter in colour, so that it lifts and complements the highlights in a painting.

Most of my paintings are completed on canvas or canvas board, so I often use a smaller inner slip to add contrast and clearly distinguish the painting from the moulding. If I use inner slips they tend to be either gold or off-white.

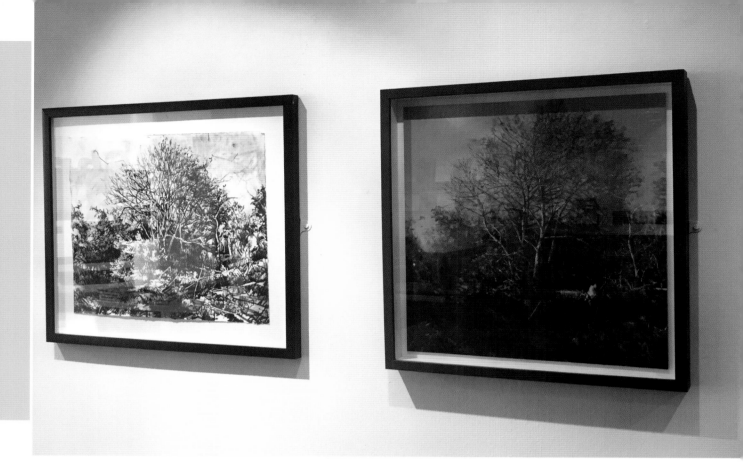

Choosing a frame

For the most part I think it is best to treat an acrylic painting as you would an oil painting – that is, to frame the board or canvas with a wooden or plastic moulding. Glass is not generally required when framing an acrylic painting unless that is a look that you are particularly interested in.

The exception to this is if the painting has been executed on paper. Paper generally needs better protection than board, both structurally and against discolouration. If you do paint acrylic on paper I would recommend framing your work as though it were a watercolour, mounted behind glass with a simple wooden frame around the edge.

Bolder and more abstract work is likely to respond better to a contemporary moulding over something very ornate. I personally tend to lean towards fairly simple mouldings, perhaps with a slight curve or raised edge to add a bit of visual interest. In terms of finish I prefer a slightly distressed look, my framer may use hints of gold leaf or bronze that peek through the final colour of the frame.

Most professional framers will have a large range of sample mouldings that you can offer up to your pictures before making a decision. It is much easier to visualise the overall look of a framed picture if you can see the frame in the flesh and check that it matches with your work. It is not uncommon for picture framers to offer custom frame finishes as well. These tend to cost more, but do mean that you end up with a frame that is completely unique and has been created to match your artwork.

It is now possible to order custom-made frames online. This tends to be cheaper, but is not always the safest option. I prefer being able to hand the work over in person so that I can be sure the measurements and moulding are correct and will fit the picture exactly.

The dark, minimal frames of these small paintings are offset by white slips. Note that the colour painting has a relatively smaller slip, so that the image is not overpowered. The bolder black-and-white artwork can stand a more dominant slip.

Reflections

on the year

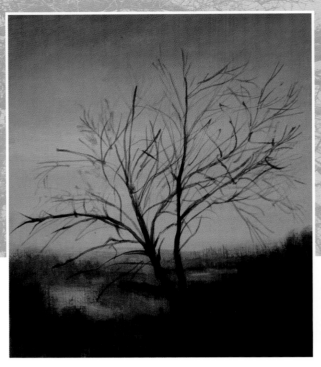
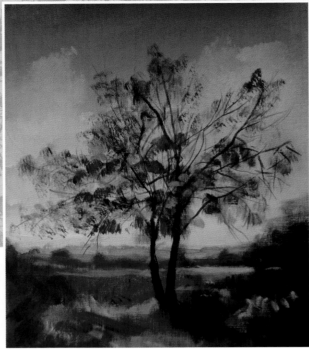

The changing landscape

We have come full circle, passing through the four seasons, each of which has brought its own distinct array of colours, weather, moods and atmospheres to provide us with a constant and ever-changing source of inspiration.

Each new year brings with it new challenges and barriers to break through, but one of the greatest things about being an artist is being able to look back and chart your progress to see how much your work has changed. Whether you are just starting out or have been painting for years, that change is a crucial part of the process, and something to remind yourself of on those wet days in the studio when nothing seems to be going your way.

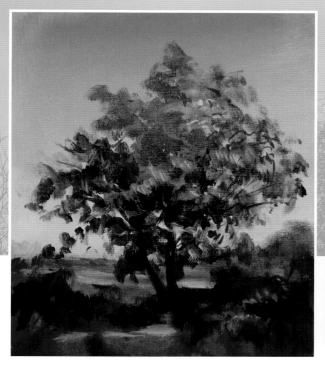
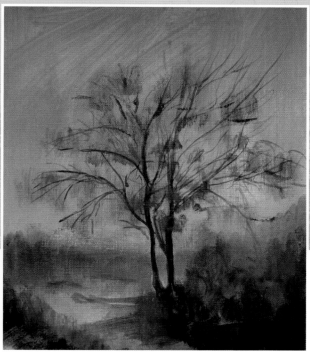

After a year

As your year closes, I encourage you to take some time to reflect on your experiences and achievements. This is also a time to plan new projects and adventures in the landscape, as the cycle of seasons begins once more. This is your chance to reflect on the successes and missed opportunities of the year before so you can plan how to grow your talent even further. Before you know it, the new year will roll around, with the landscape refreshed and stretched out in front of you once more.

My hope is that this book will have provided you with a small insight into the year of a landscape painter and that, whether brand new to painting or a seasoned veteran, you will have taken some inspiration away. I also hope that if you had never painted outside before, that this book has encouraged you to have a go.

If you have learned by following the step-by-step demonstrations or copying the other works in this book, I encourage you to build on this knowledge and try painting outside. It can be a challenging pursuit, but there is no better way to experience nature than first-hand. Injecting some of that experience into your work will inevitably improve your artistic practice.

Remember, painting is not about creating a masterpiece, it is about learning and enjoying the process. Keep interested, keep sketching, keep practising and – most importantly – keep painting!

One Tree, Four Seasons

I often work from trees, these have the courtesy of staying still but also changing dramatically throughout the year. The appearance of just one tree through the year can provide you with months of painting. It is important to be conscious of your surroundings and the landscape that is close to home as well as the more obvious landscape choices.

Other media

Acrylics are and always have been my go-to medium. I am passionate about promoting their use and allowing people to realise the potential in this often overlooked medium. I have no doubt that, in years to come, works by acrylic Masters will be hanging alongside those created in watercolour or oils.

Nevertheless, I believe it is healthy to try other ways of making art. It can sometimes be a refreshing change when things are not going well or you're trying to achieve a particular effect. For instance, I draw all the time and do lots of work using pens and pencil. Far from distracting from my acrylic work, I find that drawing accompanies and strengthens it. Trying out some other media will have many of the same benefits for you.

Oil paints

I love the richness of oils and the ability to blend and rework them. My main sticking point with oils comes from my small studio space and an unwillingness to work with lots of solvents and spirits.

I return to oils occasionally and always enjoy the process. They share certain similarities with acrylics and the depth of some colours is really unmatched. Oils also have a sense of heritage, as many of the world's great landscape masterpieces were created in oils.

What really excites me is when my acrylics are mistaken for oils, as this just goes to show the amazing potential of modern acrylics! Most of the techniques covered in this book apply equally to oils, with only minor changes.

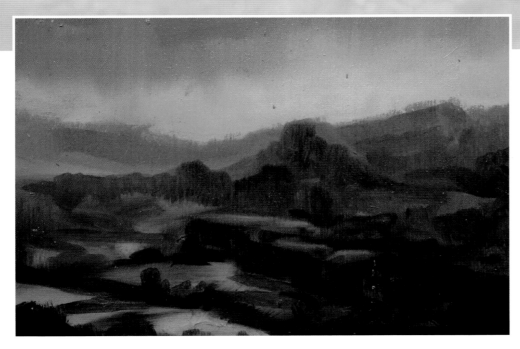

Pignano (sketch in oils)

15 x 10cm (6 x 4in)

An oil sketch made during the same trip to Italy as the acrylic sketches on pages 92–93.

Digital painting

Digital art is often met with lots of questions: "Is it real art?", "Isn't it cheating?" In answer, it is worth looking to the past. Historically speaking, artists have always been an inquisitive, experimental bunch and have always been keen to embrace new technology to supplement and inform their artwork. Where would Caravaggio and Canaletto be if they hadn't used advanced optical devices to compose their works? Where would the Impressionists have been without the collapsible paint tube?

The nature of a tablet computer means that you are still using the movement of your hand to create the work. As in all art, the relationship between the hand and the eye is the most important element at play here. The tablet simply offers you a surface to work upon and gives you a range of tools and colours – what you do with them is down to your own skill, just as with any other medium. The computer is not doing any of the hard work for you.

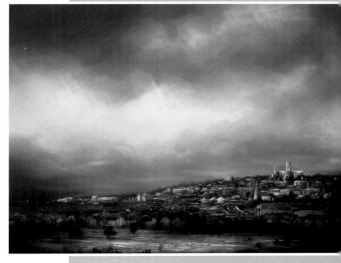

Tablet computers

Tablet computers are small computers with a touchscreen interface. There are now hundreds on the market but the most popular and well-known example is the Apple iPad. Tablet computers have a range of applications (apps) that offer a multitude of different programs – including art apps – for business and pleasure. The portability and touchscreen interface make the creation of relatively sophisticated digital art simple and accessible.

Creating digital art

In order to create digital art, the user needs to download an app designed for this onto their device. In most apps the screen of the tablet then becomes a digital canvas onto which users can draw/paint using a range of simulated colours and brushes. All the images and marks made are rendered digitally by the program and then stored on the device. The user can use their hands or a special stylus (a pen designed for use on a digital screen) in order to make marks.

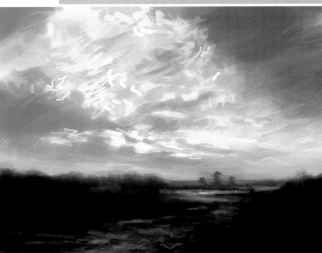

Tablets are well suited to trying different ideas without wasting physical materials. I sometimes try out a composition or colour relationship on my iPad as I can do this quickly and for free. You can work purely in the digital format then print it out in a range of sizes. More often, I use the tablet to make quick colour sketches or notes that I can instantly email back to the studio for use later as reference.

I first tried digital art when I bought myself an iPad, more out of curiosity than anything else. I found it to be an exiting and interesting medium and have used it with increasing regularity. Nothing quite compares to the feel of a real pencil against paper, the smell of oil paint or the versatility of acrylics, but digital art has its own advantages.

A selection of landscapes produced using the digital medium.

Index